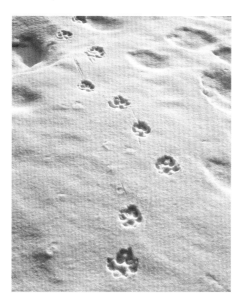

We dedicate this book to the wolves of the Sawtooth Pack.

First serving as teachers, they are now truly timeless ambassadors for their kind.

And to the memory of Dr. Gordon Haber, who, in Alaska's Denali National Park,

shared with us his time and research as we observed the wolves of the Toklat Pack with him.

His insight and compassion for wolves enriched us all.

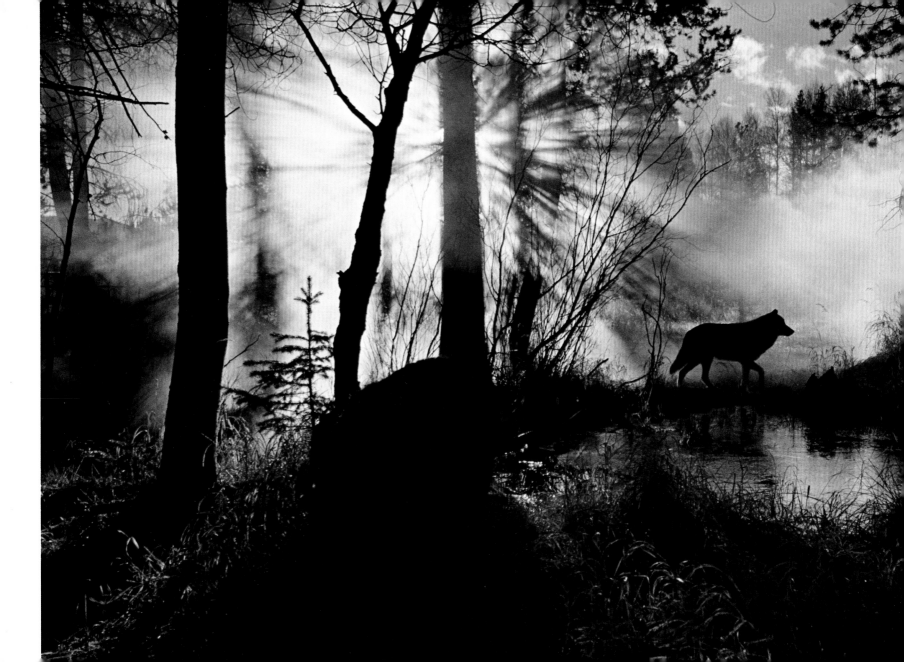

THE HIDDEN LIFE OF
WOLVES

JIM AND JAMIE DUTCHER
WITH JAMES MANFULL

FOREWORD BY
ROBERT REDFORD

NATIONAL GEOGRAPHIC

WASHINGTON, D.C.

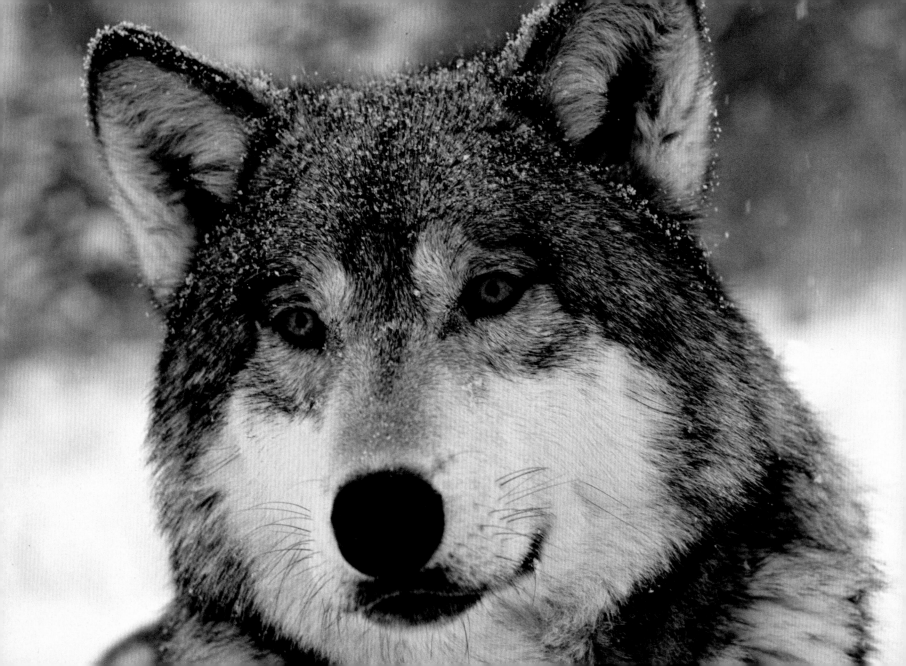

CONTENTS

Opposite: Kamots was the alpha male and a leader of the Sawtooth Pack.

FOREWORD BY ROBERT REDFORD

As a traveler crosses the open spaces of America, or watches the majestic high peaks of the West pass beneath the window of a plane, there seems to be no end to wild land. Once millions of bison and elk roamed here, carefully watched by Native Americans . . . and by wolves . . . that depended on those seemingly endless herds for sustenance, for life. It was a world in balance.

When European settlers ventured west, they eyed this same land with a different vision. Bringing with them dreams of prosperity, and the rifles to make conquest a reality, they imagined a virgin world where they, the outcasts and adventurers of the Old World, could become the rulers of this new continent.

These pioneers established themselves as the dominant predator, confronting much of the competition, both animal and human. The barrels of their guns readied the land for the blades of their plows and the arrival of their livestock. Along with their horses and families, their cattle, their sheep, and their hopes for a new life, they also carried old myths and fears from the world they left behind.

To the settlers who invaded their world, wolves were considered bloodthirsty vermin with no redeemable attributes, fit only to be eliminated in the name of progress. Newly available photography showcased frontier marksmen victorious in front of piles of dead wolves, symbols of a West made safe for human settlement.

There aren't many, if any, examples of man reshuffling the natural order to focus solely on human interests that resulted in a world changed for the better. The replacement of one top predator, the wolf, with another, the man with his rifle, had long-term effects. These effects are all too obvious today as we wrestle to reconcile the needs of ranchers, wildlife enthusiasts, hunters, and scientists with those of a vilified social animal: the wolf.

Directly descending from the same genetic background as the dogs we welcome into our families, the wolves in this drama have come to be regarded as the evil twins of our loveable and devoted pets. While some of their kin ride in the front seats of our cars, help herd our livestock, go with us to war, are fed gourmet meals, and are even invited to sleep in the beds of our children, by contrast, wolves are irrationally demonized. Tortured by traps and snares, shot and poisoned along with their pups, they are accused of a remarkable range of evil behavior, based on stories passed down since the Middle Ages, fairy tale by fairy tale.

Today, many government officials pander to voters with ill-conceived wolf "solutions" that have no relationship to reality. Ignoring the advice of serious wildlife biologists, they issue decrees ensuring that wolves will continue to be killed.

As this drama plays out, wolves—curious, caring, and intelligent—return to the land they once roamed. Sharing strong social bonds, wolves watch over each other, nurture their injured, and raise their pups among their family groups. By hunting together to feed the pack, wolves redistribute elk and deer and allow overgrazed trees and shrubs to rebound. As wolves restore natural order to ecosystems, they undo damage done long ago.

Asleep in the snow and at play in the meadows, once again wolves are back, wandering the wild open spaces of the American West.

Living on in our legends, and as the enduring symbol of the West, wolves throw back their heads in the dark of the night and howl.

We need to listen.

Robert Redford and Jim Dutcher met 34 years ago. They share inspiration in their work with film and a concern for the natural world. Mr. Redford serves on the Honorary Board of Living with Wolves.

Wolves hold a special place in the hearts and minds of many people as inspiring symbols of all things wild. For others, wolves are the creatures of nightmares, their mere existence triggering irrational fear and hatred.

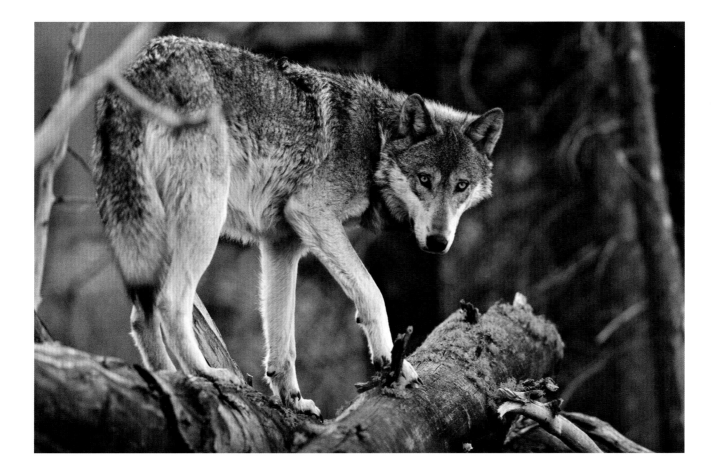

ABOUT THE AUTHORS

For more than 20 years, Jim and Jamie Dutcher have focused their lives on the study and documentation of wolf behavior. As two of America's most knowledgeable experts on wolves, they are devoted to sharing their unique background for the betterment and understanding of this keystone social species.

Having completed award-winning films documenting beavers, cougars, and marine ecosystems, Jim Dutcher turned to a more elusive and challenging subject: the wolf. After obtaining a permit from the U.S. Forest Service, he and his wife, Jamie, lived in a tented camp on the edge of Idaho's Sawtooth Wilderness, intimately observing the social hierarchy and behavior of the now famous Sawtooth Pack. Over six years, their unprecedented experiences resulted in three prime-time documentaries for ABC and the Discovery Channel. These films won Emmy Awards for Outstanding Cinematography, Outstanding Sound Recording, and Outstanding Informational Program for Science and News—the last in recognition of the meticulous fact-checking of source references that is an integral part of the Dutchers' filmmaking process.

Yet with wolves still being vilified and persecuted, the Dutchers knew that the pack featured in their documentaries could play an even more important educational role. In 2005, they put down their filmmaking equipment and founded Living with Wolves, a nonprofit organization dedicated to raising broad public awareness of the truth about wolves. Today, Living with Wolves is a nationally recognized leader in the field of wolf advocacy, with many thousands of followers actively involved in its work.

Jim served as a consultant to the gray wolf reintroduction project for the design of the pack holding enclosures for the wolves brought to Yellowstone National Park. In 1995, Idaho governor Phil Batt

appointed Jim an ex officio member of the wolf reintroduction oversight committee, on which he served for five years. For his film on cougars, Jim also won the Wrangler Award, given by the National Cowboy Hall of Fame. Jamie began her career as an assistant in the hospital of the National Zoo in Washington, D.C., and together with Jim, led three National Geographic Expeditions to Alaska, working with revered wolf biologist Dr. Gordon Haber to observe pack hunting techniques and the culture of knowledge within individual wolf families.

Jim and Jamie now travel across the United States to present their multimedia program and to share their experiences and the truth about wolves. They speak to groups ranging from students of all ages to audiences at major museums, including the American Museum of Natural History in New York, the Smithsonian Institution, Chicago's Field Museum, the Natural History Museum of Los Angeles, and the California Academy of Sciences. Nearly 200 radio, television, Internet, and print media outlets worldwide have interviewed them on the subject of wolves, and they have appeared on or in *Today, Good Morning America, People* magazine, the *New York Times*, National Public Radio, the BBC, and countless other venues.

First Litter

Littermates Kamots and Lakota were two of the first members of the Sawtooth Pack. We established a bond with them and gained their trust when they were pups by bottle-feeding them just as their eyes opened.

Creating Wolf Camp

In order to document the social life of the pack, we built an all-season tented camp. The 25-acre enclosure where the wolves lived included a rich habitat of streams, meadows, forests, and ponds under the looming peaks of the Sawtooth Mountains.

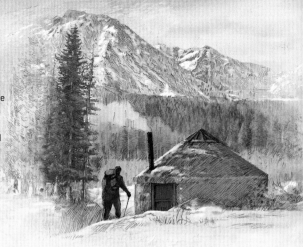

KAMOTS ("Freedom") was the alpha, the confident and benevolent leader of the Sawtooth Pack. Responsible for the welfare of the pack, he was the father of the Sawtooth pups.

LAKOTA ("Friend"), the brother of Kamots, was the pack's largest wolf, and yet its omega and the submissive instigator of play.

1991 **1992** **1993**

LIVING WITH WOLVES, GAINING THEIR TRUST

We knew that the only way to observe the intimate lives of wolves was to live with them as social partners. Gaining their trust from the time they were very young, we became part of their world. Instead of viewing them at a great distance, we wanted to be an unobtrusive part of their lives as we observed their day-to-day behavior.

Second Litter

The next year, three new males were introduced to wolf camp. Offspring of the same parent wolves as Kamots and Lakota, they were completely different in personality and coloring.

AMANI ("Speaks the Truth") was the devoted uncle of all the pups and seemed to enjoy having them climbing all over him.

MOTOMO ("He Who Goes First")—with black fur, a white chest blaze, and yellow eyes—was striking and mysterious in appearance and behavior.

MATSI ("Sweet and Brave") was the pack's beta wolf, second only to Kamots in the hierarchy. He was also the peacemaker and puppysitter.

A Better Idea

Seeking a more intimate and natural study of the pack, we moved our camp inside their territory, making our presence a normal part of their day-to-day lives. This allowed us unequaled access to their social lives.

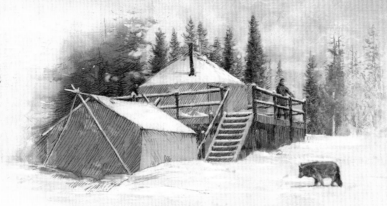

**Fourth Litter
The Sawtooth Pups**

In the sixth year of the project, two females and one male were born to Kamots and Chemukh and were the cause for great celebration among all the wolves of the pack.

1994 1995 1996

Third Litter

We introduced three new pups, two of them female. As the three generations began to settle more clearly into a hierarchy, we were able to watch their interactions.

CHEMUKH ("Black"), dark and slender, became the chosen mate of Kamots and mother of the pups. As alpha female, she was the pack's only breeding female.

WAHOTS ("Likes to Howl") slept beside our tent, awakening us in the night with his beautiful howls. He eventually replaced Lakota as the omega.

WYAKIN ("Spirit Guide") was a feisty little female, devoted to her brother, Wahots. Her efforts to hide extra food were usually discovered by Wahots, who gladly ate it.

At the end of the project, the Nez Perce Tribe of Idaho offered a permanent home for the Sawtooth Pack.

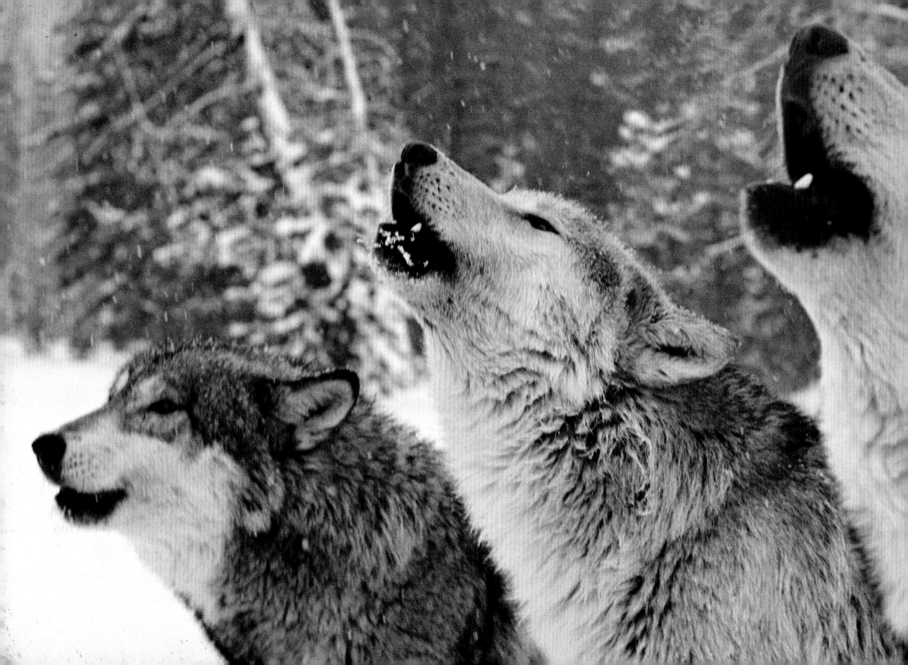

LIFE

WITH THE

SAWTOOTH
PACK

*Only the mountain
has lived long enough
to listen objectively
to the howl of a wolf.*

—ALDO LEOPOLD,
"THINKING LIKE A MOUNTAIN"

A wolf's howl has stirred human passions for millennia.

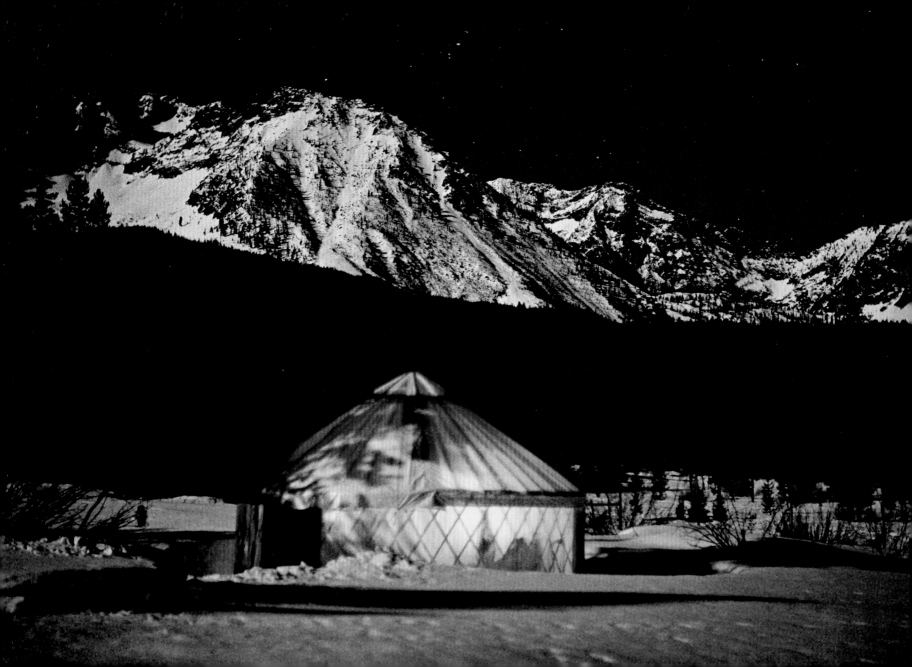

B eneath the peaks of Idaho's Sawtooth Mountains, in a den she had dug just a few weeks earlier, a young mother wolf gave birth to three pups. In 1996, when this event took place, it was nothing short of miraculous. No wolf had been born in this region in more than 50 years, but across the West, that was changing. As these three pups opened their eyes to look upon the Sawtooth Range, other first generations were being born elsewhere. One year earlier, officials from the U.S. Fish and Wildlife Service had released a handful of "experimental" wolves into two carefully selected regions, and they were now having young of their own as well.

On the edge of Idaho's Sawtooth Wilderness, we created an environment where a pack of wolves could open their lives to us and accept us as just another part of their world. We called them the Sawtooth Pack and set out to capture their intimate behavior on film—to dispel myths and show a side of wolves that is often overlooked. What we encountered was beyond our greatest expectations.

These first three pups, these innocent pioneers in the Sawtooth Mountains, were different from the others. True, they were born beside an alpine meadow in a natural den to parents who had selected each other as the alpha male and female of a genuine pack, but they were not exactly wild. They were ambassadors and teachers. Their birth was the crowning event of a project that had begun when wild wolves were little more than a memory. Along with their parents, aunts, and uncles, they formed what we called the Sawtooth Pack. Together they taught us nearly everything we know about wolves. More than that, they transformed our lives.

We have always been advocates for the animals that appear in our films, but we never expected wolves to become our life's work. Nevertheless, that's exactly what happened. The more we learned, the more intrigued we became. One film became three. Our tiny film crew morphed into a nonprofit organization. Speaking appearances grew into multimedia presentations, which grew into three-day conferences. The project we had envisioned as a two-year undertaking extended to four, then six, then our entire lives. The wolves that were the subjects of our films became our trusted friends, and we became spokespeople for their wild cousins.

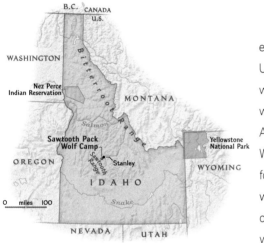

In 1990, when the project was just beginning, the United States government was already preparing its wolf reintroduction program. Across the Rocky Mountain West, people were bracing for the wolves' return—some with unbridled enthusiasm, others with outrage. The time was right for a film, but not one that dwelled on the politics. Instead, we wanted to create an intimate portrait of a wolf pack, illuminating the complex social nature of the animal that was about to step back into American life.

The problem was how to do it. At that time there were virtually no wolves in the lower 48 states, aside from a small population in the upper Great Lakes. Those that remained were practically impossible to see, let alone to film. Filmmakers working in Canada had managed to document wolves hunting, but they had filmed them with long lenses from great distances. That was an admirable achievement, but we wanted to

present the lesser known social lives of wolves. We thought if people could see the way these animals lived and played together, and witness their subtle acts of compassion and care, perhaps some of the fear and misunderstanding swirling around wolves would dissipate.

Trying to achieve this level of intimacy required getting extremely close to wolves—and staying close for a very long time. What if somehow we managed to attain the near-impossible goal and spend months in the company of a wild pack? What effect would we have on them? Would we be habituating these endangered animals to a human presence? By teaching wolves not to fear humans holding cameras, would we be teaching them not to fear less well-intentioned humans holding guns? Then and now, a wolf that loses its fear of humans does not have long to live.

The solution was clear: We had to create our own habituated pack, one that would trust us enough to be in their territory without feeling threatened but that we could keep safe from the volatile political climate. After an exhaustive search, rescue and research centers in Montana and Minnesota gave us an adult male, an adult female, and four pups.

In order to habituate the pups to us, we took charge of their care for the first few weeks. Bottle-feeding them from the moment they opened their eyes, we learned early on that this was the only way to gain a

wolf's trust. It was a round-the-clock job, staying up nights and shrugging happily when the energetic little balls of fur yanked on our hair and shredded our shirttails. We mixed up special batches of wolf puppy formula to feed them, and we weaned them on pureed chicken. Wild wolf parents returning from the hunt regurgitate an easily digestible stew for the growing pups—the wolf equivalent of baby food. Our puppy chow was no less disgusting to us, but the pups lapped it up enthusiastically. We substituted warm, damp rags for a mother wolf's tongue and, on chilly spring nights, old sweaters and our warm laps took the place of her warm fur. The pups bonded to us, and we in turn bonded to them.

Ultimately, the adult wolves we were given did not become part of the Sawtooth Pack. The adult female experienced complications with cataracts, and the adult male was not sufficiently habituated for us to film. Both found homes at wolf educational centers. It was clear that raising pups by hand was the only way to establish the level of trust needed to live with wolves.

Two pups in particular would become emblematic of the pack. They looked nearly identical—classic wolf gray with black and white markings—but early on we could already see very different personalities emerging. One was feisty and intrepid. He loved gamboling through

the grass and exploring his world. The other was more timid, and preferred following his brother rather than exploring on his own. It was the first inkling of the social hierarchy that would come to define the pack. The bolder of the two pups we called Kamots, "freedom" in the Blackfoot language. We called his timid bother Lakota, from the Lakota Sioux for "friend" or "peaceful ally." Over the next four years, we introduced six more pups, and the pack introduced the final three on their own.

Our goal was to observe the wolves not as scientists, but as social partners. Only if they bonded to us and were completely comfortable in our presence would they reveal their intimate lives, their social structure, and their subtle ways of communicating. Although we raised them to ensure they developed this bond, we never attempted to treat them as pets. Throughout the six years we spent living with them, interaction was on their terms.

We have always been quite vocal in our belief that purebred wolves and hybrid wolf-dogs make unpredictable and potentially dangerous pets. We never would have engaged in such a monumental undertaking if we hadn't had the scientific and official contacts, the experience, and the dedication to ensure the safety of not only our crew but also the wolves. As much as possible, we wanted the pack to live as wolves

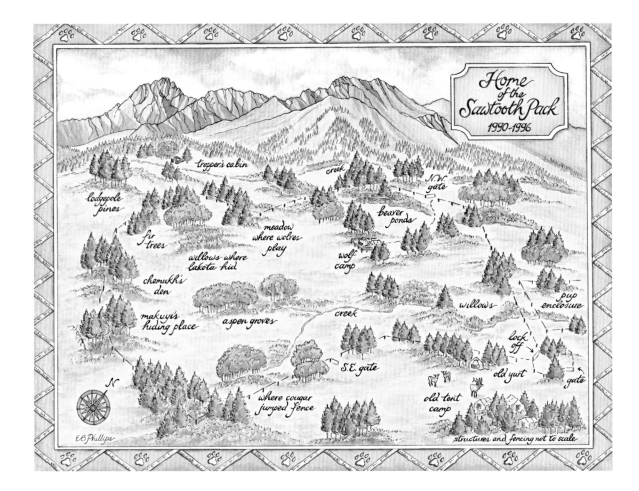

should. To achieve that, we had to create a natural home for them in a wild setting with plenty of room to roam.

WOLF CAMP

Drive north on Highway 75 into central Idaho, and you'll soon find yourself winding up a steep mountain road toward Galena Pass. Beyond this threshold, the ground drops away into the Sawtooth Valley. The headwaters of the Salmon River trickle down these slopes and gather in the valley below. There, a few ranches nestle close to the river with their backs to the vast wilderness. Above it all, the craggy spine of the Sawtooth Mountains looms to the west. The Sawtooths shoot boldly out of the valley floor, soaring gray walls in a blazing blue sky. It's a Wild West setting that rivals the more famous Grand Teton National Park.

Tucked away at the base of these mountains lies a bright riparian meadow. Tiny braided streams course though the grass, nourishing stands of willow and aspen before flowing into a lively mountain brook. Thick stands of spruce and lodgepole pine guard the perimeter, breaking just enough to reveal the Sawtooths in stunning backdrop. We had searched for the better part of a year for the perfect spot to create our wolf camp, facing a maddening list of criteria. It had to be far enough into the wilderness to avoid attracting attention or bothering the local residents, but it had to be accessible by four-wheel drive in the summer and snowmobile in the winter. It also had to be an area that the U.S. Forest Service would allow us to use. Above all, it had to be suitable wolf habitat with fresh water, a mix of cover and open space, and good places for denning. The moment we set foot in this meadow, we knew we'd found the spot. From the hushed beauty of a spruce forest blanketed in new snow, to the pastel spray of spring wildflowers, to the bold reds and golds of autumn, it was all that we as filmmakers could have hoped for.

More important, the land offered everything a pack of wolves would need. There were dense patches of forest and a maze of willows where they could seclude themselves and feel safe. There was a pond of spring water to drink from and to splash in. Fallen trees offered a choice of denning sites, and a grassy meadow provided a sunny nursery for raising pups. The wolves genuinely seemed to love being there.

Wolf camp was an ever-evolving project. After securing permits from the U.S. Forest Service, the U.S. Fish and Wildlife Service, and the Idaho Department of Fish and Game, we had to get permission from three local ranchers to cross their land. Wolf reintroduction was four

years in the future, but it was already a contentious issue. During the autumn of 1990, we staked out 25 acres, creating the world's largest wolf enclosure. Just outside the enclosure, we set up two sleeping tents and a round Mongolian-style yurt, which became a cook tent, a workspace, and the center of camp life.

Maintaining the camp and caring for the wolf pack was a seven-day-a-week job. The long Idaho winters were especially laborious. When three feet of snow piled up in a single day, we had to keep our tent roofs swept free, lest they collapse under the weight. We had to haul and chop a steady supply of firewood, especially for nights when temperatures dropped to 40° below zero. And we always made sure we had a clear path to the outhouse. Critically, we had to maintain contact with the local sheriff's department. If a deer, elk, or antelope turned up dead on the highway, we had permission to collect it for wolf food.

A few seasons into the project, we made a simple alteration that proved revelatory. We built a platform eight feet off the ground inside the wolves' territory, put the yurt on top, our sleeping tent on the ground beside it, and encircled it with chain-link fencing. Suddenly we were no longer entering and exiting the wolves' space every day; we became a constant fixture within it. More than ever, the wolves just ignored us. By

this time, the pack was a mature family of six males and two females, and they began to reveal their lives in rich detail. When we remember the Sawtooth Pack, we remember them most fondly from this time.

THE SAWTOOTH PACK

At the very heart of the pack were two of the pups we first raised. They were nearly identical in appearance, but in personality they were yin and yang, embodying the polar extremes of wolf society. Like two supporting pillars, they brought stability to the pack, enabling it to flourish in harmony.

Kamots ("Freedom"): From the moment Kamots opened his eyes, we could see he was a spirited and confident little guy, throwing his head back, yodeling out his puppy howl, and charging through the tall grass. He was always eager to investigate new things. By the time he was a yearling, he'd established himself as the undisputed alpha—the pack leader. At mealtimes, he presided over a deer carcass with a ferocity that was sometimes frightening to behold. Other wolves joined the feast at his discretion and kept eyes on him as they ate. But there was nothing mean-spirited about Kamots. He taught us that being an alpha isn't about being the toughest or meanest wolf; it's about taking

Even at the young age of about eight weeks,
Kamots had the confidence of an alpha.

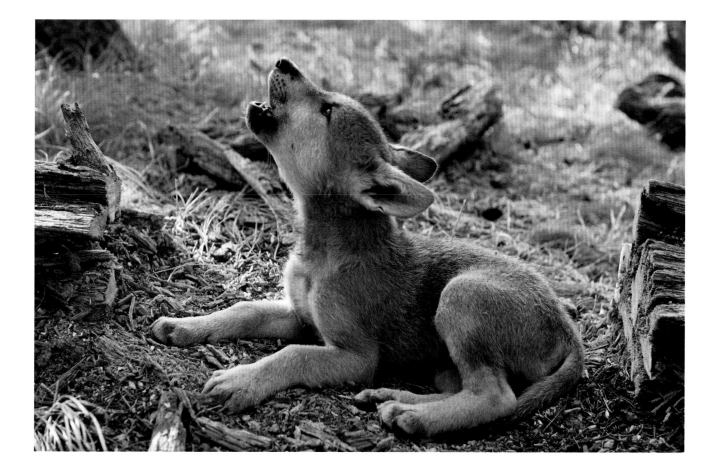

on the responsibility of caring for the entire pack. If there was a strange sound in the forest, Kamots was invariably the one to investigate it. With his authority came a level of seriousness and a desire for order, but we often saw him frolicking with the others and happily suspending his duties for a good game of tag.

Lakota ("Friend"): As the social order of a wolf pack has a top, it also has a bottom. This unenviable role was imposed on Kamots's littermate, Lakota. We will never know all the factors that contribute to a wolf's falling into this position, but in this case, size and strength did not appear to be factors. Lakota grew to become one of the largest wolves in the pack, though it was often hard to tell, since he held himself in a submissive crouch in the presence of the others, in an attempt to look as small as possible.

It was difficult to watch Lakota endure rough treatment from the rest of the pack, and yet he taught us that the omega has a purpose. His submission diffused tensions within the pack and likely reduced fighting among mid-ranking wolves. Since it was in his best interest to keep the pack's mood light, he was often the one to instigate a game of tag by dropping into an unmistakable "play bow" and inciting one of the other wolves to chase him.

As we collected recordings of the pack's vocalizations, we began to notice that Lakota had the pack's most beautiful howl (in our human opinion). Those times when the pack gathered in a "rally" and began to howl together were always tense for Lakota. The excitement and frenzy of the rally would often spark the sort of dominance displays that wolves use to reinforce their standing in the pack, and Lakota always got the worst of it. Nevertheless, he always joined in, throwing his head back, shutting his eyes, and howling with all his heart. Hearing him, we could have sworn he was singing the blues.

THE SECOND LITTER

A year later, three new pups joined the ranks, born to the same parents as Kamots and Lakota. In appearance, these three littermates were as different as three wolves could be, ranging from pale beige to gray to black. We decided to name them with words from the Blackfoot language, since the Blackfoot Nation once claimed much of the territory where wolves were to be reintroduced.

Matsi ("Sweet and Brave"): He was the lightest of all the wolves, with a uniform pale coat that looked almost golden in the sunlight. Matsi was the pack's beta male, dominant over all except the alpha. Matsi clearly

accepted Kamots's rule without so much as a whimper, but he wouldn't sacrifice his place on an elk carcass for anyone else. Matsi taught us the most about a wolf's loyalty and devotion to its pack. When a new litter arrived, Matsi became puppy sitter, always keeping a watchful eye on the young ones. After the adults fed, the pups would surround Matsi and lick his muzzle, and he would regurgitate a portion of his meal for them to eat.

More than anything, Matsi taught us that wolves form friendships. From the very beginning, Matsi developed a close bond with Lakota. The two would often play together, and when Lakota secluded himself in the forest to avoid the pressures of his rank, Matsi would often leave the rest of the pack and join the omega. The two just seemed to like each other. At other times, when a mid-ranking wolf was harassing and dominating Lakota, Matsi would charge into the scene and forcibly insert himself between Lakota and his tormentor, giving the omega a chance to slink away to safety. There was no apparent reward in it for Matsi; he just seemed to be keeping the peace and looking out for his friend.

Amani ("Speaks the Truth"): Most wolves are just part of the pack—dominant over some, subordinate to others. But from Amani, we learned that every wolf, no matter where he stands in the social pecking order, is a complicated individual with a unique personality. He looked like Kamots and Lakota, with classic gray and black markings, a light-colored face, and a dark mask. To our eyes, his countenance always bore a slightly comical expression.

Indeed, Amani often played the clown, especially when pups were around. He didn't tend to their care as Matsi did. He just loved to play with them, lying in the grass, eyes half-shut in sheer bliss, as the pups climbed on his back, yanked on his tail, and chomped on his ears. Yet Amani could turn right around and be a downright bully. No wolf ever beat up on Lakota as much as Amani did. He may have felt that his position in the pack was precarious, and he had to demonstrate that he was no omega. He was equally committed to dominating his brother Motomo, but it usually didn't work out in his favor.

Motomo ("He Who Goes First"): Black with a white blaze on his chest, piercing yellow eyes, and a mysterious personality to match, Motomo was quietly curious, and we'd often find him just staring at us as we worked—not getting too close or trying to attract our attention, just watching. His relationship with his brother Amani was a fascinating case study in hierarchy. Frequently, Amani would dominate Motomo, but when food was in play, Motomo made a special point of keeping his brother off the meal as long as possible.

Motomo, a mid-ranking wolf of the Sawtooth
Pack. We often found him just staring at us as we
worked, not getting too close or trying to attract
our attention, just watching.

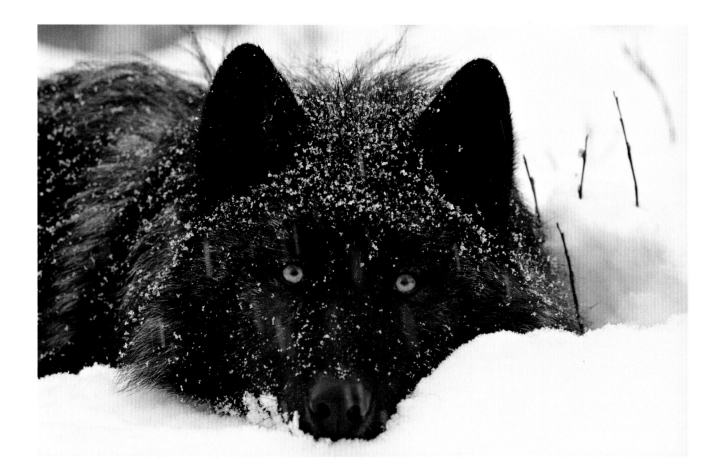

Amani and Motomo also showed us that mid-ranking wolves cooperated as well as competed. One of our favorite stories of the pack involved these two. We had found a very small deer killed on the highway and had brought it to the wolves. Even though they had eaten recently, Kamots and Matsi seemed determined to have it all to themselves. On the sidelines, Motomo and Amani whined to each other quietly. Suddenly, Motomo ran at the kill and grabbed a small chunk of fur and meat. Kamots furiously chased him off, but the moment the alpha abandoned the kill, Amani raced in, grabbed one of the deer's severed hind legs, and raced toward the willows. Seeing his mistake, Kamots turned and chased after Amani, at which point Motomo immediately dropped the small morsel, returned to the carcass, grabbed the second hind leg, and ran off in the other direction. A bewildered Kamots decided it was best just to stay put over what was left of the meal. Of course we can never be sure, but it appeared that Motomo and Amani had hatched a plan for mutual benefit.

THE THIRD LITTER

In the spring of 1994, we added another three pups, two females and a male. Their arrival marked the moment that the pack truly matured, becoming a dynamic family of eight. By this time, it had been decided that the Nez Perce Tribe would have a pivotal role in overseeing wolf reintroduction in Idaho. Simultaneously, the tribe also had agreed to provide a permanent home for the Sawtooth Pack at the end of the project and to help us create an education center on Nez Perce land. In honor of this agreement, we decided to give the new pups names derived from the Nez Perce language.

When we first released these new pups to the rest of the pack, it was wonderful to see the nurturing instincts of the adults. As the submissive pups flopped over onto their backs, Kamots gently approached and gave each a reassuring lick, welcoming them into the group. Matsi in particular made sure they were safe, disciplining them when their play got too rough and ensuring that they were well fed.

Wyakin ("Spirit Guide") and Wahots ("Likes to Howl"): Two of the three new arrivals were a brother-sister pair. Both were gray with light tan and brown markings. Wyakin was a feisty little female with an enormous appetite. Her brother, Wahots, had a more gentle spirit, but he loved outsmarting his sister. Whenever she ate, Wyakin would gorge herself and then grab more and stash it away. Wahots quickly learned to watch where she went. Once she was done, he'd stroll off nonchalantly

and eat every one of her caches. A little later we'd see Wyakin checking each of her hiding spots, perplexed. She never did catch on.

Wahots and Wyakin never let us forget that a wolf pack is a family. From the moment these two entered the world, they were inseparable. They spent what seemed like hours engaged in games—subtle expressions of dominance but also of deep affection, highlighting the family bonds that hold a pack together. As adults, these two took their places in the lower ranks of the pack hierarchy, and eventually Wahots slipped into the omega spot, finally giving Lakota a break.

Chemukh ("Black"): As her name suggests, she was a dark wolf, similar in appearance to Motomo but slender with a long, narrow face and a shy personality that sometimes gave way to nervous aggression. As she matured, she seemed destined for a life at the bottom of the pack hierarchy. So it was a surprise to us when, nearly two years after her arrival, Kamots selected Chemukh as his mate. We thought Wyakin had a personality more suited to the role of alpha female, but Kamots thought otherwise. It may have been a simple luck of the draw: Chemukh was first to come into estrus, enabling her to conceive. Once she mated with Kamots, the two formed a bond, cementing her role as alpha female, the pack's only breeding female.

THE SAWTOOTH LITTER

In early 1996, Chemukh started exhibiting new behavior. She began exploring every corner of her territory, sniffing and inspecting every fallen tree, and digging compulsively in different areas. We soon realized she was selecting a site for a den. The other wolves must have realized it, too. They got in the spirit by digging shallow pits of their own. Of no help to Chemukh, they genuinely seemed to know what was coming. She finally chose the hollow under a fallen spruce and, without help from Kamots or any other wolf, excavated a cavern more than six feet long. The other wolves were brimming with excitement, one moment racing around exuberantly and the next back at the den site, whining and shifting from one front paw to the other. They were barely able to contain themselves. One April afternoon, she slipped away so quietly that no one took note of her departure. Only when we awoke the next morning to find the pack all gathered around the den, quivering and whining in excitement, were we aware that she had given birth.

The Sawtooth Pups: The pups born to Kamots and Chemukh, two females and a male, were the last wolves to join the Sawtooth Pack. There was no mistaking the pack's mood regarding this event. It was, in a word, celebratory. When Chemukh emerged from her den, each wolf

made sure to check on her and give her a respectful lick on the muzzle. Once the pups joined the rest of the pack, the adults doted on them. As they started eating solid food, Kamots allowed them to dive in first on a deer carcass. Wyakin settled into the role of helpful aunt and eager babysitter. Amani took on the role of playmate and clownish uncle, not so much caretaker as entertainer.

All this devotion made it clear that, although pups are nearly always born to the alpha pair, they belong to the family as a whole. We called the male Piyip ("Boy") and the two females Ayet ("Girl") and Motaki ("Shadow"). They were still pups in the summer of 1996, when we moved the pack to Nez Perce land.

Now our days with the Sawtooth Pack exist only in our memories. They allowed us to reach across the barrier that separates our two species, accepting us as friends and social partners. In telling their story, and in sharing what they have to teach us about their wild brethren, we hope to repay our debt of gratitude.

AFTER THE SAWTOOTH PACK

Anyone who looks into the eyes of a wolf, whether as friend or as foe, is forever changed. Perhaps it is their similarity to our trusted dog companions that colors our impressions both for and against wolves. Some people sense the dog's intelligence and empathy and feel an instant kinship. Others see an independent and unruly canine that won't "kennel up" and do what we want it to. Or perhaps even more it is the wolf's similarity to ourselves that moves us. We admire their expressiveness, cooperation, fierce devotion to family, and unabashed love of their young. Yet we resent them for eating the animals we want to eat—our wild game and, occasionally, domestic livestock.

No other animal has the power to invoke such extreme passions in humans, even dividing communities and turning friend against friend. As we came to know the Sawtooth Pack intimately, and as we have since come to know the wild packs that now make their home in the Idaho mountains, we have learned to expect heartbreak.

One day, a few years after our project ended, we decided to visit that riparian meadow where the Sawtooth Pack had once lived. As we walked up the trail toward wolf camp, each familiar landmark sparked a sudden precious memory: the aspen tree where Motomo used to sit and watch us, the maze of willows where Lakota would coax Kamots or Matsi into a game of tag, the den where Chemukh had given birth. We went there seeking to reflect on what we'd accomplished and where we

were headed. We hoped that in the flood of emotion there would also be clarity and a path forward.

That moment came as we walked along the creek bed toward the pond. There beneath our feet was a row of wolf tracks. It was a sight so familiar that for a moment we failed to notice anything odd about it. But then the meaning of what we were observing suddenly dawned on us, and with it came a rush of pure elation. The Sawtooth Pack was gone, but wild wolves had taken their place. We were overjoyed. It seemed such a fitting and positive end to our story that we could only hope that the lingering traces of the Sawtooth pack would make these newcomers feel welcome.

As it turned out, the return of wild wolves to the Sawtooths was just one more chapter in the tumultuous story of the wolf's return to the West.

These newcomers became known as the Basin Butte Pack, numbering about 14 wolves. They gained a reputation for being visible, offering one of the few opportunities to see wild wolves outside of Yellowstone. Much to the delight of tourists, the previously unimaginable presence of wolves quickly led to a devoted following of wolf-watchers who gathered along the road with spotting scopes and binoculars.

The Basin Butte Pack also was suspected of killing livestock. And for a wolf in the West, that is the unforgivable offense.

Three days before Thanksgiving 2009, members of the Basin Butte Pack were gathered in a clearing when a helicopter swooped in and federal Wildlife Services agents gunned them down. The wounded alpha female ran for two miles. Betrayed by her radio collar, her blood trailing in the fresh snow, a final shotgun blast ended her life.

What became known as the Thanksgiving Massacre is hardly the exception. It is just one event in a long ledger of conflict: Wolves appear; wolves flourish; wolves kill livestock; men kill wolves. If we are ever to break this cycle, we must be willing to see these exceptional animals as more than random killers of livestock, more than competitors for our big game, and more than just numbers fulfilling a government quota. In order to coexist with wolves, we need to look deeper into their social structure to see that they, too, live in a society that relies on leadership, learned behavior, and family bonds. We know that they are an indispensable part of a healthy ecosystem, but if we are to share the landscape with them, we need to understand how wolves learn and develop patterns of behavior. Only this new understanding will give us the ability to live with wolves—and offer them any hope of living with us.

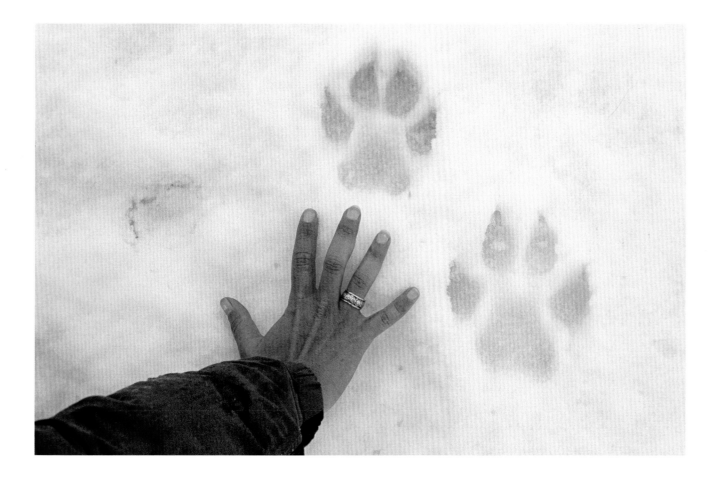

Large paws act like snowshoes, enabling a wolf to travel easily on top of the snow.

Under the looming peaks of Idaho's Sawtooth Mountains, with a special-use permit from the U.S. Forest Service, we built a vast enclosure, rich with aspen groves, streams, ponds, and meadows. Here the Sawtooth Pack would reveal to us their intimate social lives. From the beginning, it was our hope that these wolves would act as ambassadors and educators, guiding us to a better understanding of their species.

*A mountain
with a wolf on it
stands a little taller.*

EDWARD HOAGLAND,
RED WOLVES AND BLACK BEARS

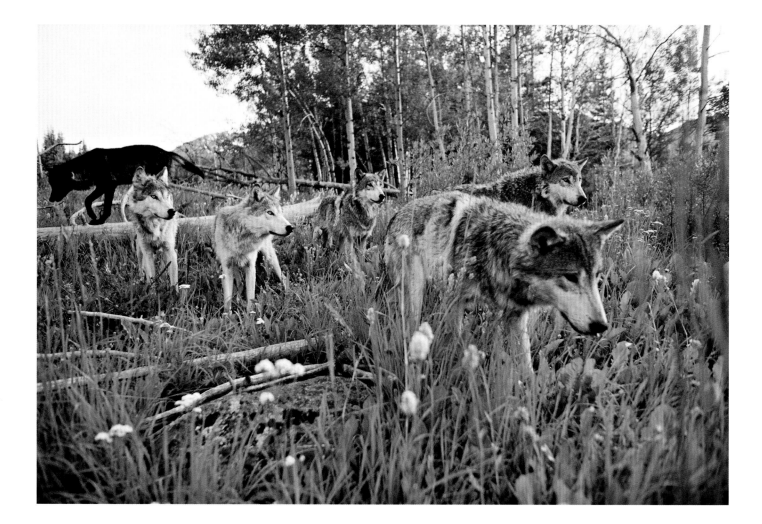

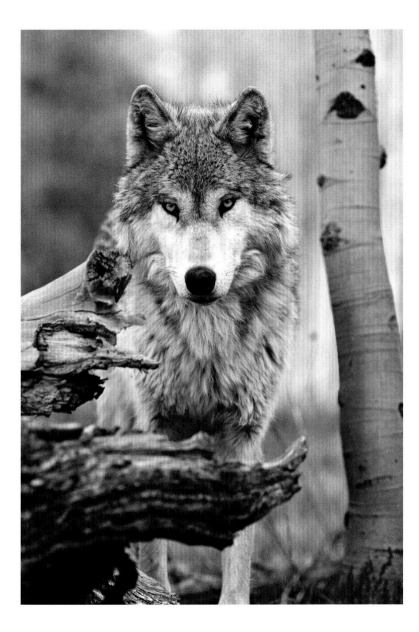

Wolves are instinctively afraid of people, so wary that they alter what they are doing when they sense they're being observed. Because the wolves of the Sawtooth Pack were habituated to our presence, we were able to witness their natural behavior.

Opposite: Wolf camp was an ever evolving project, and our resources were decidedly limited. Our heat came from firewood, our shower water came from the creek or melted snow, and our light and cooking flame came from candles and propane. In order to gain the trust of the pups, we bottle-fed each one from the moment he opened his eyes.

We need to calibrate our sense of success in terms of the kindness and respect we add to the world through protecting animals and ecosystems rather than harming them.

MARC BEKOFF, *THIRTY WRITERS ON WHAT WE NEED TO BUILD A BETTER FUTURE*

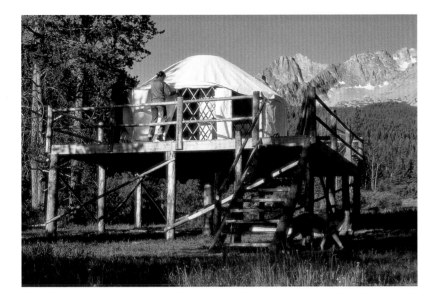

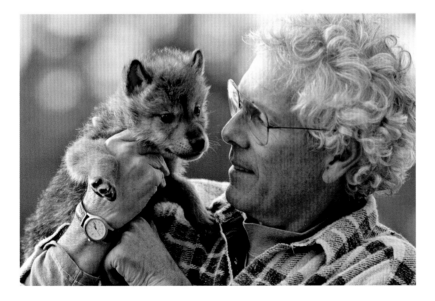
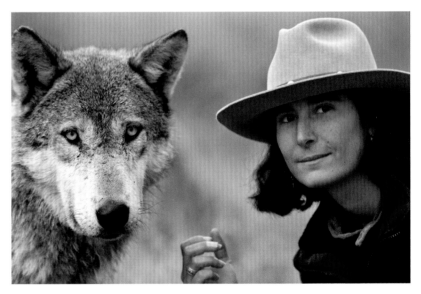

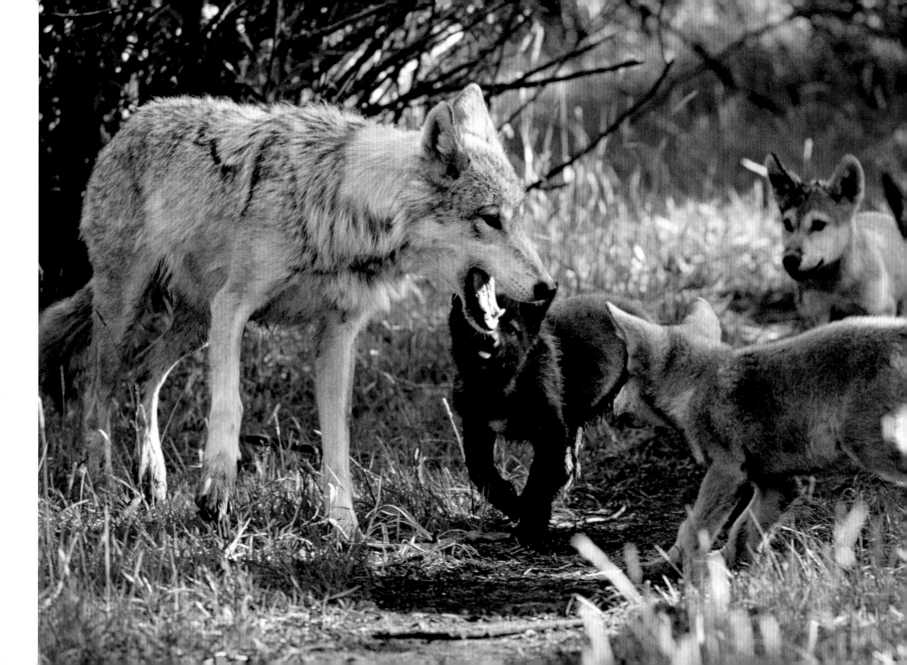

Opposite: At around six weeks, wolf pups are weaned and the pack moves them a mile or less from the den site to a rendezvous site. Here the pack reunites with the pups after a hunt. If the mother joins on a hunt, she will leave the pups in the care of a "babysitter."

Jamie joins Wahots in a howl. The bonds we formed with the wolves when they were pups lasted through their entire lives.

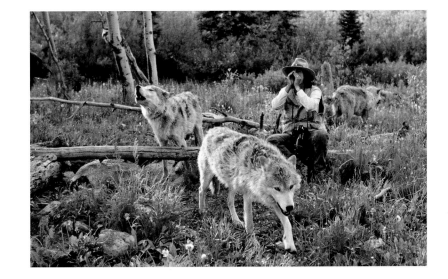

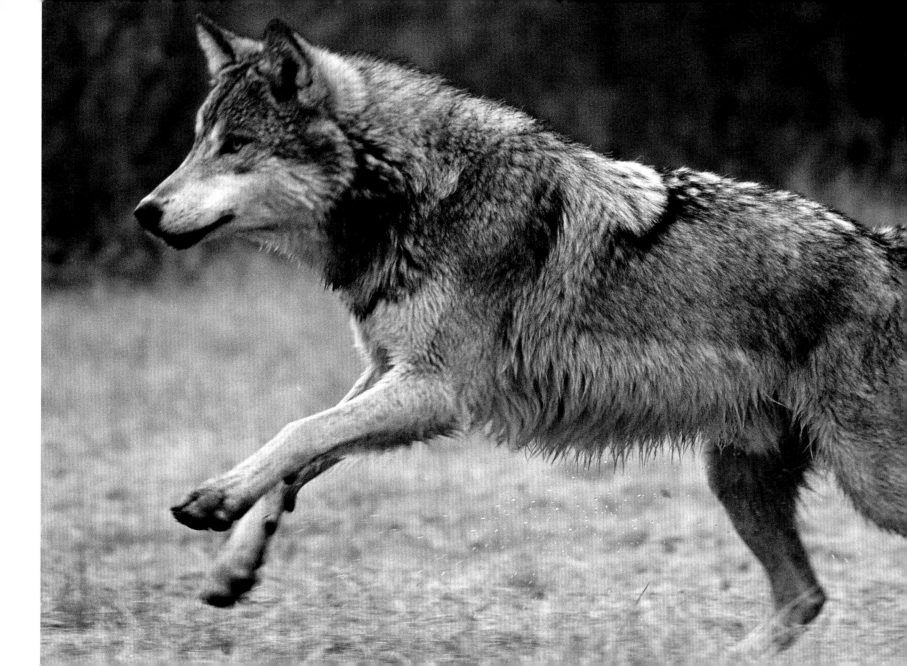

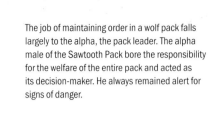

The job of maintaining order in a wolf pack falls largely to the alpha, the pack leader. The alpha male of the Sawtooth Pack bore the responsibility for the welfare of the entire pack and acted as its decision-maker. He always remained alert for signs of danger.

The caribou feeds the wolf,
but it is the wolf
who keeps the caribou strong.

NUNAVUT KEEWATIN SAYING

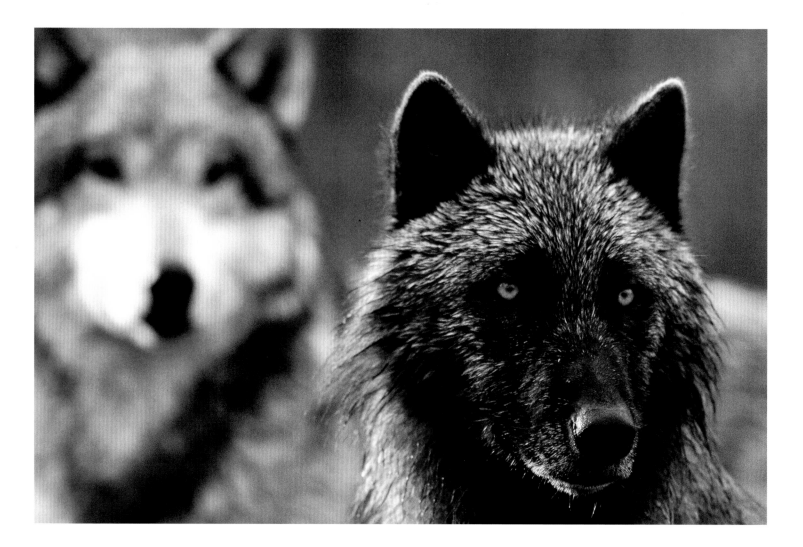

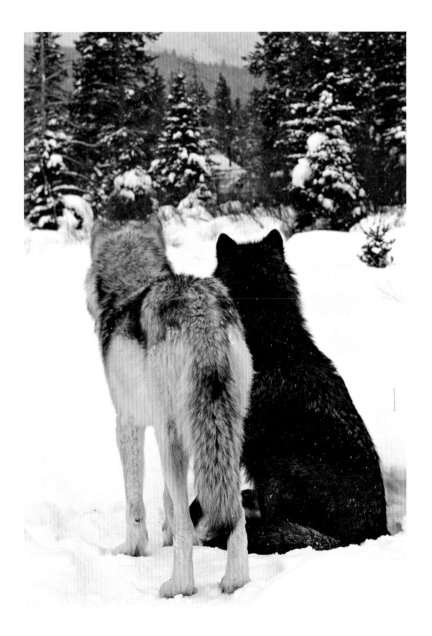

The alphas are the leaders of the pack, maintaining pack stability, the most vigilant and first to respond to potential threats to their family. Late winter is the breeding season, when the alpha male and alpha female mate. On very rare occasions, if conditions are right and there is an abundance of prey, others in the pack may be allowed to breed. In difficult times, it is possible for no breeding to occur.

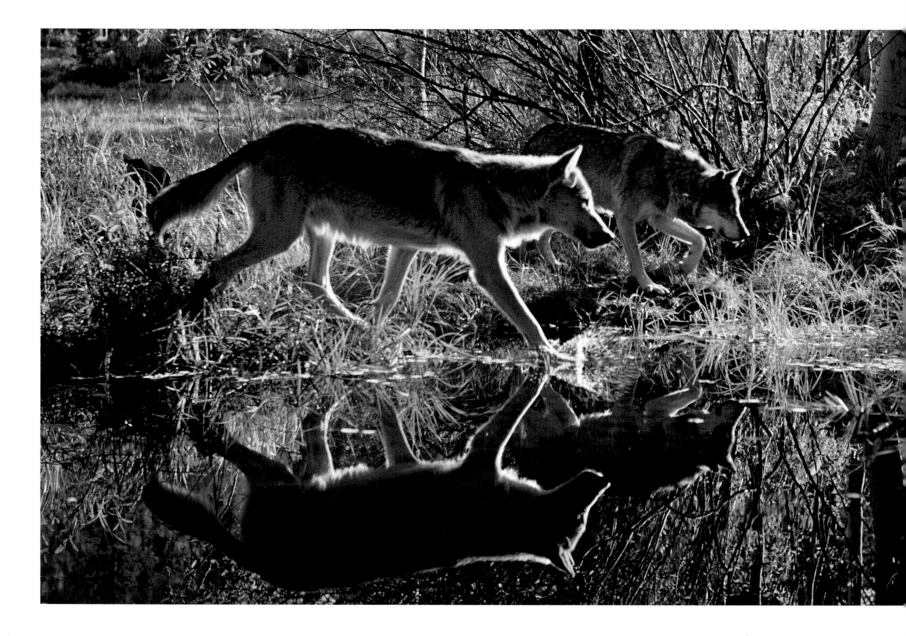

Matsi (foreground), the beta wolf, was second in command to the alpha. He was the peacemaker of the pack and often acted as the puppy sitter.

Once shy nomads from Pacific slopes
to fireweed meadows and tide flats,
they would call us from our longhouses
with their white-throated song.
When the wind returned the seven breaths
the snowfall yelped from dawn to dusk.
The hunters in our family always waited
like shadows to hear our brothers'
winter count take us back to the deer,
the running beauty striking off their hooves.

DUANE NIATUM, *KLALLAM*

Wyakin was a mid-ranking wolf in the Sawtooth Pack. The majority of wolves in a pack are neither leader nor underdog. Most are mid-ranking wolves, filling the vague area below beta and above omega. The social positions of these wolves are more difficult to determine through observation because they constantly change.

We create wolves. The methodology of science creates a wolf just as surely as does the metaphysical vision of a native American . . . Each of these visions flows, historically, from man's never-ending struggle to come to grips with the nature of the universe.

BARRY LOPEZ, *OF WOLVES AND MEN*

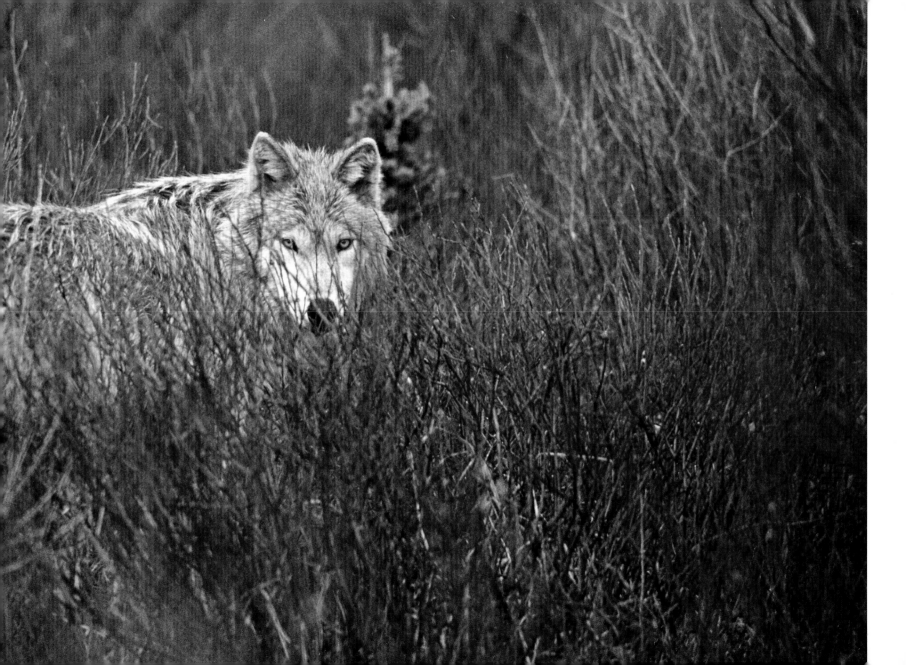

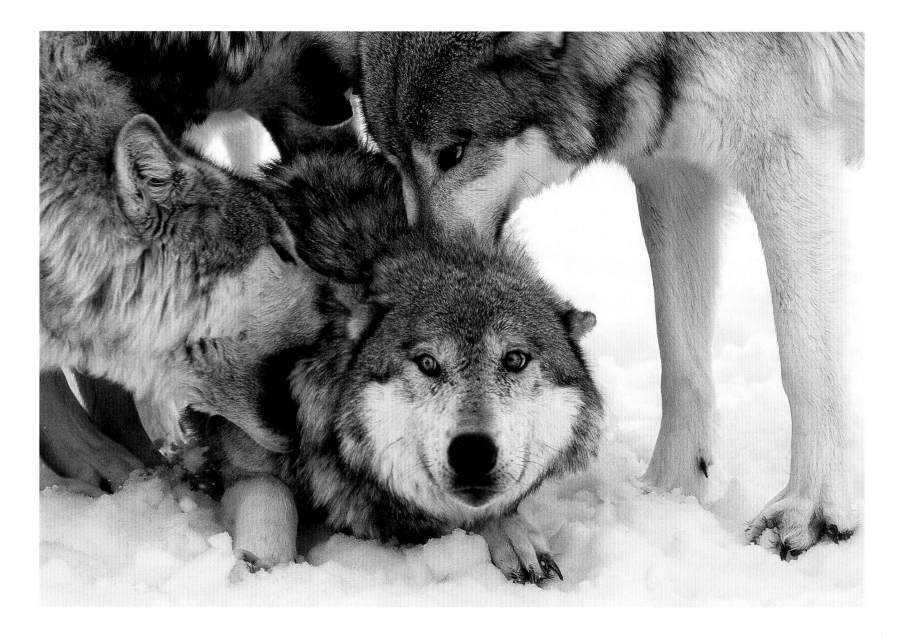

Opposite: The lowest ranking wolf in a pack is called the omega. In the Sawtooth Pack, Lakota held this position for many years.

The omega must constantly submit to his fellow pack members, and he is often dominated by them or treated as a scapegoat. Lakota was harassed most often by Amani, a mid-ranking pack member.

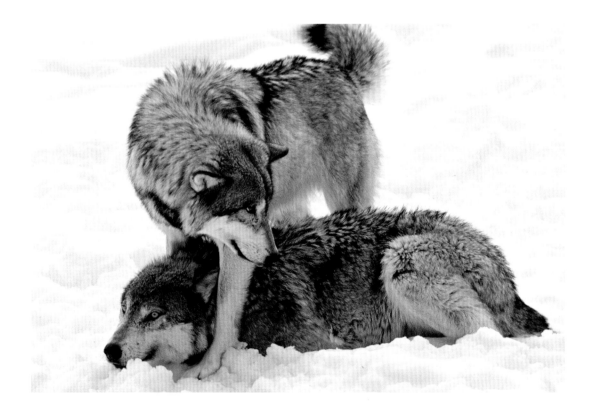

Frequently, the omega instigates play, helping to alleviate tension, filling an important role within the pack. No other position requires as much skill in diplomacy and appeasement. The better an omega's ability to coax the others into setting aside the pack hierarchy for a while, the better his life will be.

Of all the native biological constituents
of a northern wilderness scene,
I should say that the wolves present
the greatest test of human wisdom
and good intentions.

PAUL L. ERRINGTON, *OF PREDATION AND LIFE*

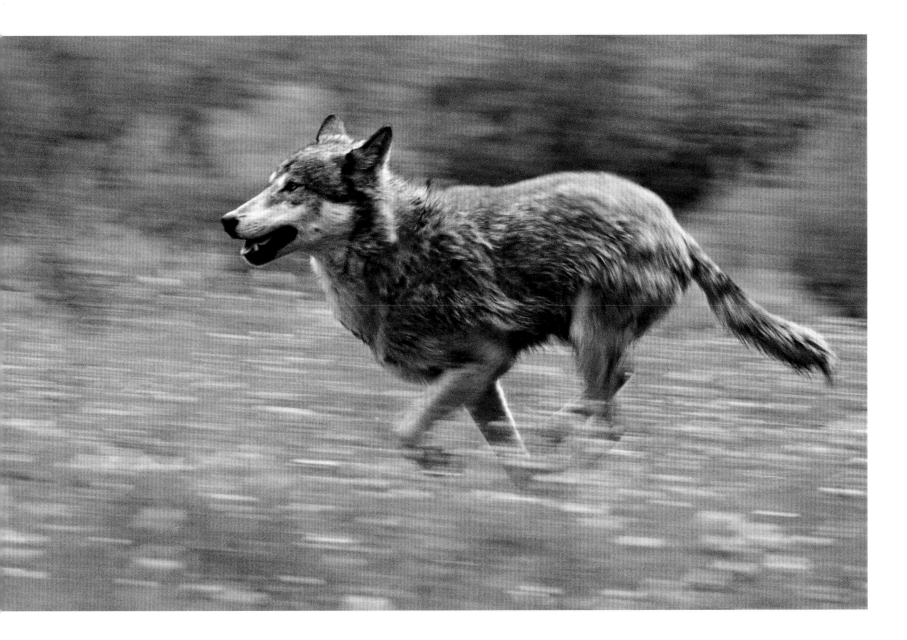

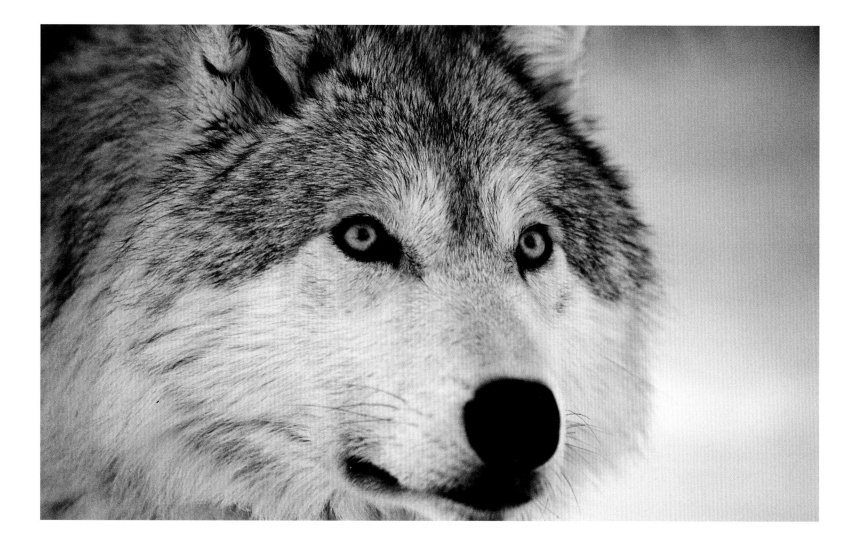

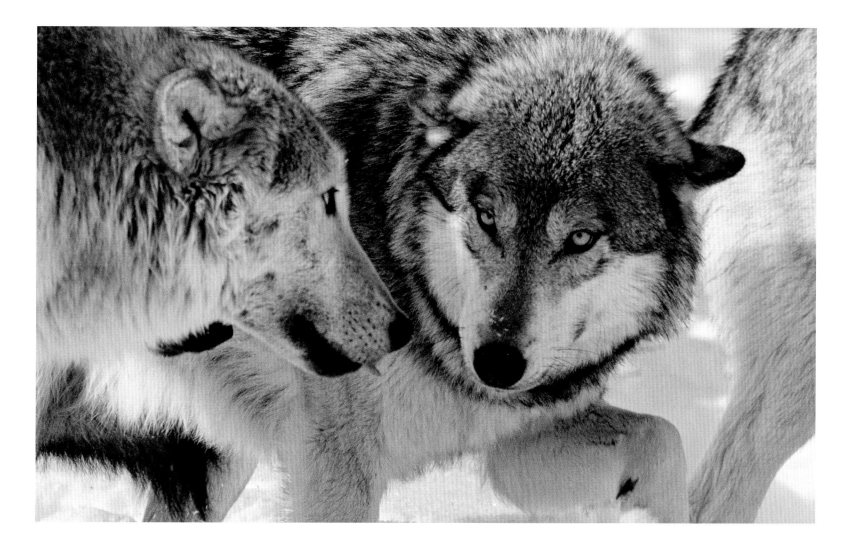

Preceding page (52): The eyes of wolves are particularly suited for hunting. Although their vision is roughly as sharp as that of humans, they possess superior night vision, peripheral vision, and motion detection.

Preceding page (53): Wolves communicate on many different levels, some quite subtle. Besides howls, other vocalizations include whines, barks, yips, and growls, while other communication takes place through eye contact and body language.

Below: We let the wolves approach us if they wanted to; if they chose to ignore us, we didn't pursue. They would often make contact by sniffing and licking us for a moment when we entered their territory, but we never initiated contact. Wolves greet each other in exactly the same way.

Opposite: Lakota (center) receives a reassuring glance from Matsi, the beta wolf. Matsi would use his size and status to prevent other wolves from being too aggressive with Lakota. Often, Lakota would look to Matsi to make sure things didn't get out of hand.

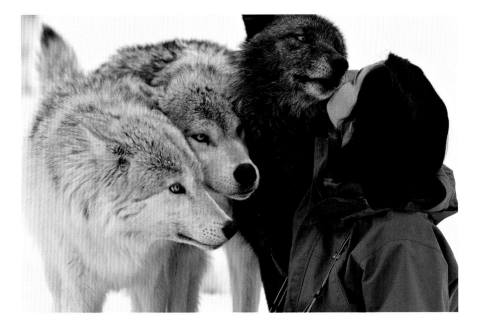

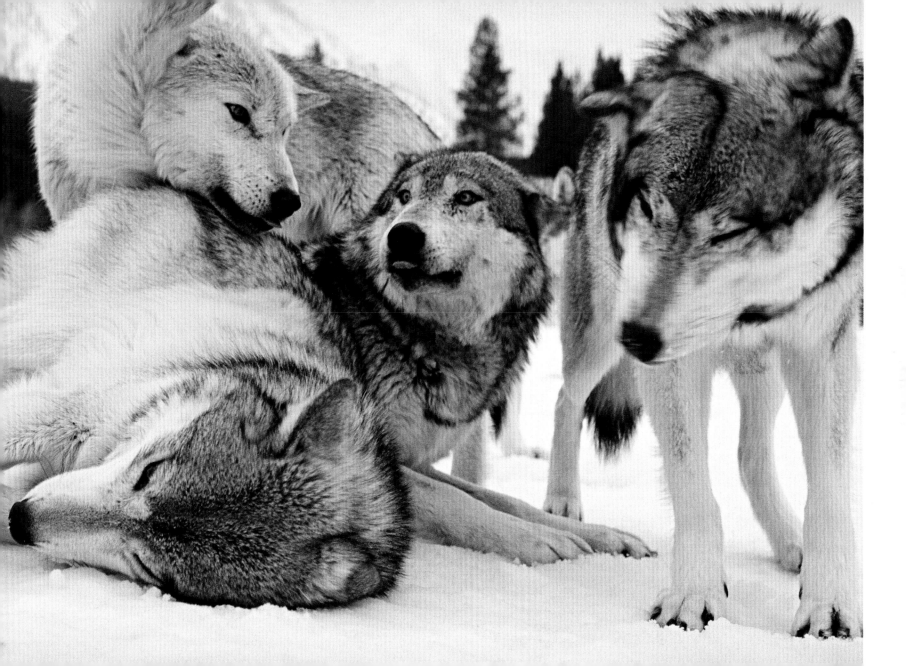

Once wolves lived throughout most of North America. More than half a century ago, wolves were deliberately exterminated from nearly all of their former range. In the 1990s, wolves were reintroduced into central Idaho and Yellowstone National Park.

On the ragged edge of the world
I'll roam,
And the home of the wolf
Shall be my home.

ROBERT SERVICE, *THE NOSTOMANIAC*

WOLF LANGUAGE

A wolf pack maintains order through its hierarchy. This order is constantly reinforced by displays of dominance and submission in a complex mix of vocal and physical communications that wolves employ to express and maintain their status. Mistakenly, people too often interpret this language as being vicious and evil, but it is simply the way wolves communicate.

A wolf's posture when encountering other wolves says a lot about its status in the pack. Subordinates crouch and often lick at the dominant wolf's muzzle like a puppy, while alphas are readily identifiable by their stiff-legged gaits and high tails.

Wolves have an extensive repertoire of sounds. Whines and whimpers indicate friendly interaction but also show frustration or anxiety. Growls and snarls are threatening or defensive. Barking is rare, usually an alarm signal. Howls seem to be about togetherness, whether the wolves are gathering for a hunt, mourning a lost pack mate, or announcing territorial or mating intentions.

Smell is probably the most acute of a wolf's senses. Male and female urine differ in chemical composition, so scent marking—urinating on trees—can advertise availability. A paired couple may leave double scent marks, declaring their status as mates and warning other wolves to stay away.

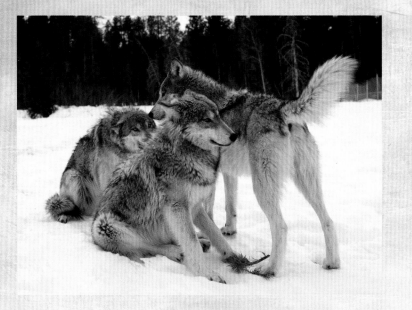

POSTURE: High-ranking wolves carry themselves erect and may even place their heads on top of a subordinate wolf's neck or back.

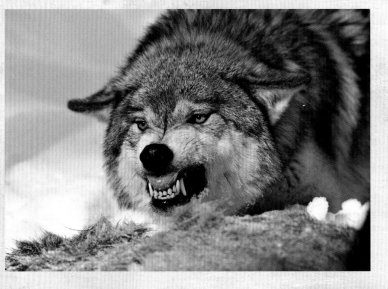

FACIAL EXPRESSIONS: A wolf's face is a dynamic display of visual cues. A dominant wolf's curled lips, bared teeth, fixed stare, and ears jutting out horizontally tell other wolves to back off.

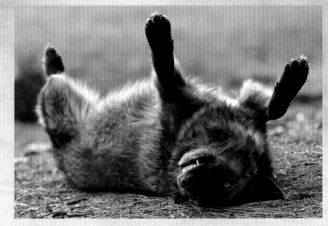

SUBMISSIVE POSTURE: This lower-ranking wolf shows submission by rolling over and showing his belly, the most vulnerable part of his body, to the dominant wolf.

DOMINANT TAIL: A confident alpha male or female carries its tail high, as a visible sign of authority, signaling a leadership role in the pack structure.

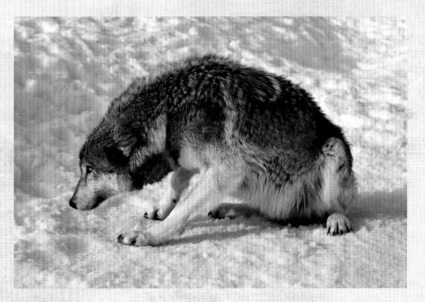

SUBMISSIVE TAIL: Tucked between the legs and under the body of a submissive wolf, the tail is a noticeable sign of non-aggression to other wolves.

CROUCHING POSITION: The omega wolf, the lowest member in the pack hierarchy, displays its role physically by assuming a crouched position when approaching another wolf.

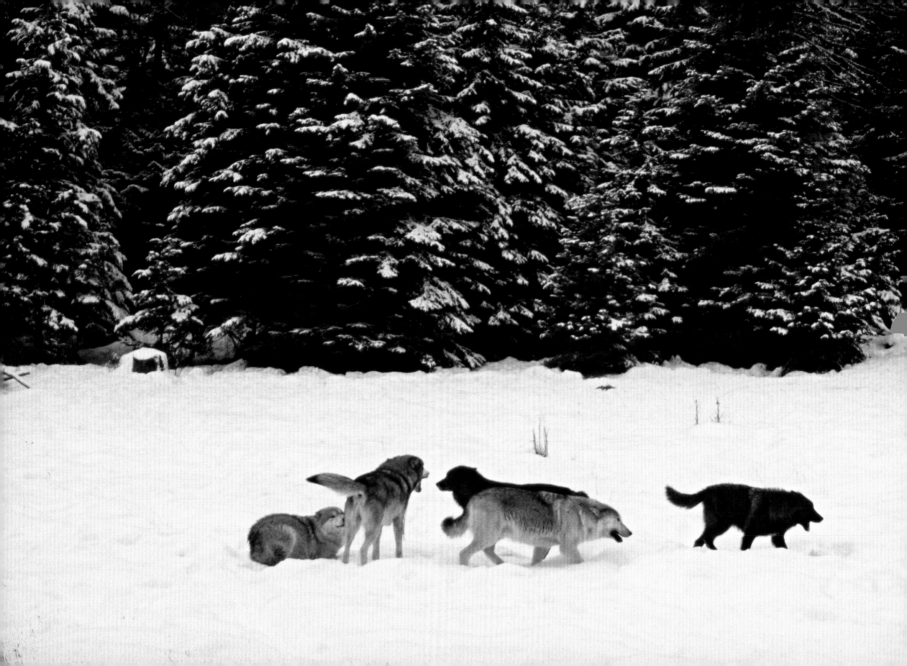

THE
WORLD
OF THE
WOLF

*Any glimpse into the life
of an animal quickens our own
and makes it so much the larger
and better in every way.*

—JOHN MUIR, *JOHN OF THE MOUNTAINS:
THE UNPUBLISHED JOURNALS OF JOHN MUIR*

In a pack, a wolf finds strength and security.

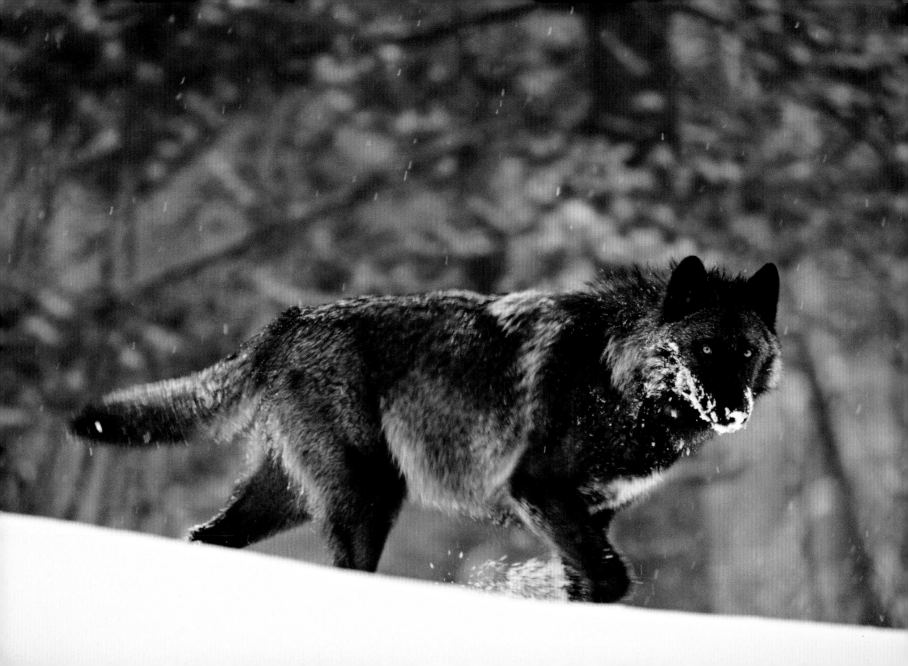

A horde of savages moves across the land, terrorizing peaceful herds of grazing animals—a loose confederation of killers, fighting over the spoils, kept in line by a brutal commander that holds power through intimidation. For hundreds if not thousands of years, this was the commonly held view of a wolf pack. It's also pure fantasy. The modern study of wolves has revealed the true nature of a pack, and it is far less fanciful and far more familiar than many people had imagined. A wolf pack is quite simply a family. Wolves are complex, adaptable creatures, so it's not surprising that wolf families, like human families, are diverse in their structure and behavior.

A wolf pack can be nuclear, consisting of only parents and a few offspring, or it can be large and extended, including aunts and uncles, siblings, grandparents, and even adoptees. As with human families, young adults often strike out on their own to find mates, to establish new homes, and to start new families.

We often hear the phrase "lone wolf," an expression of grudging admiration. A lone wolf is a rugged individualist, uncompromising and independent, driven to forge his own path, unfettered by the sentimental need for companionship. In reality, few people would ever want to live this way—and, as it turns out, few wolves would either. Wolves, males and females alike, may go through periods alone, but they're not interested in lives of solitude. A lone wolf is a wolf that is searching, and what it seeks is another wolf. Everything in a wolf's nature tells it to belong to something greater than itself: a pack. Like us, wolves form friendships and maintain lifelong bonds. They succeed by cooperating, and they struggle when they're alone. Like us, wolves need one another.

A wolf pack often begins with boy meets girl. Anywhere there are wolves, there are young males and females out looking for one another. If the circumstances are right, the two forge a bond

A lone wolf is a wolf that is searching, and what he seeks is another wolf. Like us, wolves form friendships and maintain lifelong bonds. They succeed by cooperating, and they struggle when they're alone. Like us, wolves need each other.

that often lasts a lifetime. About two months after mating, the female gives birth. With this act, the pair has created the most basic form of a wolf pack and they have become alphas—the breeding pair and the pack leaders.

Every wolf pack takes on a unique identity. The first wolf pack to form naturally in Yellowstone National Park following reintroduction was known as the Leopold Pack. The pack's history, chronicled by park biologists Doug Smith and Matthew Metz in Yellowstone's 2008 wolf report, offers an excellent case study of wolf pack dynamics. The Leopold Pack began in 1996 when a female identified as 7F met a male called 2M. The pair bred for seven successive years—quite a long partnership—and many of their offspring founded other packs.

When the alpha female, 7F, died in 2002, it was assumed that her mate, 2M, would attract and breed with a new female. Instead, an outside male called 534M worked his way into the pack, ousted 2M as the leader, and mated with one of the Leopold daughters, called 259F. 2M left the pack and took some of his offspring with him into exile, but the rest of the family stayed with the new leaders. When 259F also died, one of the females who had left with 2M returned and became a new breeding female—remarkable fluidity for what Smith and Metz once called "Yellowstone's most stable pack." With every new discovery, scientists continue to adjust our understanding of wolves.

A new breeding alpha, an adoptee, a usurper—all help to stir up the gene pool and keep wolf populations healthy. Wolves that aren't able to mix this way run the risk of inbreeding. The famous wolves of Isle Royale in Lake Superior have revealed what happens when a wolf population becomes genetically isolated. A breeding pair arrived on the island in 1949, crossing over from Canada on an ice bridge during a particularly cold winter. Since then, no new wolves have migrated onto Isle Royale. For a while, the wolves there seemed healthy, but in the past ten years, paralyzing bone deformities have begun to surface, and the population has plummeted from more than 50 wolves to fewer than a dozen.

Isle Royale serves as a cautionary tale for wolf recovery. We cannot expect wolves to survive, a pack here and a pack there, in isolated areas that we deem acceptable. Virtual islands in seas of human development carry the same genetic risks that real islands do. Especially when hunters are added to the mix, wolves that try to move from one population to another often don't complete the journey, and groups become ever more isolated. If the gene pools are not sufficiently large and geographically connected, the health of entire populations can suffer.

PACK HIERARCHY AND PACK BONDS

In theory, any wolf can become an alpha by becoming a parent. Based on our experience, though, it appears that certain wolves have a stronger alpha drive. Kamots was clearly the boldest of his littermates. He briefly shared his territory with an older male wolf, but at a very young age he began carrying himself in a dominant fashion, holding his head and tail higher than his pack mates did. He assumed the alpha position without any challenge from the other wolves.

The other wolves in the pack showed their deference to Kamots with submissive behaviors, postures, and vocalizations. When approaching Kamots, a subordinate wolf would usually crouch with tail held low, lick the alpha's muzzle, and whine gently. Kamots was not normally aggressive with other pack members. The mood of the subordinates was not one of fear but of friendly, submissive respect and recognition of Kamots's status. On the other hand, squabbles between other wolves were often transferred to Lakota, the omega. For example, if Kamots dominated Amani over food, Amani would often turn and dominate Lakota. While it looks rough at times, dominance and submission are ritualized ways of maintaining order, cohesion, and unity.

Although social ranking is important to the story of the Sawtooth Pack, far more compelling—and far more critical to our understanding of wolves—are the intense bonds wolves in a pack have with one another. For every moment of aggression we witnessed within the pack, we observed ten gestures of affection. They would greet each other nose to nose and walk together shoulder to shoulder, tails wagging, clearly appearing to enjoy one another's company.

When one of the first pack members was killed by a mountain lion, we observed a drastic change in the pack's behavior. Until that event, seeing the pack coursing through the meadow in a game of tag or keep-away was a daily occurrence, but afterward, we observed no play for six weeks. The spirit had simply left them. Expressions of solidarity were usually common, but now the wolves drifted about their territory separately, engaging in minimal interaction and frequenting the spot where the attack had occurred, sniffing the ground in silence. Their normally exuberant howls became eerie and mournful, and for these six weeks they tended to howl alone. To us, it appeared that they were remembering—and mourning—their pack mate.

When we were filming wolves in Alaska, our friend, the late wolf biologist Gordon Haber, joined us as a guide. In 1966, Haber took over

Generally Kamots, the alpha male, initiated
the howl. The other members of the pack would
quickly join in.

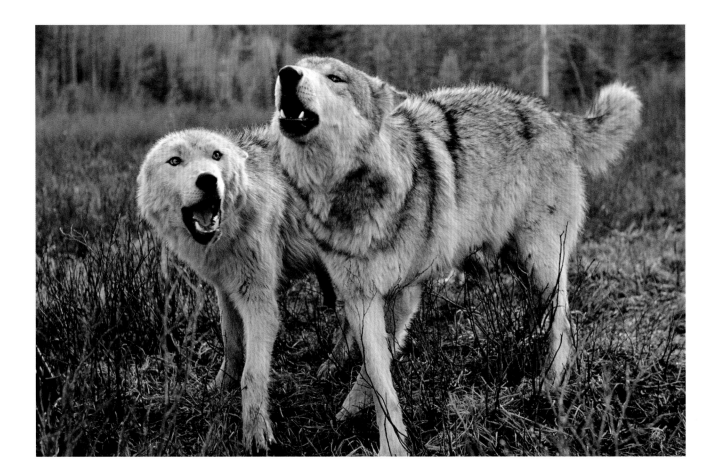

the study of Denali's Toklat Pack from pioneering biologist Adolph Murie. Much of Gordon's research focused on the social dynamics of wolf "families," as he often called them, an approach we valued and respected. As evidence of the deep devotion and solidarity within a pack, Gordon showed us the skull of a male that had suffered a broken jaw, likely kicked by a moose or caribou. The injury had healed, and the wolf had lived for several more years. A wolf with such an injury certainly could not have hunted and could not have eaten solid food for some time. The only way that he could have survived was for his pack mates to have taken care of him, likely by regurgitating food for him as they would for pups. There was no practical reason for the others to care for him, but he was one of them, a bonded pack member and part of the family. They wouldn't let him down.

Haber also documented a touching sequence of a yearling female wolf coaxing her four-month-old sibling across a shallow river. When the pup froze in fear halfway across, the older female rushed into the river, playfully slapping the water with her paws. The pup retreated to the other side, but his older sister persisted in her coaxing. Finally he worked up his nerve and picked his way across, where she greeted him with licks and a wagging tail. It's interesting that this job of confidence building fell to an older sibling rather than to a parent. Perhaps, just as with humans, motivation comes when an older sibling says, "Look, I can do it."

On no occasion are the social bonds of wolves more clear than during a pack rally. A rally occurs when the pack howls together in chorus—one of the most mysterious and moving events in nature. It is a call to assembly, a territorial claim, a declaration of solidarity, and a celebration of being alive and being together.

Among the Sawtooth Pack, Kamots was usually the first to howl. Throwing his head back, eyes shut, muzzle pointed toward the sky, he unleashed the first beautiful notes. His first howls sparked what appeared to be a contagious and truly involuntary urge in the others. They would gather around Kamots in a frenzy of licks, yips, whines, growls, and wagging tails. The sound welled up inside them, and soon they were all belting out in chorus.

TERRITORY, TRAVEL, AND DISPERSAL

An individual wolf needs a society, and every wolf society needs a homeland. As wolves have bonds with one another, they also have a close attachment to their home turf. They know the land. They know the

animals that live there, and they know how to hunt them. Their territory is their survival.

There isn't really a standard size for a wolf pack's territory. A six-wolf pack in Minnesota survived in a territory of just 13 square miles, while in Denali National Park, Alaska, a pack of ten claimed a vast range that spanned 1,693 square miles. Most important, a territory must provide a living; it must have prey. An array of other factors comes into play as well—for example, the presence or lack of neighboring packs, pressure from humans, the type of prey, and even the topography of the land itself.

In places with healthy wolf populations, neighboring packs establish buffer zones where their territories overlap. These neutral areas limit contact and conflict. As among humans, however, wolf societies can be expansive—and covetous of others' riches. There are many recorded occasions of one wolf pack attacking its neighbor pack in deliberate territorial conquest. But conflict may be tempered by relationship: New packs are often formed as offshoots of older established packs and may stake out a territory close by. Wolves have even been known to make social calls on parents and younger siblings in their old pack. They appear not to forget their old family bonds, which may actually contribute to a more peaceful coexistence.

When a young wolf leaves its birth pack, it is called a disperser. Most young wolves are gripped by the urge to breed, usually in their second year. If this urge is strong enough, they may leave the pack—one of the few times when lone wolves really do exist, but not for long. At any time of year, young wolves of both sexes are crisscrossing one another's territories or roaming into previously unoccupied land. Many meet and pair up close to home and then establish a territory near their former packs. But other dispersers are pioneers. A determined wolf moves at an easy lope of about five miles an hour. It can sustain this pace day after day as it zigzags back and forth, sniffs for scent markings on trees, and searches for signs of fellow wolves.

Just four years after wolves were reintroduced in Idaho, the first wolf was spotted in Oregon, more than 150 miles away. No other wolves lived in Oregon at the time, but something had driven that individual there—perhaps he was searching for a mate in new territory. A few years later, wolves were turning up in pairs. In 2011, a radio-collared male wolf known as OR-7 left its pack in northeastern Oregon and blazed a trail south, becoming the first known wolf in California in 87 years. By 2012, OR-7 nearly made history again by crossing into Nevada, but instead he doubled back, returned briefly to Oregon, and then headed

If a wolf leaves the pack, he or she is called a disperser. This is one of the few times when lone wolves really do exist, but they are usually not alone for long.

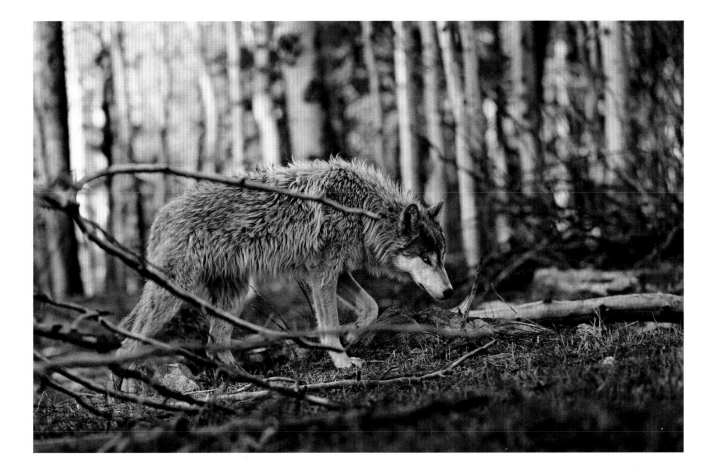

all the way back to California—a journey of well over 1,000 miles and counting. His saga is evidence of how a single disperser can, in just one generation, redistribute a pack's genes into an entirely new area.

FOR THE LOVE OF PUPS

As diverse in personality as wolves are, one trait seems to be universal: They fawn over pups and indulge their every need. As we saw with the Sawtooth Pack, adult wolves will bring bones to pups as gifts. Their devotion to their young certainly appears to be as powerful as ours.

Pups are usually born as winter gives way to spring, between late March and early May in North America. A litter typically numbers from four to six. The pups are born blind and toothless, barely able to crawl, nestled safe in a den their mother has dug for them, often the same den the pack has used for generations. The other wolves in the pack get very excited, but for the first few weeks, only their mother has contact with the newborns. When Chemukh gave birth to pups in the Sawtooth Mountains, the rest of the pack gathered outside the den, quivering with excitement and cocking their heads at the chirps and squeals coming from below. But no wolf—not even Kamots—dared to look inside. The den was Chemukh's and Chemukh's alone.

In just three weeks, wolf pups begin to move around and poke their heads outside the den. At last, all the older siblings, aunts, and uncles meet them. Soon, when older wolves return from feeding, they are greeted by a flurry of pup licks and whines, which provoke the involuntary response of regurgitating a portion of their meal, a semidigested stew devoured eagerly by the pups. Even completely unrelated adults will make this sacrifice. It's the natural way wolves carry and deliver food to their young.

At this stage, one of the younger adults may take on the role of babysitter, freeing the mother to go off in search of prey. After all, she, the alpha female, is usually one of the most experienced hunters. Adult wolves exhibit a nearly limitless tolerance for the pups' rambunctious behavior. Watching the Sawtooth Pack, we were initially amazed to see Amani, who typically had a short fuse, happy as could be, stumbling through the grass with one pup attached to his tail and two more gnawing on his back legs. This kind of tolerance—even indulgence—is typical of a nonbreeding wolf like Amani. Only a deeply social and family-oriented animal would demonstrate such devotion to another's offspring. Wolves in a pack have a powerful drive to care for one another, to protect and preserve their family.

As the weather warms, the pack moves the pups away from the den to a safe area, known as a rendezvous site. As the pack hunts, at least

one wolf remains behind, acting as a guardian while the pups sleep and play. Adults returning from the hunt bring what they can carry from the kill back to the rendezvous site. The pups instinctively fight over the spoils as they begin to sort out their own levels of dominance and submission.

The pups won't stay around the site for long. After just 12 weeks, they are traveling with the rest of the pack, following along as the older wolves hunt, and observing how it's done. They still lack the skills to survive, but they now feed on kills with the rest of the pack. Pups need all the calories they can get. Their parents, the alphas, make a place for them at the carcass, dominating subordinate wolves that try to eat before the pups get their fill. Since a wolf pack is a family unit, this dominance suggests that parents are looking out for their youngest offspring, who are growing rapidly.

There's a reason for all this obsessive care. Still, it may not be enough. The first year of life can be very challenging and dangerous for a wolf pup litter. Born as the snow melts, they develop so fast that by autumn, in about seven months, they are nearly indistinguishable from adults. It is crucial that they reach full size before the coming winter, so they put on weight rapidly. During this time of accelerated growth, pups can starve or become weak and susceptible to disease. It's estimated that only half of wolf pups survive to adulthood.

HUNTING LESSONS

An adult wolf can live well on rodents and other small game, so why do wolves hunt in packs? The reason likely comes down to pups. The youngest wolves can't hunt for themselves, so it's up to the adults to bring in surplus food by tackling prey that is generally too big for a single wolf to catch. Working as a team pays off for all.

It is often said that the alphas lead the hunt. That isn't to say that the alphas are barking orders out in front of the chase. Rather, the alphas are the keepers of the pack's knowledge. As older and more experienced hunters, they know what prey to go after, where to find it, and how best to approach it. Wolves less than a year old follow along excitedly, eager to be part of the action but contributing very little to the job. As they mature, their participation steadily increases. In this way, young wolves learn more than just the skills to become solid hunters; they develop preferences for certain conditions, types of prey, and hunting strategies. In effect, they learn the pack's hunting culture.

Scientists are very conservative when it comes to making official statements regarding how much wolves actually strategize and cooperate during the hunt. Yet many researchers readily recount observations

of what appeared to them to be a pack of wolves using specific tactics and working as a coordinated force.

Our friend, biologist Gordon Haber, told us stories of hunts he witnessed, explaining how the wolves changed their strategy based on weather, terrain, and prey behavior. His famous Toklat Pack often preyed on Dall sheep on the rocky slopes of Alaska's Denali National Park. Haber observed that the wolves always climbed the slopes and attacked from above. Dall sheep are superior climbers and could easily evade the wolves by running uphill. The wolves learned to anticipate this evasion, so they attacked in a manner that cut off this escape route, sometimes waiting for two days to stage an ambush. In the book *Among Wolves: The Work and Times of Dr. Gordon Haber,* Haber's amazement at the skill and athleticism of these animals is contagious:

> I watched in disbelief as Toklat wolves literally skied, stiff-legged, straight down icy chutes, adjusting their upraised tails back and forth for balance . . . trying to intercept sheep that were fleeing below from several other Toklat wolves chasing from another direction. The three bounded over the top of a high, narrow, rocky ridge at full run and jumped immediately—apparently without looking first—into the top of an icy chute and skied straight down.

As he spent decade after decade studying wolves in Alaska, Haber observed many specialized hunting strategies. In summer, he repeatedly witnessed wolves drive herds of caribou into a dry riverbed, where the hoofed animals were bound to stumble on the round stones. And in the deep snow of winter, when caribou travel single file on well-trampled paths, the wolves would follow close behind and patiently wait until their presence caused the rearmost caribou to become uneasy, panic, and try to move up in the file. Those caribou that tried to get ahead had to leave the firm path and bound through deep snow. Eventually, a weak one would struggle and get bogged down. Only then did the wolves close in for the kill.

Even in ideal hunting conditions, a strong, healthy caribou, moose, or other prey animal actually has a very good chance of getting away from a wolf pack. Despite erroneous claims, wolves are not "killing machines." Hunting is difficult and dangerous. A kick from an elk can shatter a wolf's jaw. Wolves test animals first. While they may occasionally take down a bull elk in its prime, odds are they'll find an easier mark—usually one that

To survive, wolves must learn to communicate and collaborate. Senior pack members pass on hunting strategies and techniques to younger wolves.

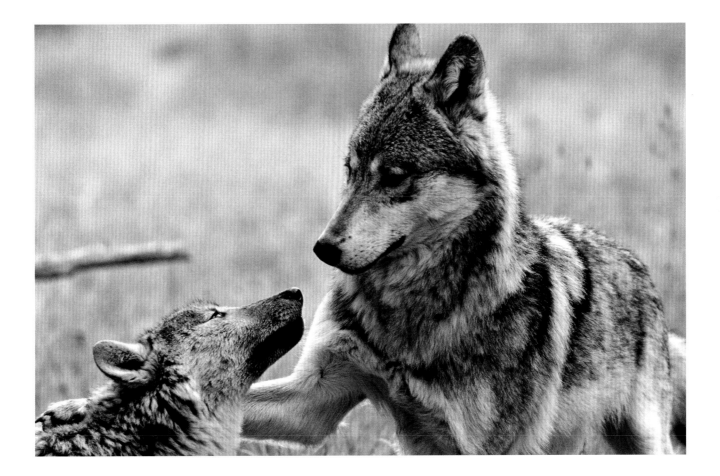

is injured, sick, very young, or weakened with age. Pressure from wolves favors the survival of the strongest, fastest, and healthiest. Thus, wolves reduce the spread of disease and limit the passing of genetic defects to the next generation. Over eons, the wolf has given the deer its swiftness, the elk its stately grace, the bison its power.

TIME OUT FOR PLAY

It's an unmistakable gesture of wolves, dogs, and other canids: head low, forelegs splayed wide, rump held high and topped with a wagging tail. It's an invitation to play, and wolves of any age are eager to accept.

Nearly anything can spark a game. Gordon Haber noted that "a good meal is usually a hard-earned, happy event. And over the next day or two, before they begin hunting again, almost anything is likely to trigger another bout of spirited play." Among the Sawtooth Pack, in addition to post-meal celebrations, we noticed a heavy snowfall seemed to put them in a lighthearted mood. Often it was Lakota, the omega, who started the games, bouncing up and down then ducking in to a play bow, enticing Kamots or Matsi to chase him. Surprisingly, after chasing Lakota, the more dominant wolves would often turn around and get Lakota to chase them in return. It reminded us of a human family in which a stronger older brother allows a younger brother to pin him in a wrestling match. Both know it isn't real, but for a moment they suspend the normal rules. For Lakota, these were moments of pure joy.

Beyond games of tag, wolves love to play with objects. Anything will do—sticks, bones, or pieces of hide—but unfamiliar objects hold special fascination. When a visiting U.S. Fish and Wildlife official carelessly set his camera on the ground, Kamots and the pack spent the better part of an afternoon entertaining themselves with it, gradually reducing it to a mass of plastic and wire. A wolf who gets hold of a toy prances about, flipping the object into the air and then retrieving it, daring the others to try and steal it. To anyone who has watched two or three dogs playing with a stick or a ball, it's a familiar scene.

We also noticed one peculiar obsession, especially among young wolves, that has been documented in Yellowstone as well. Wolves love ice. When the pond froze in winter, the wolves became entranced with the air bubbles that moved beneath the clear surface. They'd snap at the bubbles and bounce on the ice with their forelegs until they finally broke through the surface. Then they'd seize the sheets of ice in their jaws and fling them down, apparently enjoying the sight and sound of shattering ice. We imagined how fascinating ice must be in a wolf's

world—solid yet translucent and fragile, appearing overnight as if by magic and smashed back into nonexistence with ease.

Not surprisingly, play is most common among younger wolves. Pups that have just emerged from the den often do little else. As many biologists have noted, play among juveniles tones muscles, builds coordination, hones skills that will be useful in hunting, and helps young wolves establish their place in the hierarchy. But that doesn't explain why adult wolves engage in play. Observing dogs playing together, biologist Marc Bekoff noted that if one became aggressive, the play ended abruptly. For dogs, wolves, humans, or any other social creatures, the rules are the same: You can't play with someone you don't trust. Through play, adult wolves stay in tune with one another. For an animal that lives and hunts as a group, a solid foundation of trust is critical.

THE CONSEQUENCES OF BROKEN BONDS

If we are to live with wolves, we need a clearer understanding of a wolf's world to guide our perceptions, treatment, and management of this animal. Wolves aren't reactive automatons that chase and kill whatever they see. They live in societies tied to a specific homeland. They develop patterns of behavior and pass them from generation to generation. Wolves have, in essence, a culture. When that culture is destroyed, their behavior becomes more erratic and unpredictable.

The Toklat Pack of Alaska, which hunted Dall sheep, is a perfect example. Although the pack's territory is primarily within Denali National Park, it extends beyond the invisible park boundary. Local hunters killed many of the Toklat wolves, whenever it was legal. In 2005, the Toklat alpha female was trapped, and the alpha male was shot. Only six wolves remained, all juveniles. They had not yet achieved the hunting proficiency required to capture elusive prey such as Dall sheep, nor had they learned the pack's territorial boundaries. The survivors retreated to a fraction of their territory and subsisted by hunting snowshoe hares. A decades-old tradition and specialized technique of hunting Dall sheep on high, rocky slopes abruptly ended. With the death of the alphas, generations of knowledge and experience simply vanished.

Others have observed the consequences of broken wolf packs. In a June 2010 article in *New Scientist*, "Wolf Family Values," Sharon Levy contrasts hunted and nonhunted wolf populations as reported by geneticist Linda Rutledge. In the area surrounding Algonquin Provincial Park in Ontario, Canada, wolves have been hunted legally for more than a century. During that time, hunters were responsible for two-thirds of all the wolf

deaths in the region. When the hunting of wolves was banned in 2001, researchers saw a pronounced change in the social structure of packs.

When hunting was legal, families were destroyed, pack cohesion was dissolved, and wolves gathered into small groups of often unrelated animals, resulting in loose, gang-like pseudopacks. After hunting was halted, the family unit returned. Where predation on moose was once nearly nonexistent, it increased dramatically. A moose provides much more meat than a deer, but it is more difficult to take down. An increase in moose predation indicates that stable families—families in which young wolves have time to learn and surviving parents to teach them—produce more competent hunters.

We as humans cannot fail to comprehend the tragedy of losing two-thirds of one's family. In war-torn countries we have witnessed the devastating legacy of uneducated, emotionally shattered human orphans. We also have ample evidence of what happens when we repeatedly damage animal societies. One of the most relevant examples is that of elephants, animals no less intelligent, social, and family-oriented than wolves. In Africa, India, and Southeast Asia, poachers routinely target older elephants for their tusks, thus shattering families, depriving the youngest elephants of critical social bonds, and destroying the herds' knowledge of foraging areas and migration routes. In areas where poaching is high, rogue elephants—especially adolescent males—run amok, attacking other wildlife and each other, rampaging through villages, destroying crops, and sometimes even killing people. Biologists who study elephants say they are witnessing a total breakdown of elephant culture.

Wolves are incapable of wreaking the kind of havoc that elephants can cause, but when we, in our shortsightedness, destroy the social structure and accumulated knowledge of a wolf pack, the survivors develop aberrant and dysfunctional behavior. We change their world so much that they no longer behave like wolves. Then we blame the wolves for the problems we've created.

If we are to move forward and learn to coexist with wolves, then our treatment of them must reflect what we now know. A wolf is not a solitary creature, and a wolf pack is not a loose confederation of random individuals. Wolves care for one another. They play together into old age, they raise their young as a group, and they care for injured companions. When they lose a pack mate, there is evidence that they suffer and mourn that loss. When we look at wolves, we are looking at tribes—extended families, each with its own homeland, history, knowledge, and, indeed, culture.

As the new pups began to explore their world, Amani, a mid-ranking male, took a special interest in them, seeming to regard the recent arrivals as newfound playmates.

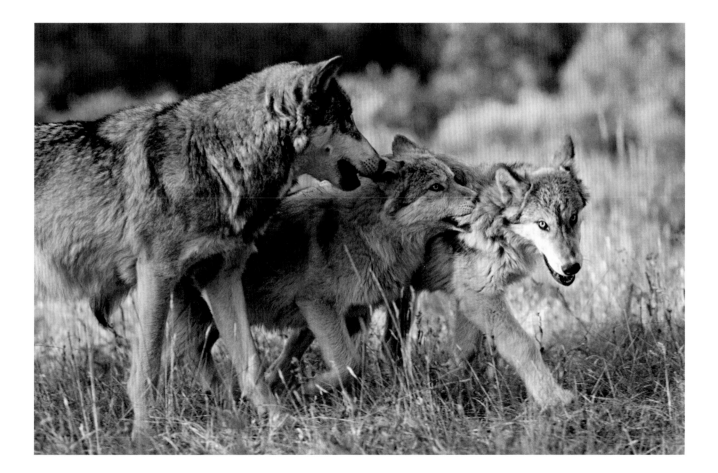

Howling increases during breeding season. Generally, in the Sawtooth Pack, a howl would begin with a long, mournful sound from the alpha. Everything else in the forest seemed to fall silent. As other members of the pack joined in, the chorus swelled to a soulful frenzy.

And when, on the still cold nights,
he pointed his nose at a star
and howled long and wolflike, it was
his ancestors, dead and dust, pointing nose
at star and howling down through
the centuries and through him.

JACK LONDON, *THE CALL OF THE WILD*

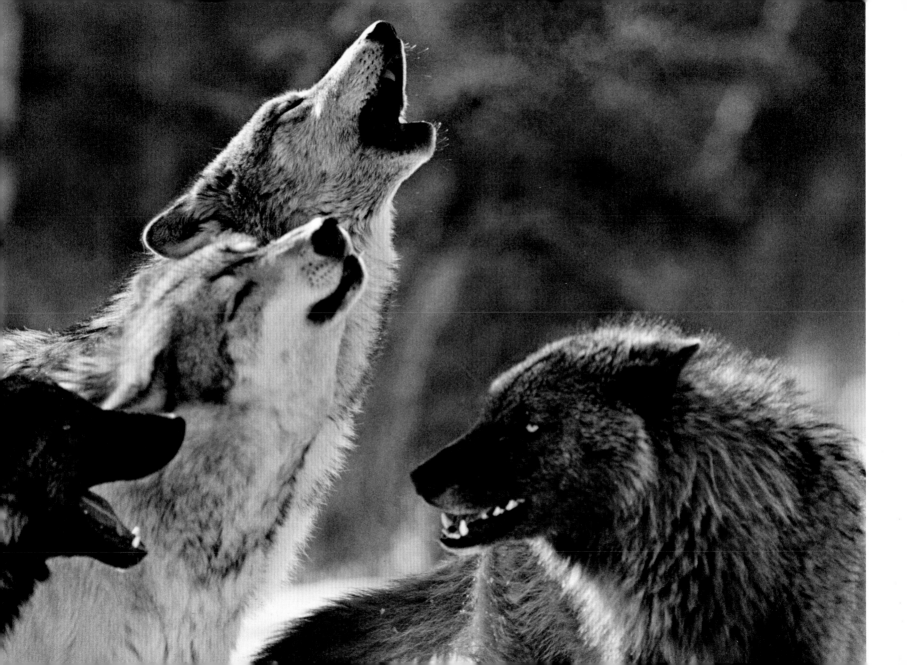

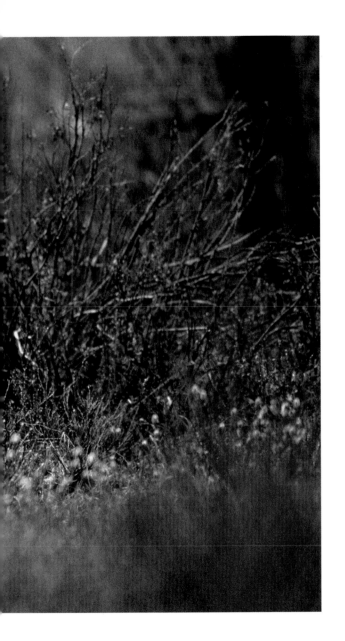

Seeing a wolf in the wild is extremely unlikely. However, now that wolves have been reintroduced to Yellowstone, 150,000 visitors a year visit the park to see the wolves, adding $35 million to the local economy.

Opposite: Our goal was to observe the wolves not as scientists, but as social partners. The only real means of developing a true bond between a wolf and a human being is for the person to raise the wolves from pups. Once bonded, the wolves accept the company of that human just as they accept the company of their own pack mates.

Following pages (84–85): Often pups torment the adult wolves by gnawing on their ears or pouncing onto their backs in a mock attack. Puppies develop and maintain their own pup hierarchy for their first few years of life, and their ranks are established early.

*I've always said that
the best wolf habitat
resides in the human heart.
You have to leave a little space
for them to live.*

ED BANGS, NORTHERN ROCKY MOUNTAIN WOLF
RECOVERY COORDINATOR, U.S. FISH
AND WILDLIFE SERVICE

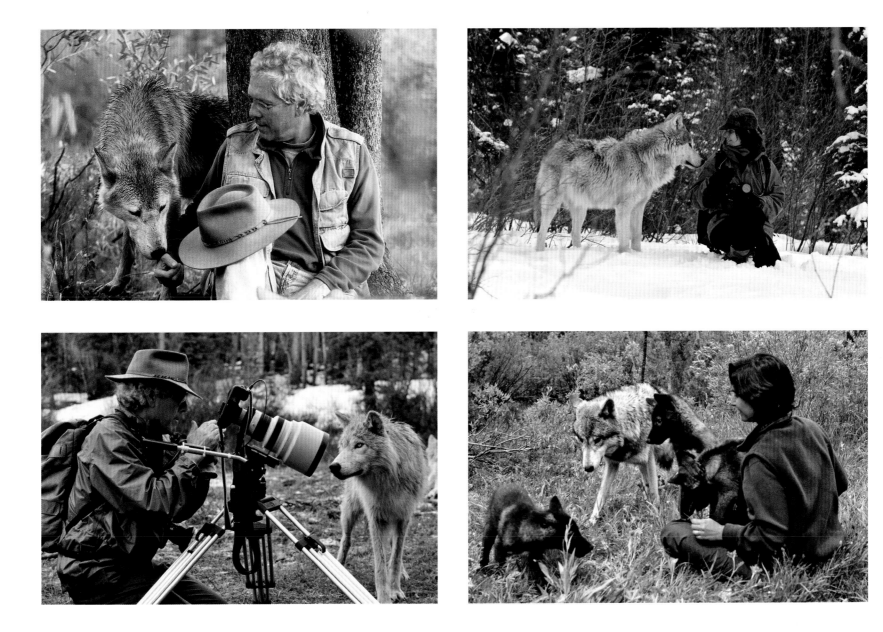

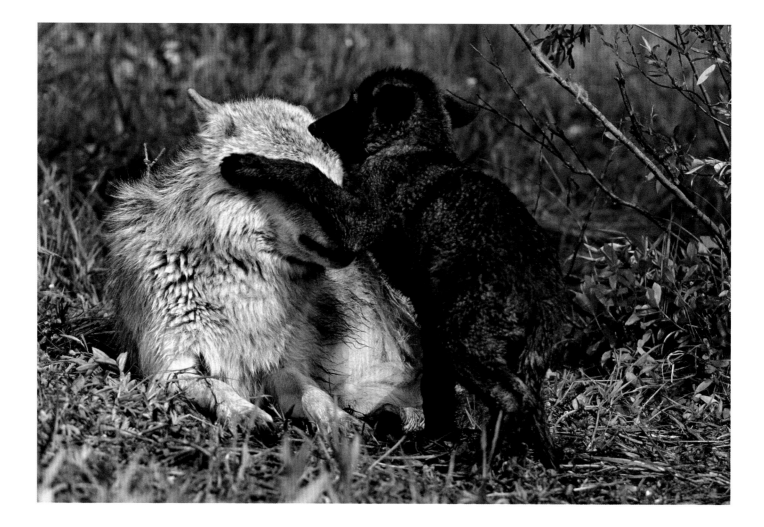

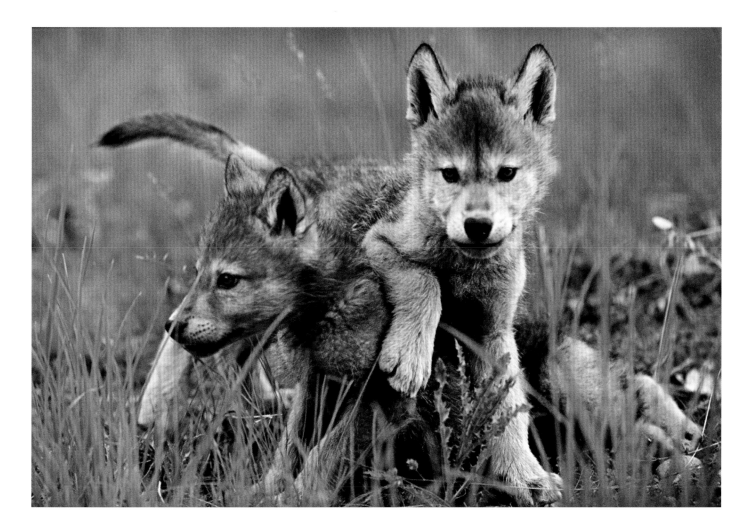

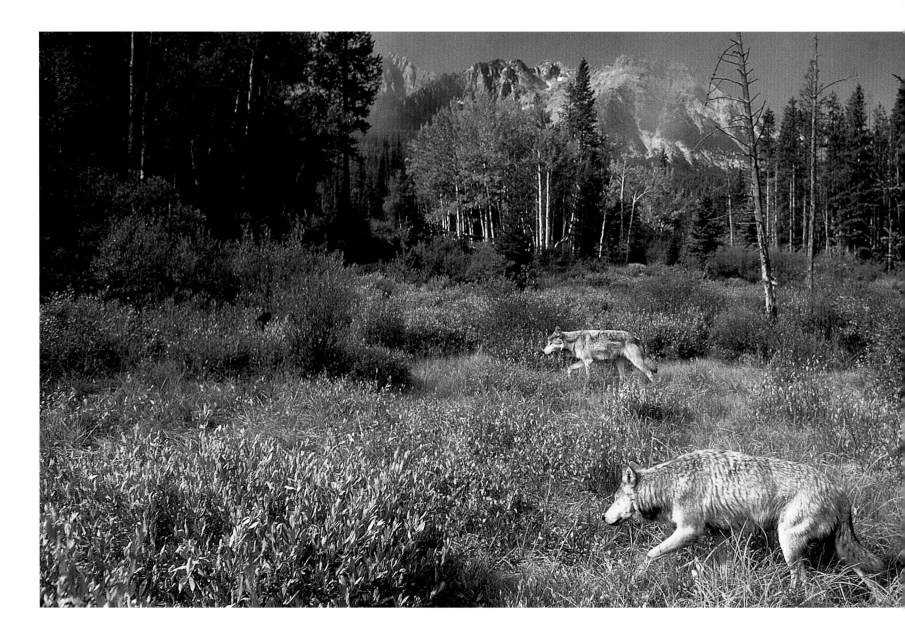

Watching the way wolves interact with one another, it's easy to see why so many early human cultures revered wolves. Hunting societies especially admired and even imitated the wolf's skill. As predators, human beings and wolves have comparable limitations, and therefore must employ social cooperation to succeed.

I observe, near all gangues of Buffalow
wolves and when the buffalow
move those animals follow,
and feed on those that are killed
by accident or those that are too pore
or fat to keep up with the gangue.

CAPTAIN WILLIAM CLARK, OCTOBER 20, 1804, FROM HIS
JOURNAL OF THE LEWIS AND CLARK EXPEDITION

Each wolf devotes itself completely to the pups that are born to the alpha pair, making sure that the pups grow up to be strong and beneficial additions to the pack. Only a deeply social and family-oriented animal would demonstrate such devotion to another's off-spring. Their absolute adoration of pups is the most complete manifestation of their devotion to the pack.

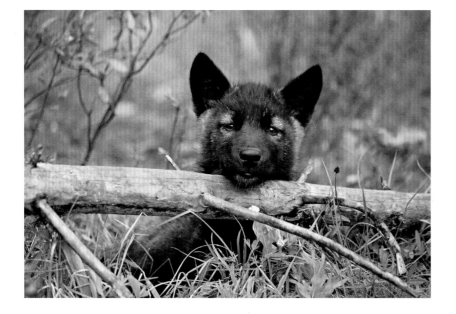

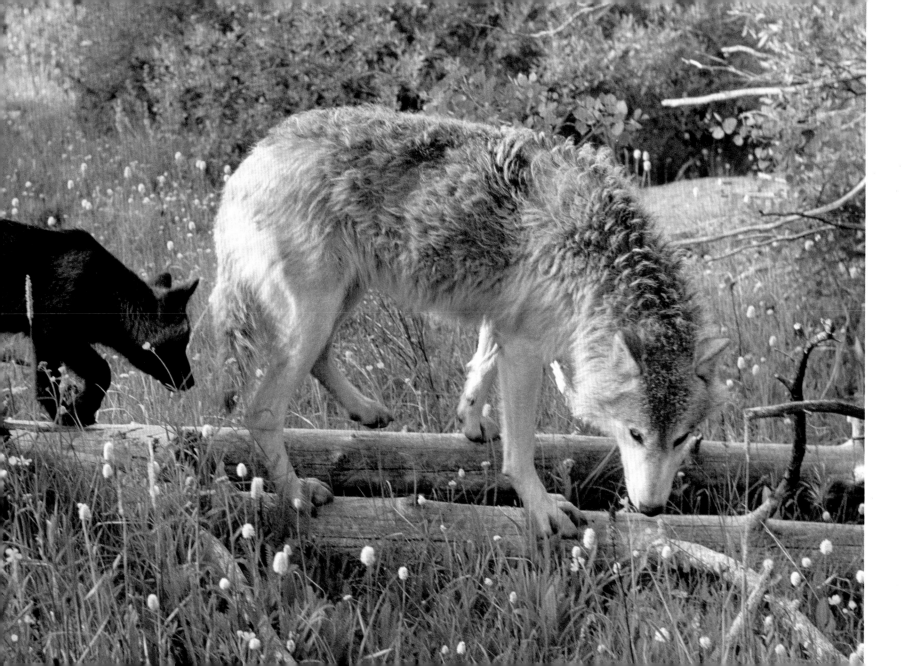

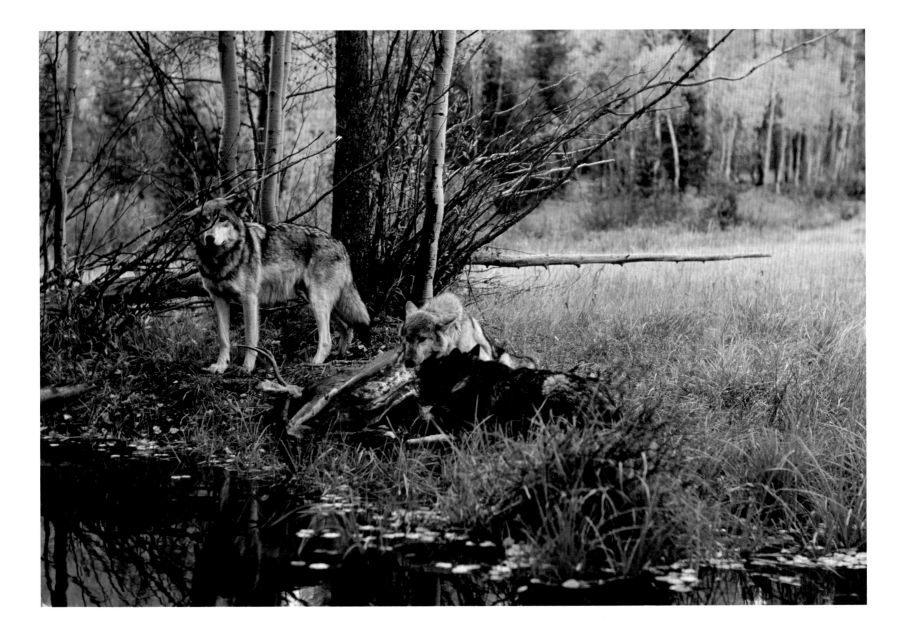

In judging what he can handle
and what should prudently be left alone,
this carnivore brings to his daily work
sophisticated skills completely beyond
our human ken. These are made possible
by inborn capacities effectively tuned
and developed in the young animal
through an apprenticeship that only
the capable survive.

DURWARD L. ALLEN, *THE WOLVES OF MINONG*

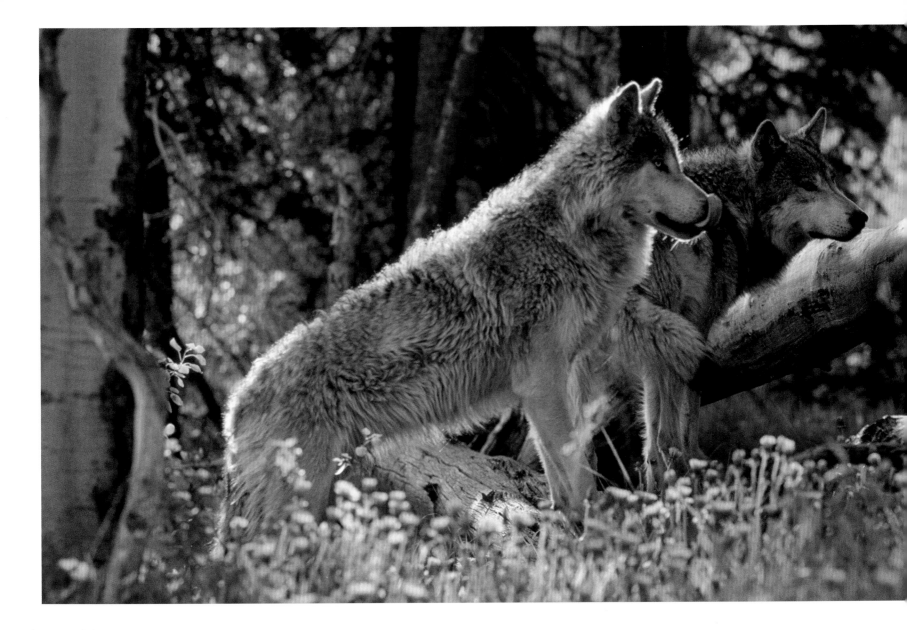

Opposite: Of all a wolf's sharp senses, its sense of smell is the most developed. It is estimated to be up to 100 times more sensitive than that of humans. With its powerful nose, a wolf can detect prey several miles away.

Hunting is difficult and dangerous work. A kick from a moose or elk can shatter a wolf's jaw.

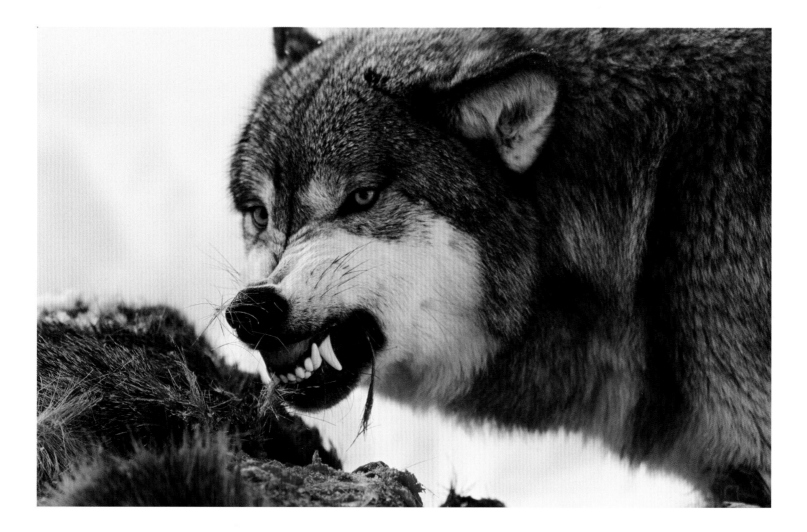

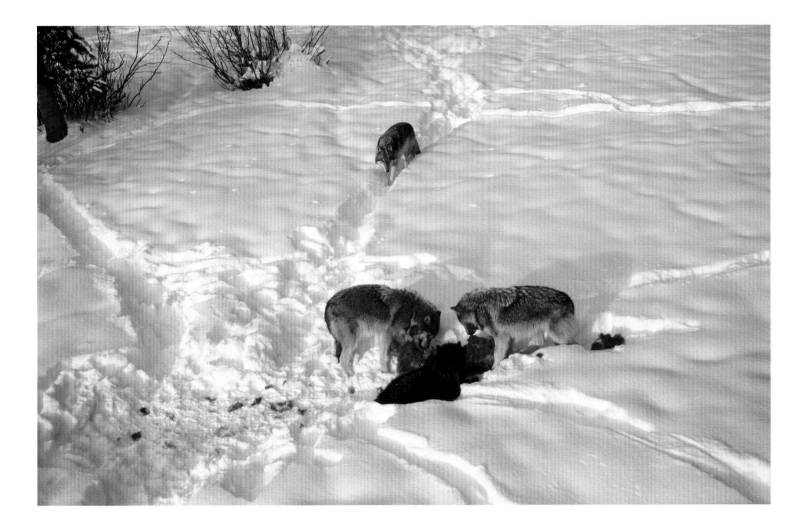

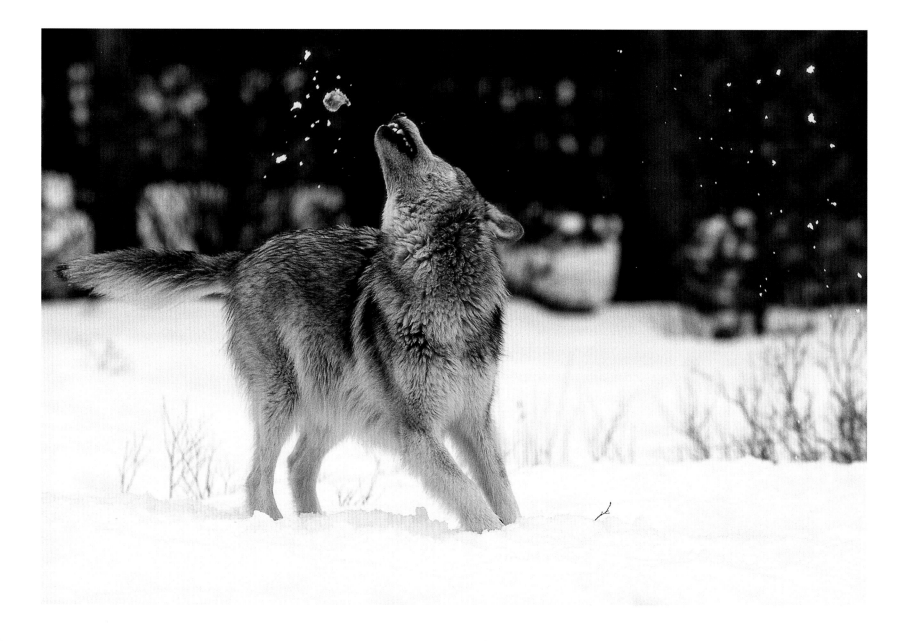

For a long time, wolves were seen but not looked at. Grown scarce they made themselves elusive, and their actions were interpreted more than observed. Recently, though, they have begun to emerge from their night.

PAUL-EMILE VICTOR, *L'EMPIRE DES LOUPS*

Play is vital to every stage of a wolf's life. It allows wolves to release pent-up energy, to hone their physical skills, and to establish social bonds. These subtle and shifting relationships within the pack demonstrate that wolves can show aggression, affection, guilt, humor, and other attributes common within human families.

*I think wolves are probably the perfect symbol
of that earlier time before we human beings
set out to conquer nature. They are the resistance
movement to everything that we represent . . .
They remained free, wild, undomesticated,
dangerous—and long after they no longer
posed a real threat to us and our survival,
I think we still held it against them
that they were out there free and wild
and dangerous and went out to do as good
a job as we could of getting rid of them.*

DAYTON DUNCAN, *THE NATIONAL PARKS: AMERICA'S BEST IDEA*

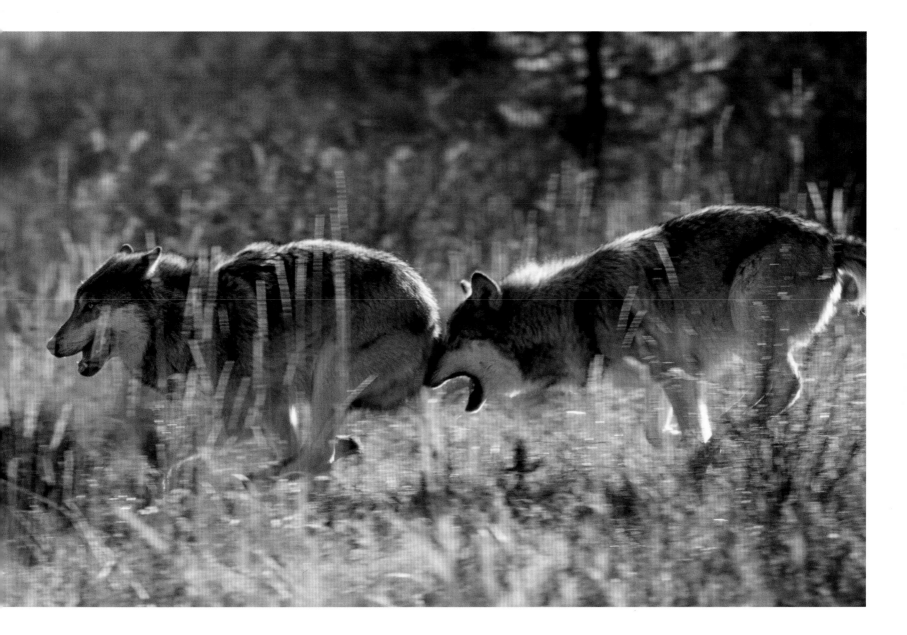

This is one of the most unmistakable gestures of wolves and other canids: head low, forelegs splayed wide, rump held high and topped with a wagging tail. It's an invitation to play, and wolves of any age are eager to accept.

Opposite: Wolves love ice. When the pond froze over in winter, the Sawtooth Pack would become entranced with the air bubbles that moved beneath the clear surface.

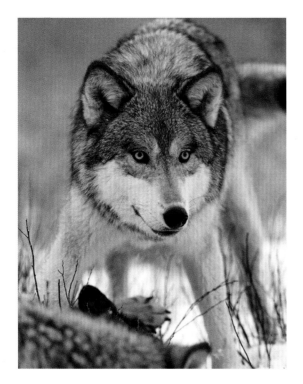

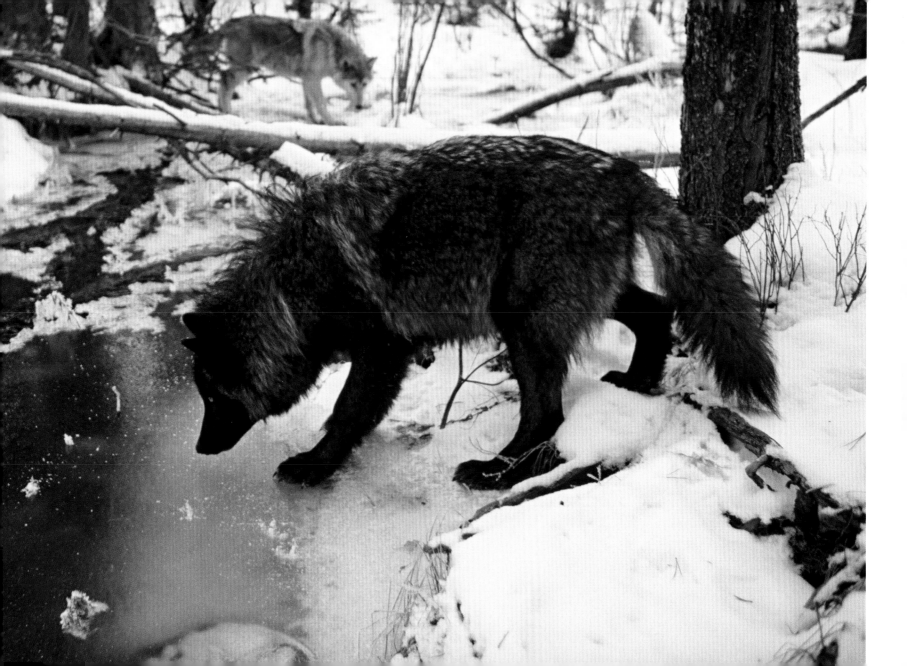

During a hunt, the young wolves watch the behavior of the adults to witness how they change their strategy according to conditions and type of prey. Youngsters learn how the hunters handle each different situation—what to do when the prey dashes for open ground, jumps into a river, or turns to defend itself.

Wolves may feature in our myths,
our history, and our dreams,
but they have their own future,
their own loves,
their own dreams to fulfill.

ANTHONY MILES

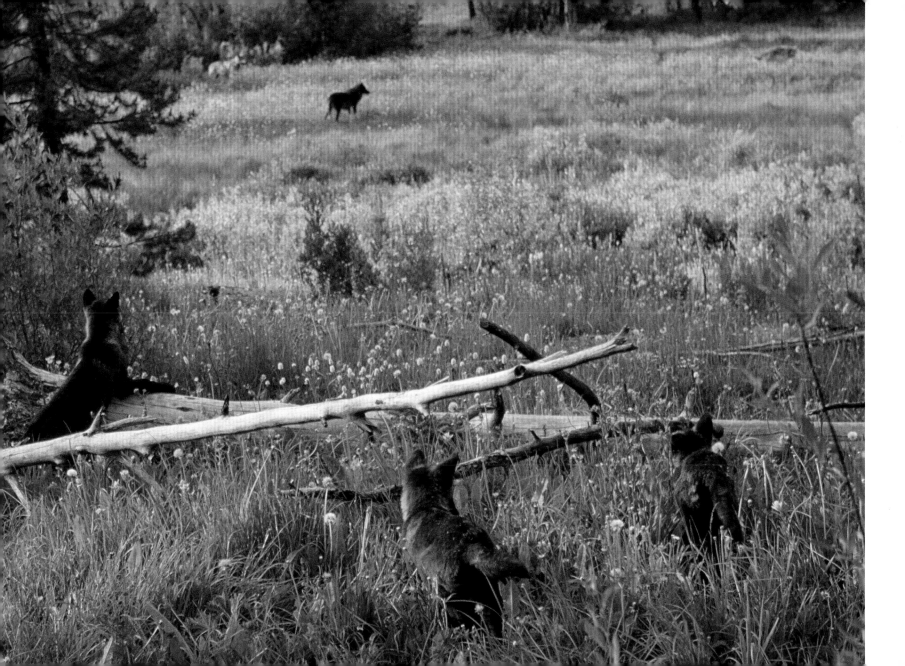

FOUR PERCEPTIONS

The wolf may be the greatest shape-shifter in the animal kingdom, appearing through history and in cultural representations from around the world as everything from savage hell-dog to benevolent spirit. It all depends on who is looking and what lessons they have already learned about the nature of wolves.

In our years speaking on behalf of the wolf's return, we have also come to know many people on all sides of the issue. Not surprisingly, we've found that one's perception of the animal itself guides one's position in the debate. These perceptions seem to fall into one of four categories.

■ THE WOLF OF NIGHTMARES

This is the wolf of fables, fears, and superstitions. European settlers brought the image of a savage, deceitful, and sinister creature with them to the New World. Tales like "Little Red Riding Hood" were passed down through generations, stoking fears. Horror films and Halloween stories continue to perpetuate the myths of werewolves and wolfmen who turn fanged and bloodthirsty by the light of the full moon. Who's afraid of the Big Bad Wolf? Judging from fairy tales, cartoons, and popular culture, we all should be. These fairy tales have been modernized to depict a crafty predator that stalks innocent children at school bus stops and kills for the sheer joy of it. Because we are unconsciously programmed to fear the wolf, we consider it a dangerous species. Many people still believe that wolves pose a serious and perpetual threat to human life, despite volumes of evidence to the contrary.

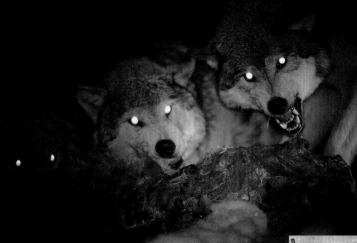

Since medieval times, wolves have been viewed as evil competitors for food, smart and cunning, and living in dark forests where men were not in control. These concepts were carried to the New World with settlers.

Without even being aware of it, generations of parents have passed along the archetype of the "big bad wolf" in singsong fashion to their children. This 1933 sheet music from Walt Disney's "Three Little Pigs" reminds us of the lovable, carefree piglets and the ravenous wolf, lurking in the shadows and ready to take advantage of their careless home construction techniques.

Fairy tales like "Little Red Riding Hood" turn the native pack hunting talents of the wolf—social planning, coordination, and surprise—into vile human characteristics such as connivance, deception, and trickery. At a deeper level, Red Riding Hood walks into the woods—primeval nature—and encounters evil, symbolized by the wolf.

When men are called wolves, the implication is that they treat women as prey and that their hunger for sex overwhelms their higher human nature.

■ THE SPIRIT WOLF

The Wolf of Nightmares finds its mirror image in the Spirit Wolf, a similarly mythical conceptualization of the animal's inner quality, experienced and expressed in human terms. Born and nurtured in the cultures of many Native American tribes, the Spirit Wolf is a creature of great wisdom, revered as a spiritual guide. Many modern-day wolf lovers are drawn to this positive image, but traditional meanings often get co-opted and distorted, leaving the animal draped in a veneer of clichéd symbolism. Although this perception reflects a high regard for wolves, it disregards the science and the realities of wolf behavior. This standard, created by human beings, can muddy the effort to find real solutions to real problems in the world that we share with wolves.

In 1910, the photographer Edward Curtis created this portrait of Apuyotoksi—literally "light-colored kidney" and commonly called Yellow Kidney —a Piegan Indian. For his portrait the warrior donned his wolf-skin war bonnet.

The Nez Perce Tribe welcomed the Sawtooth Pack to their new home on tribal lands with ceremonial dancing. Many Native American cultures hold special reverence for wolves, honoring their hunting prowess and social nature.

Totems standing in Vancouver's Stanley Park celebrate Canada's First Nations. The Sky Chief Pole, carved by Hesquiaht artist Tim Paul and Ditidaht artist Art Thompson, includes the face of a wolf.

The Sherdak Pen people of northeastern India followed the traditions of Mahayana Buddhism. This late 19th-century mask, worn by Sherdak Pen lamas in monastic dances, represents Khya, the wolf or black dog.

■ THE MANAGED WOLF

The Managed Wolf, a modern perception, almost always wears a radio collar. It is a faceless animal, appearing only as data—statistics of distribution, predation, and reproduction. Biologists observe it and record its physiology, movements, and behaviors; state and federal officials tag it, count it, relocate it, and often kill it. Although this perception of the wolf has a basis in sound science and acknowledges the animal's intelligence, it is often unconcerned with the wolf's individuality, devotion to family, and capacity for emotion. The Managed Wolf is the subject of study rather than an individual with a family, a culture, and a distinctive personality.

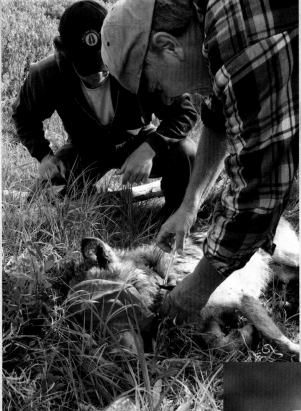

Carter Niemeyer, wolf biologist (right), carefully collars a wolf after examining it to determine its age, sex, and health. Next, he will release it into the Bear Valley of Idaho, at the edge of the Frank Church-River of No Return Wilderness.

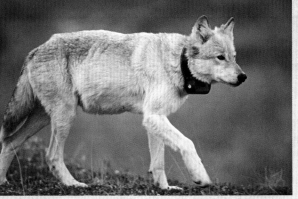

Radio collars are put on one or two wolves in a pack when possible. These collars transmit information that aids wildlife managers and researchers in tracking the movements and locations of individual wolves and packs.

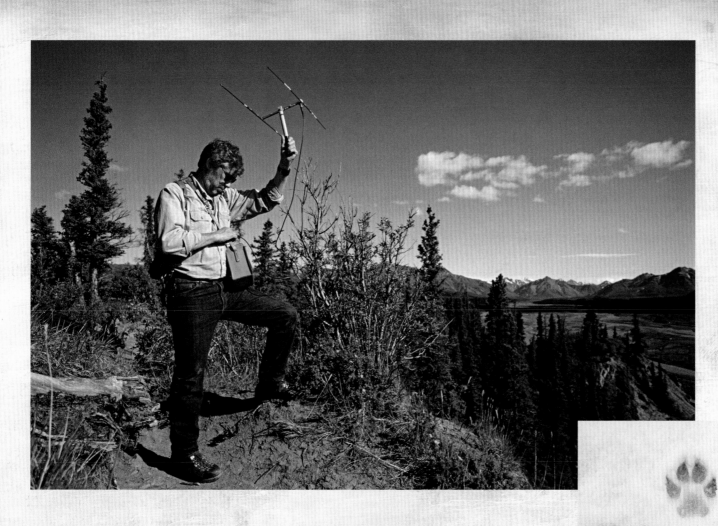

Wolf biologist Gordon Haber tracked, studied, and watched over the Toklat Pack in Denali National Park in Alaska with the aid of radiotelemetry.

Skilled trackers learn to determine vital information about wolves, including their size, number, and travel, by studying their paw prints. Winter snows offer excellent opportunities to follow these prints.

■ THE SOCIAL WOLF

Through our years of living with wolves, the Social Wolf is the animal we have come to know and respect—neither demon, nor deity, nor data. These are intensely social creatures that exhibit extreme devotion to their pack, their family. Wolves care for each other as individuals, form friendships, and nurture their own sick and injured. The behavior we have seen leads us to present wolves as creatures capable of communication, the transfer of knowledge, and even the expression of emotion. They are thus deeply vulnerable to management practices that destroy their social structure. This is the new understanding of wolves that we want to share.

Over the years, we observed obvious affection between Kamots, the alpha, and Matsi, the beta. They never seemed to challenge each other. Choosing to spend time together, they appeared to simply enjoy each other's company.

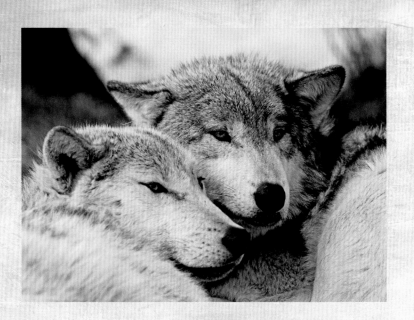

Wolves release tension by playing, while also keeping their physical skills strong and reinforcing their bonds within the pack. Matsi and Lakota, who appeared to be friends, regularly found time to play.

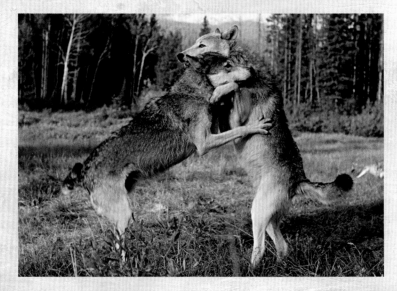

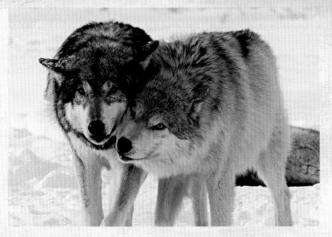

The wolf pups often slept together, curled up beside one another, the head of one pup draped over the neck of the other, in a manner both assertive and affectionate, enforcing their bond as pack mates.

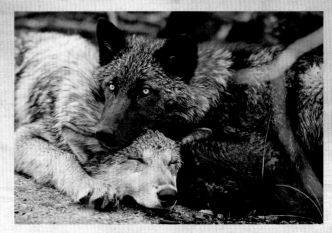

Pack bonds were reinforced by the individual relationships that the wolves had with each other. Rarely did two wolves pass each other without playfully rubbing shoulders or exchanging a brief lick.

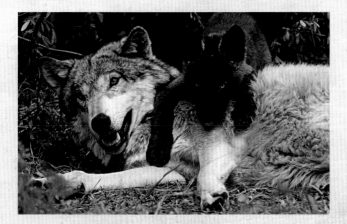

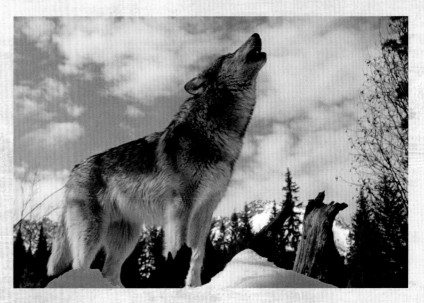

Amani never tired of playing with the pups, who climbed on him and chewed on his tail and ears. Although he was not their father, he seemed to be totally devoted to them, clearly demonstrating his bond to another's offspring that were part of his pack.

For three weeks after Kamots died, a single wolf was heard howling in the night. While we never knew who it was, from our experience living with these wolves, we always believed it was his brother, Lakota.

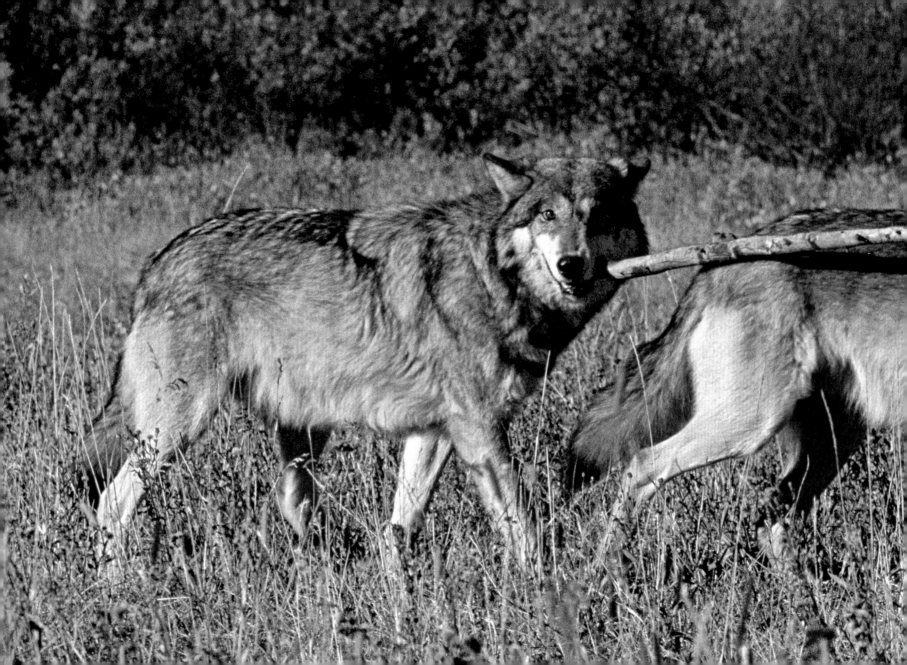

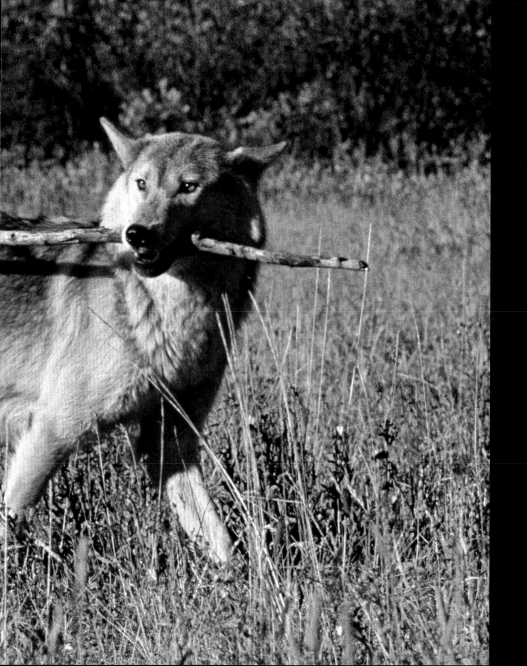

THE

TRAIL

OF THE

WOLF

When the Man waked up he said,
"What is Wild Dog doing here?"
And the Woman said,
"His name is not Wild Dog any more,
but the First Friend,
because he will be our friend
for always and always and always."

—RUDYARD KIPLING,
"THE CAT THAT WALKED BY HIMSELF," *JUST SO STORIES*

Wolves of all ages seem to enjoy playing with newfound objects.

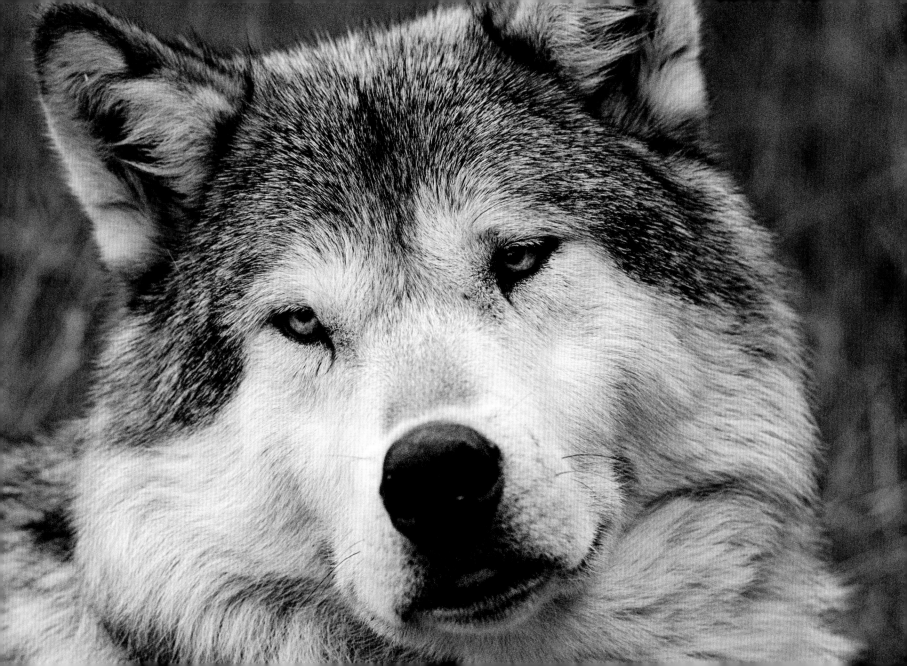

We recognize the face, a broad mask that tapers gracefully into a long muzzle. We have looked into the eyes, bright with curiosity. We understand the messages conveyed through posture: the alertness in a cocked ear, the playfulness of a bow, the confidence and fear equally betrayed by an expressive tail. We can be forgiven for thinking we already know the wolf, for in many ways we already do. Genetics leaves little doubt that domestic dogs, our canine companions, are descended from wolves. But this question continues to intrigue: When and how did domestication happen?

There is something about wolves—a combination of their intelligence, their similarity to dogs, their presence in myth and lore, and their history of persecution—that absolutely captivates the hearts and minds of many people.

Until very recently, the most repeated theory involved wolves that hung around human settlements and dug through our garbage. Eventually, some of these scroungers ingratiated themselves to us and became the dog's ancestors. But a few recent discoveries tell a different story of domestication, one that happened much earlier and more nobly.

A 33,000-year-old canine skull recently discovered in Siberia proved to be that of an early domestic dog. DNA testing revealed that this particular dog was a genetic dead end; none of its progeny survive today. However, that fact doesn't make the find scientifically insignificant: It implies that other dogs were domesticated in other places, at other times. Perhaps the domestication of dogs happened near the Chauvet-Pont-d'Arc Cave in France, where a pair of 26,000-year-old footprints reveals a dog walking next to a human child as a companion. Or maybe it happened in what is now the Czech Republic, where other Paleolithic dog skulls have been unearthed. Or, most likely, it happened in many places, over and over again. Wherever humans and wolves found each other, it seems, friendship was inevitable.

Author Mark Derr has immersed himself in the subject, in the hopes of weaving a unifying theory. In his book *How the Dog Became the Dog,* as well as in several articles, Derr suggests that human domestication of dogs grew not from subjugation but from friendly interspecies socialization based on mutual benefit. "The emerging story sees humans and proto-dogs evolving together: We chose them, to be sure, but they chose us too," writes Derr. "Both wolves and humans brought unique, complementary talents to a relationship that was based not on subservience and intimidation but on mutual respect." He notes that "several scholars have even suggested that humans learned to hunt from wolves," and likewise that "some scholars have suggested that we—dog and human—influenced each other's evolution."

Given the strong loving bonds we share with our dog companions, it is not surprising that growing archaeological evidence suggests that humans befriended wolves—or at least respectfully coexisted with them—long before we domesticated them, and we domesticated them long before we settled into an agricultural life. However it happened, it was clearly to our benefit. The traits that wolves passed on to dogs served us well as we became shepherds and farmers. We capitalized on the wolf's territorialism to create a dog that steadfastly guarded our flocks and property. We put the wolf's superior sense of smell and knack for locating prey to use as trackers and retrievers on our own hunts. We transformed the wolf's skill at harassing and maneuvering big grazing animals into a herding instinct, helping us move our livestock.

The wolf also passed along its most indispensable qualities: devotion to its pack, sociability, and a capacity for learning, communication, and expression. In turning the wolf into the dog, we created the ultimate companion, a faithful friend that can understand our intentions even better than our fellow primates can. Knowing all the wolf bequeathed to our beloved dogs, how strange that we reserve for wolves a special hatred that we hold for no other animal. We brought our domestic dogs along with us, into our fields, pastures, and cities. Wolves are the dogs that stayed behind, favoring their wild ways. Perhaps we can't forgive them for that.

TURNING AGAINST THE WOLF

A culture's attitude toward the wolf generally reflects its economic relationship to it. Native Americans, especially the nomadic hunters of the Great Plains, hold wolves in high esteem, a relationship similar to the kinship that Derr suggests existed between wolves and

hunter-gatherers. The Pawnee identified so closely with the wolf that in Plains sign language, the sign for *wolf* and *Pawnee* are the same.

In many Native American cultures, there was a stigma attached to killing a wolf; in others there was not. The Nunamiut Inupiat of Alaska routinely hunted wolves for their fur and traded the pelts with other tribes. Despite such cultural variations, it's safe to say that in precolonial North America, people at least tolerated and usually respected the wolf as a loyal family animal, a keen hunter, and a bearer of warm fur. Nowhere in Native American tradition do we see any evidence of rancor, rampant villainization, or calls for total annihilation of the species. That required Europeans.

In Europe, Asia, and the Middle East, relations between human and wolf have been strained since we domesticated our first sheep. Then, as now, wolves occasionally preyed on our livestock, hardly surprising given that for eons, the wolf and its prey had evolved in tandem. The better wolves became at hunting, the better deer, caribou, and antelope became at evading them. Then humans started fiddling with the evolutionary clock by turning tough aurochs and nimble mouflon into domestic cattle and sheep. We bred our animals for what we wanted them to provide: work, wool, and meat. We also bred them to

be passive and tractable—qualities that put them at a distinct disadvantage when predators were around.

The wolf's hunting style doesn't help its case. Lacking the power of a lion or a bear, wolves cannot strike with a quick ambush. They pursue prey, surround it, exhaust it, bite its hindquarters, and often seize the animal by the muzzle to bring it down. The animal may die of shock or blood loss, and it isn't always quick. Viewed through the lens of human morality, such behavior has made wolves appear vicious and moblike. However, wolves have limited hunting tools: They have stamina for chasing, jaws for biting, and teamwork.

Intelligent and opportunistic, wolves proved to be cunning adversaries, finding ways of evading us and getting at our livestock. Like many wild animals, wolves posed some danger to humans under very rare conditions, but fear of the animal grew disproportionately to the actual threat. Ancient fables such as "The Wolf in Sheep's Clothing" portray the wolf as a deceitful and treacherous beast that eats children.

Any favorable portrayal of the wolf in Europe showed the animal not as a teacher or a fellow hunter but as a warrior totem. In Norse mythology, the wolf assumes both positive and negative roles, manifesting as the destructive god Fenrir and also as a powerful symbol of

Wolves may travel as far as 20 miles in a day following prey. Moving at about five miles an hour, they can sustain their steady trot for many hours.

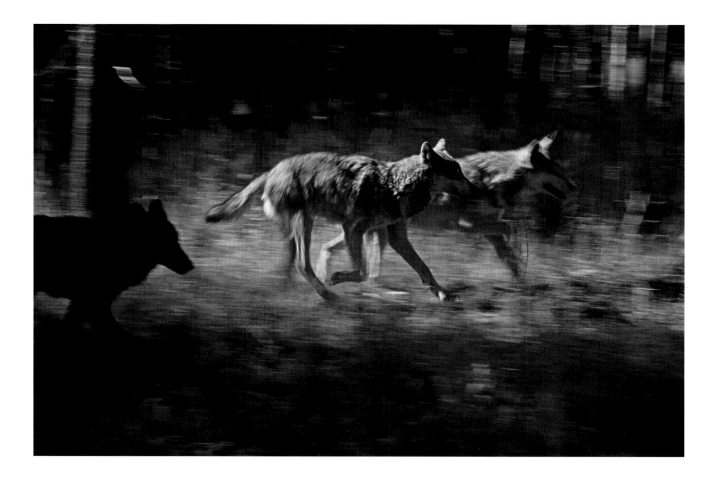

bravery in battle, dedicated to the god Odin. In the mythological history of Rome, twin brothers Romulus and Remus were abandoned and left to die, but a mother wolf protected and nursed them until they were rescued. The twins went on to found the great city.

With the rise of Christianity, wolf symbolism took a decided turn for the worse. The new religion arose and spread primarily in cities, where it reached a population that increasingly envisioned itself as separate from nature. It couldn't have helped that Christians adopted the motif of God the Shepherd. They viewed themselves as the peaceful flock, thus providing the perfect counterpoint to pagan wolf-warriors. In 793, Viking raiders descended upon the peaceful monastery of Lindisfarne in the British Isles like a pack of ravenous wolves tearing into a flock of sheep. One couldn't ask for better symbolism.

Old superstitions found new life in Christian Europe, and, as the writer Barry Lopez notes in his book *Of Wolves and Men,* "Fear of real wolves occasionally bordered on hysteria." In times of war and plague, opportunistic wolves most likely exhumed human corpses, hastily buried in shallow graves. Wide-eyed reports of savage beasts fighting over the grizzly spoils and desecrating hallowed ground all but proved that wolves were attendants of the devil. Europeans distilled their fears of witchcraft, of pagan men and beasts of the forest, into a demonic half man/half wolf—the werewolf—that ran wild at night, killing livestock and sometimes people. Children learned the tale of "Little Red Riding Hood," whose duplicitous villain—eater of grandmothers and little girls—lives in our collective imagination even today.

These concepts were cemented into the minds of English colonists who set sail for the New World in the 17th century. The island the colonists left behind had already been nearly cleared of wolves. All across Europe, extermination efforts were underway, bounties were in effect, and wolf populations were declining, but nothing would compare to the anti-wolf wave that crashed on the shores of North America. If ever there was a combination of circumstances, attitudes, motivations, and justifications for a full-scale war against the wolf, this was the perfect storm.

NORTH AMERICA: FULL-OUT WAR

From the Old World, the newcomers brought sheep, cattle, and a fervent belief in private property. They also brought their fears of chaotic nature and their conviction that the dark, untamed forest was the realm of the devil. They were absolutely certain of their holy duty: to subjugate the land for Christian man's use. It was the perfect symbiosis of

economic ambition and religious justification. The first North American wolf bounty was offered in 1630, just two years after the Massachusetts Bay Colony was established. By the 1800s, a man could make a decent living as a wolf killer for hire.

In 1900, wolf hunter Ben Corbin penned the manual *Corbin's Advice, or The Wolf Hunter's Guide.* Although the book was written well into the wolf's final years in the United States, there is probably no better distillation of the prevailing American attitude toward wolves—or, for that matter, toward the continent's native human inhabitants:

> I can not believe that Providence intended that these rich lands, broad, well watered, fertile and waving with abundant pasturage, close by mountains and valleys, filled with gold, and every metal and mineral, should forever be monopolized by wild beasts and savage men. I believe in the survival of the fittest, and hence I have "fit" [fought] for it all my life . . . The wolf is the enemy of civilization and I want to exterminate him.

This passage is unambiguous. God himself provided this land for us, and any man or beast that stands in our way must be subdued or killed.

The passage also hints at something deeper: pure, pathological hatred.

We don't need words to see how deep this hatred has run; it is evident in our deeds. It wasn't enough just to kill a wolf. Many hunters felt the animal should suffer to pay for its many sins. Trappers would sometimes simply cut off the wolf's lower jaw and leave the animal to starve in agony, or leave out hunks of meat stuffed with nails that would perforate the wolf's stomach and cause a slow death. Ben Corbin himself describes throwing baited fishhooks into wolf dens, waiting for the pups inside to swallow them, and then dragging them out and killing them. It was routine for ranchers, farmers, and wolf hunters to stuff animal carcasses with strychnine. Any wolf that fed on the carcass was sure to be poisoned—as was any coyote, fox, bear, eagle, raven, or other opportunist that chanced upon the bait.

By end of the 19th century, the U.S. government got into the game for keeps. Far from enacting a broad vision of conservation, the National Park Service began as a division of the U.S. Army that was assigned tasks that included ridding new national parks such as Yellowstone of "destructive" animals—namely, wolves. At long last, federal and state governments concluded that they could do the job of wolf extermination far more quickly and efficiently than the bounty hunters could, and, funded by taxes, they launched the final chapter: a scorched-earth campaign of

A wolf pack weighs many different factors when selecting its target. As circumstances change during the hunt, the target may change as well.

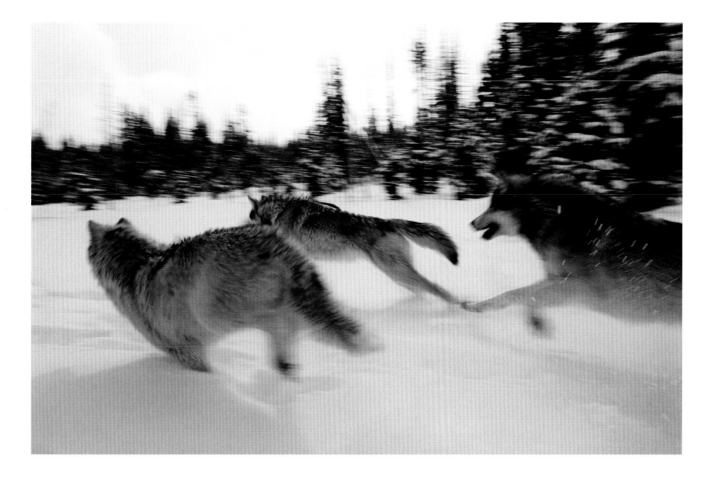

bullets, traps, poison, and even intentionally introduced mange. Vernon Bailey of the U.S. Bureau of Biological Survey called it "the most systematic and successful war on these pests ever undertaken."

By 1900, wolves were gone from the entire eastern half of the United States, save a small population in northeast Minnesota. In Canada, the provinces of New Brunswick, Nova Scotia, and Newfoundland exterminated their wolves around the same time. The wolves of the western United States were gone by the 1940s, except for a few stragglers, with killing of wolves continuing well into the 1970s. Since the *Mayflower* dropped anchor, we have most likely killed more than a million North American wolves.

CHANGING ATTITUDES

Not everyone in North America was of a single mind about wolves and other wild animals. Even as the extermination effort reached a fever pitch, there were those who suggested we might be losing something. Writing in his journal on March 23, 1863, Henry David Thoreau lamented that his Massachusetts woods now felt incomplete. "When I consider that the nobler animals have been exterminated here, the cougar, panther, lynx, wolverine, wolf, bear, moose, deer, beaver, turkey, etc., etc., I cannot but feel as if I lived in a tamed and, as it were, emasculated country," he wrote. "The whole civilized country is, to some extent, turned into a city, and I am that citizen whom I pity."

In the 19th century, much of the justification for killing wolves and other predators was religious in tone: Eradicating these animals was fulfillment of God's plan of taming the dark wilderness. Some, like Thoreau, comprehended the tragedy of a broken ecosystem philosophically before we were able to comprehend it scientifically. And they understood that human beings are not exempt from that tragedy, whether we realize it or not. The human spirit exists not apart from nature but within it. When we cut down the forests and kill the wild beasts, we lose the connection to our own humanity.

One of the last government wolf hunters was a man named Aldo Leopold. Early in his career, he bought in to the concept that removing wolves from the environment was an improvement, thinking, as he said, "that because fewer wolves meant more deer, no wolves would be a hunter's paradise." But as the final wolves were dying in the West, Leopold began to observe the degradation that human acts had wrought upon the land. In his short 1944 essay "Thinking Like a Mountain," Leopold expressed what would soon become irrefutable science:

I have lived to see state after state extirpate its wolves. I have watched the face of many a newly wolfless mountain, and seen the south-facing slopes wrinkle with a maze of new deer trails. I have seen every edible bush and seedling browsed, first to anemic desuetude, and then to death. I have seen every edible tree defoliated to the height of a saddlehorn . . . In the end the starved bones of the hoped-for deer herd, dead of its own too-much, bleach with the bones of the dead sage, or molder under the high-lined junipers. I now suspect that just as a deer herd lives in mortal fear of its wolves, so does a mountain live in mortal fear of its deer.

Leopold and others were beginning to understand that the wolf's presence in nature was not destructive; its removal from nature was. We as a culture are still struggling with this simple concept, but it took root firmly enough to provide the scientific foundation for the reintroduction of wolves. When, after a 70-year absence, a pack of wolves finally formed naturally in Yellowstone, park biologists fittingly named it the Leopold Pack.

Many who did not want to see wolves restored portray the reintroductions of 1995 and 1996 as knee-jerk government actions undertaken to appease bleeding-heart bunny huggers without proper research or planning. In truth, wolf reintroduction had been a topic of discussion since the late 1960s. When the Endangered Species Act was passed in 1973, gray wolves were among the first animals placed on the list. For two more decades, government officials worked with—and occasionally were sued by—ranchers, hunters, and environmental nonprofits as they worked to create a reintroduction strategy. It was anything but knee-jerk.

REINTRODUCTION

On a January morning in 1995, a convoy of trucks lumbered down a Salmon River road toward its end at Corn Creek in the Frank Church-River of No Return Wilderness. Onboard were U.S. Fish and Wildlife personnel, press photographers, an Idaho Fish and Game veterinarian, and several aluminum crates. Inside, frightened eyes peered out at the passing forest. The operation proceeded under tight security. This was the most controversial animal reintroduction effort in the nation's history, and many of the wolves' new human neighbors had vowed to shoot them on sight. Officials carefully hoisted the crates from the truck. The doors lifted, and

three wolves shot out, wide-eyed and frantic. One wolf refused to budge and was dragged into its new home at the end of a snare pole. A photograph of this wolf, snarling and terrified, ushered wolves back into Idaho.

In Yellowstone, wolves were brought to three separate locations. In the hope that they would develop a sense of territory, they were placed in temporary acclimation pens for two months before being released, unlike Idaho's wolves. In 1996, more wolves were released in Idaho and Yellowstone. In total, 66 wolves were released into the Northern Rockies.

Just two weeks after the first Idaho release, the first of the reintroduced wolves was dead. A female called B13F had moved eastward and onto a ranch along the Salmon River. There she was shot. Local officials immediately declared that she had killed a newborn calf. A photograph of the dead wolf lying beside a partially eaten calf began to circulate, tacked up in local bars and gas stations. For ranchers and hunters who had railed against reintroduction, it was instant vindication.

Shooting a wolf in the act of killing a cow was then, and is now, a legal act, but the rancher denied killing the wolf. When federal officials attempted to search the ranch for evidence, the ensuing altercation nearly erupted in violence. Later, a necropsy (an animal autopsy) indicated that the calf had died naturally moments after birth. The wolf had not killed it. At the very worst, she had taken the opportunity to feed on the carcass after the calf was already dead. Ranchers accused the federal government of faking the necropsy to protect their precious wolves. State politicians seized on it as a states' rights issue. People entrenched themselves on whatever side they had already chosen. The event set the tone for where we are today: a vicious cycle of false accusations, political hostility, and senselessly dead wolves.

Looking back on the history of wolves in North America, we can't help but wonder how much progress has actually been made. Powerful and influential special-interest groups representing the hunting and ranching industries routinely publish information that contradicts a century of scientific progress and environmental awareness. One anti-wolf spokesperson routinely offers up eerily familiar sound bites, such as, "If the Devil had an animal, it's the Canadian wolf. It is the most vicious, cruel predator in North America." Posters and bumper stickers refer to the wolf as a "government-sponsored terrorist" and "the Saddam Hussein of the Animal Kingdom." The language and imagery have been updated for the 21st century, but the sentiment is not that different from the writings of Ben Corbin more than a hundred years ago. Today, as in

1900, anti-wolf rhetoric is a mishmash of political and religious jargon that plays directly into contemporary fears and biases.

In 2011, the state of Idaho went so far as to declare a state of emergency in response to the supposedly dire and imminent threat posed by wolves:

> The uncontrolled proliferation of imported wolves on private land has produced a clear and present danger to humans, their pets and livestock, and has altered and hindered historical uses of private and public land, dramatically inhibiting previously safe activities such as walking, picnicking, biking, berry picking, hunting and fishing.

In the nearly two decades since reintroduction, however, wild wolves have injured no one in Idaho—or any of the lower 48 states.

Since the federal government was responsible for reintroducing wolves and—until recently—enforcing laws to protect them, it's hardly surprising that modern-day wolf mythology largely taps into big-government conspiracy theories. Where once the devil lurked in the untamed wilderness, now apparently he lurks within the U.S. Department of the Interior and the U.S. Fish and Wildlife Service. An aggressive misinformation campaign has convinced many people that federal biologists secretly reintroduced a giant, ultra-aggressive sub-species of Canadian wolf that never lived here in the first place. Others claim that wolf populations are exponentially higher than official estimates, and that huge "super-packs" of 25 wolves or more lurk just outside of major towns.

Some hunters make dire predictions that the insatiable wolves will eat all of our game animals—elk, deer, moose—and that once that prey is exhausted, they will move on to small game, then to our pets and children, and, finally, to each other. When official wildlife reports show stable game populations, they are simply labeled as lies. Some even go so far as to claim that reintroduction is a huge conspiracy. As the accusation goes, wolves were brought back intentionally to kill all the game animals. With the game animals gone, there will be no need for hunting. Once there is no need for hunting, the theory continues, the government can repeal the Second Amendment to the Constitution and round up all our guns.

In 1900, killing a wolf was an act of self-assured progress. For many hunters today, it is an act of self-righteous defiance, a lashing

out at an intrusive federal government, at urban environmentalists, and at anyone else perceived as a threat to regional self-determination. As before, the hatred leveled against wolves is so overblown, so disproportionate to the impact wolves actually have, that it borders on the pathological. Wolves aren't just shot; they are mutilated, and their radio collars are destroyed to make it harder for biologists to identify them. Photos of dead wolves are captioned with political taunts and posted on websites, where hunters brag about gut-shooting wolves with small .22-caliber bullets and leaving them to die in agony over several weeks. Trappers have strung traplines as close as possible to national park boundaries, specifically targeting well-known, well-loved, and well-studied packs, abruptly ending decades of research.

As rational human beings, we struggle to comprehend this kind of behavior. What made people spread thousands of tons of poison across the open landscape? What made them risk their own lives and those of their domestic animals for the chance to kill a single wolf? What made us spend thousands upon thousands of dollars to drive wolves to the brink of extinction? What, today, makes some ranchers shake with rage when they speak about an animal that kills dramatically fewer cattle and sheep than bad weather does?

One side effect of this hatred is a fixation on the financial drain that wolves are claimed to represent, with no regard for their potential economic benefits. However, wolves can and do attract serious tourist dollars. In Yellowstone and surrounding communities, wolf tourism alone is estimated to inject more than $35 million a year into the local economy. During that brief period when the Basin Butte Pack thrived near Stanley, Idaho, tourists were staying in hotels, eating in restaurants, buying gas, and paying for other recreational services. Vacationers spend substantial time and money to visit wild places and see wild animals. Clearly, wolves are a novel attraction. Local entrepreneurs who try to capitalize on the presence of wolves can now find themselves shunned and even threatened in their own community for daring to cast the despised beasts in a positive light.

Economic shortsightedness, fear, superstition, political regionalism, and ancient grudges held since the dawn of civilization: All play off one another to create the terrible—and nonexistent—beast of our nightmares. Meanwhile, the real animal gets lost in all the noise. Wolves are neither demon nor deity. They are smart, social, family-oriented creatures that work together for survival. Indeed, they are quite a bit like us.

Wolves seem unaffected by the bitter cold, tucking their noses under their tails when they sleep. Their warm winter coats are made up of two layers of fur: the top layer of guard hairs, which give the coat its color, and a thicker insulating layer that keeps heat in.

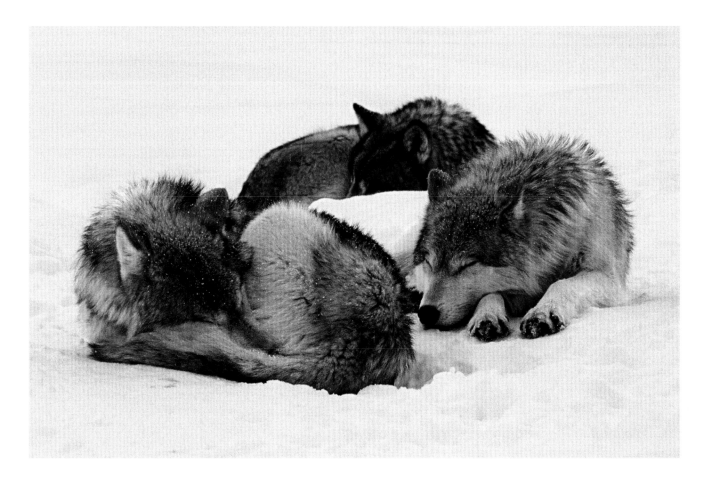

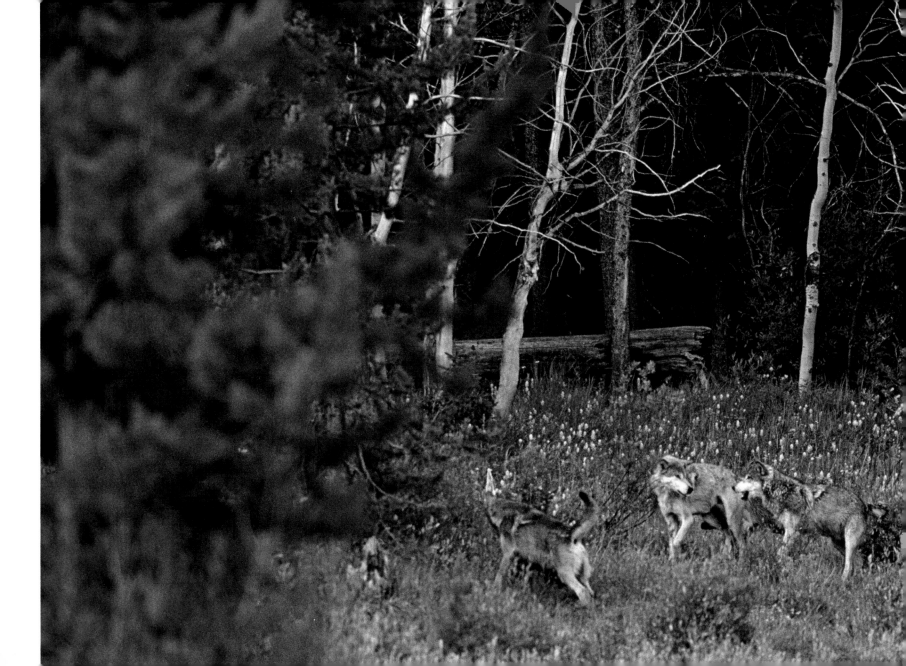

The enclosure in which the Sawtooth Pack lived was the largest of its kind and encompassed a wide range of natural wolf habitats, from subalpine fir groves to meadows to spring-fed creeks. Here the wolves enjoyed water, shade, hiding places, and open spaces for games of chase. The advantage of having so much space was that the wolves were able to just be themselves.

The West is where we belong,
the Wolves and I,
and my old friends now dead.
May we meet again
on the Other Side.

BLUE HORSE, LAKOTA WARRIOR,
RECORDED IN 1906 BY NATALIE CURTIS

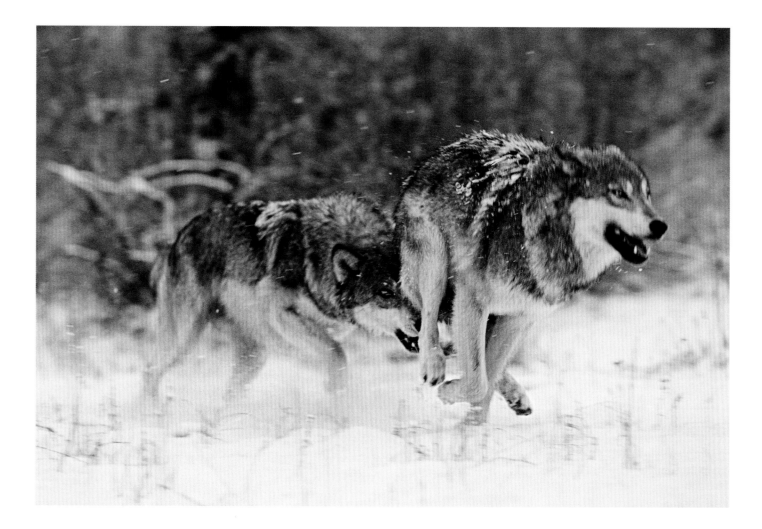

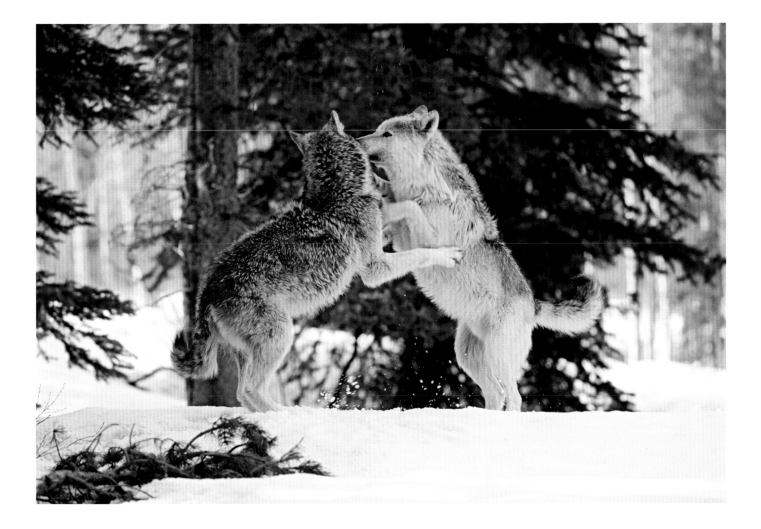

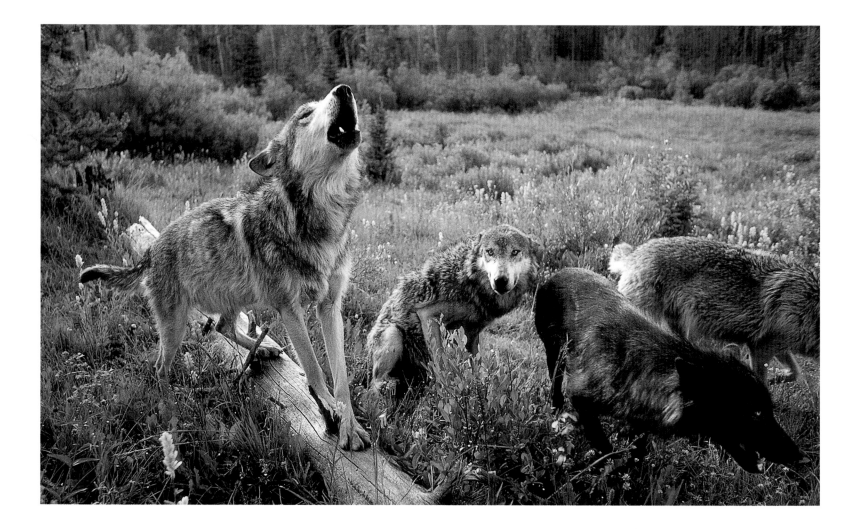

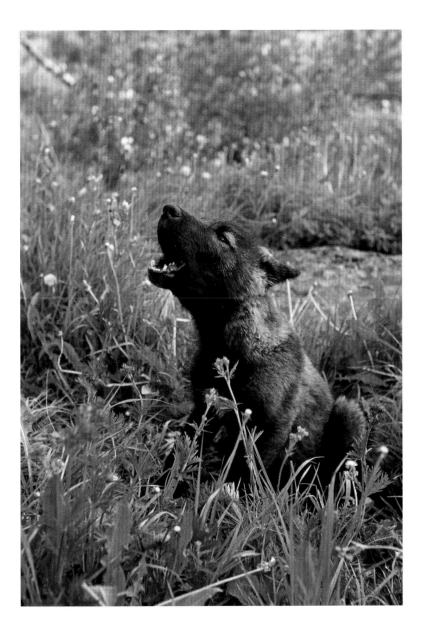

Preceding page (130): Surprisingly, after chasing Lakota (the omega), Kamots (the alpha) would often turn around and encourage his brother to chase him in return.

Preceding page (131): Matsi and Lakota had a special friendship, often playing and relaxing together apart from the rest of the pack. Matsi genuinely seemed to enjoy Lakota's company, and Lakota appeared overjoyed to have a friend.

Opposite: Group howls were risky times for Lakota, here in the center. He always kept his tail tucked, his shoulders hunched, and his head lowered as he tried to make himself as inconspicuous as possible.

The adult wolves knew when their howl was over, but young, enthusiastic pups often did not. Caught up in the excitement, they would often let out a final "oop" before realizing the song was over.

Opposite: Kamots was a marvelous leader. The confidence he had shown as a pup blossomed into a calm benevolence that was a joy to witness. There was an alertness about him not present in the other wolves, and his face often bore an expression that, at least to people, registered as concern. When a strange sound rang out in the surrounding forest, Kamots was the first to prick up his ears and trot off to investigate. Perhaps the rest of the pack did not behave this way because they knew they didn't need to. They knew Kamots would keep them safe.

The brothers and sisters of the wolf's
ancestors are the ones who came over
to the campfire to join our ancestors
and became our most loyal pets.
The wolves' ancestors are the ones
who refused to come to the campfire
and we have never forgiven them for that.

DAYTON DUNCAN, *THE NATIONAL PARKS:
AMERICA'S BEST IDEA*

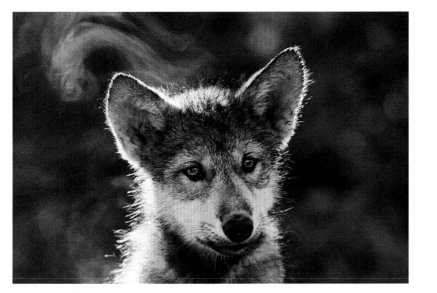
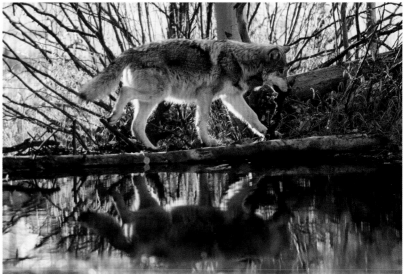
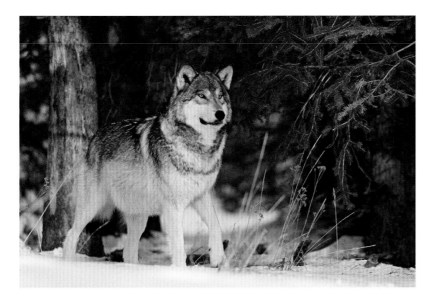
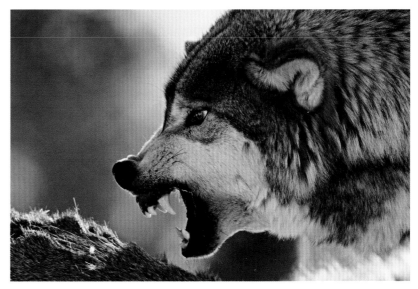

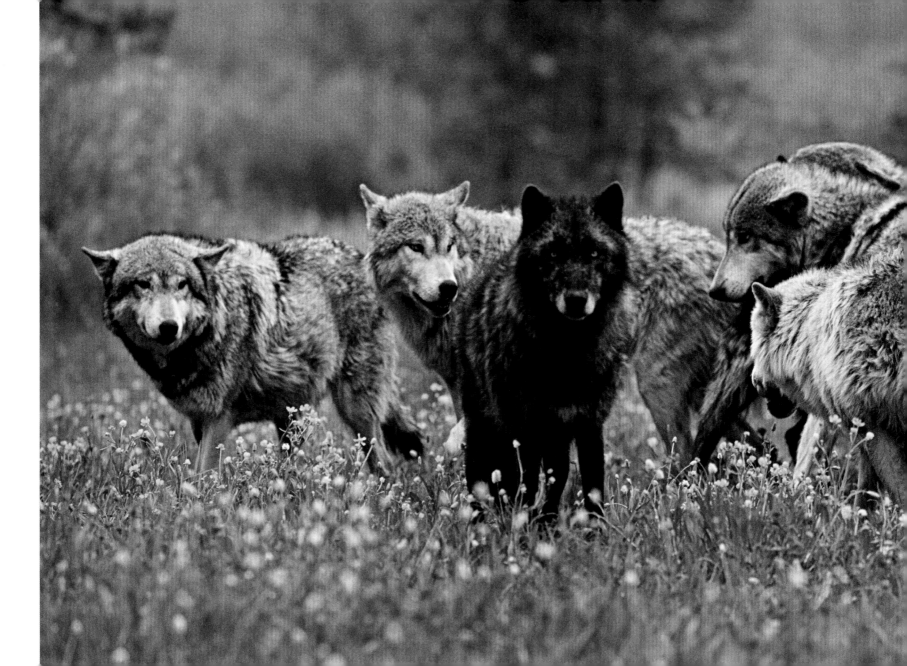

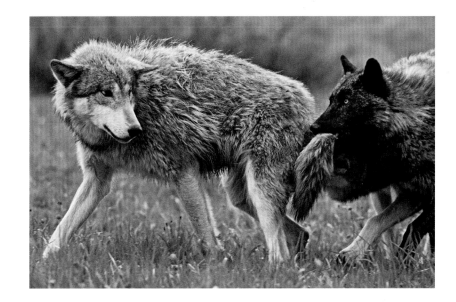

A wolf pack may trail a herd of elk, caribou, or other large prey for days before making its move. During this time, the wolves are already hunting—assessing the herd and looking for an animal that displays any sign of weakness.

We have doomed the wolf not for what it is, but for what we have deliberately and mistakenly perceived it to be—the mythologized epitome of a savage, ruthless killer—which is, in reality, no more than a reflected image of ourself.

FARLEY MOWAT, *NEVER CRY WOLF*

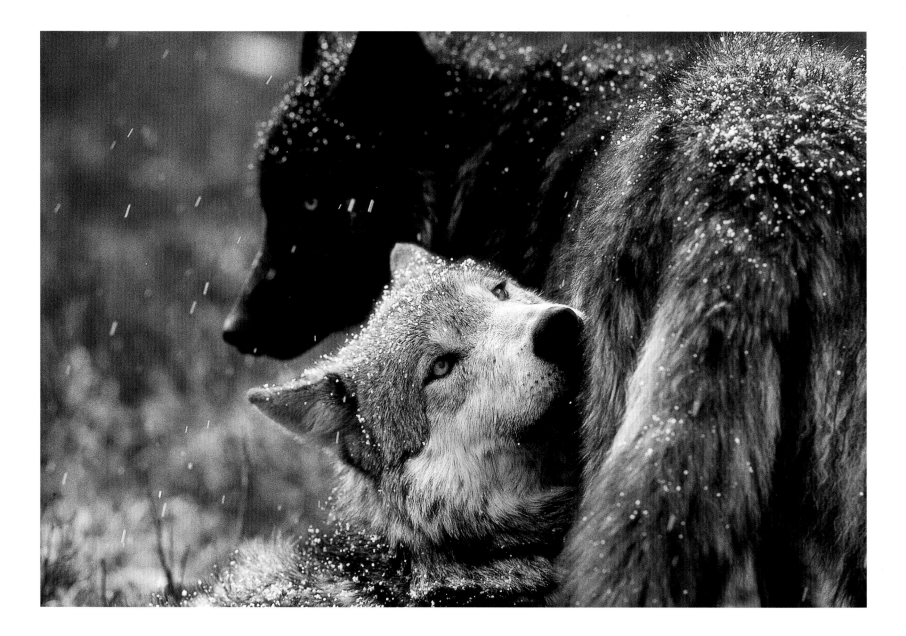

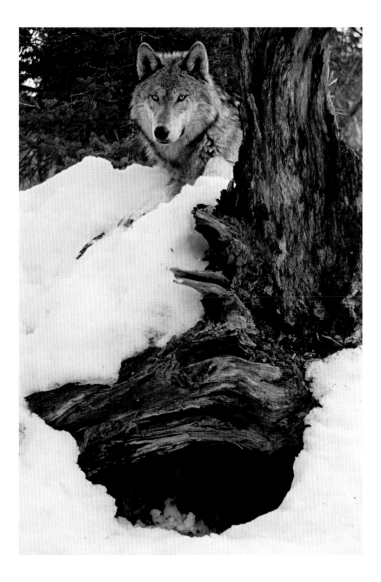

Opposite: It is common behavior in a wolf pack for the alpha pair to be the only pair to mate. It keeps the numbers in control, for too many wolves in the pack, especially pups, would be a liability. Many hungry mouths and not enough hunters mean they could all suffer.

The other wolves in the Sawtooth Pack were very excited about the birth of new pups, but for the first few weeks only their mother had contact with the newborns. When Chemukh gave birth to pups in the Sawtooth Mountains, the rest of the pack gathered outside the den, quivering with excitement, cocking their heads at the chirps and squeals coming from below. Here, Lakota stands guard over the den.

Pups are usually born as winter gives way to spring, in a litter averaging four to six pups. They are born blind and toothless, barely able to crawl, nestled safe in a den their mother has dug for them, often the same den the pack has used for generations.

Opposite: The pups idolize the adult wolves in every way. They walk exactly where the adults walk, sniffing whatever flower they sniff, chewing whatever bone they chew, and mimicking their every move. In this manner, knowledge passes down from the older wolves to the younger wolves as they assimilate into the adult hierarchy, usually in their second year.

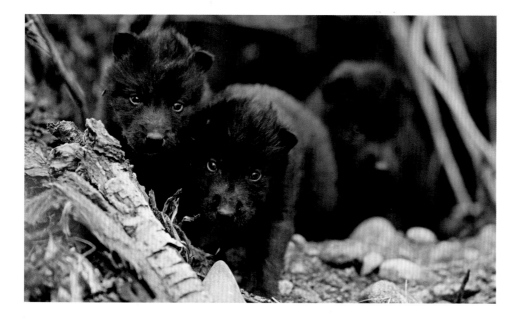

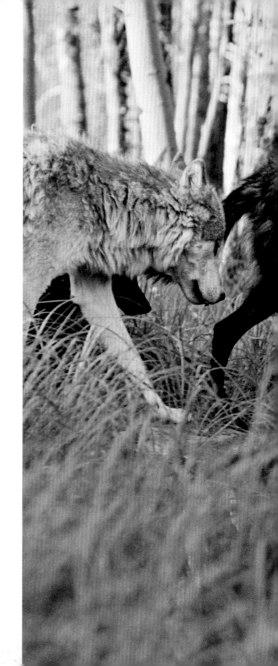

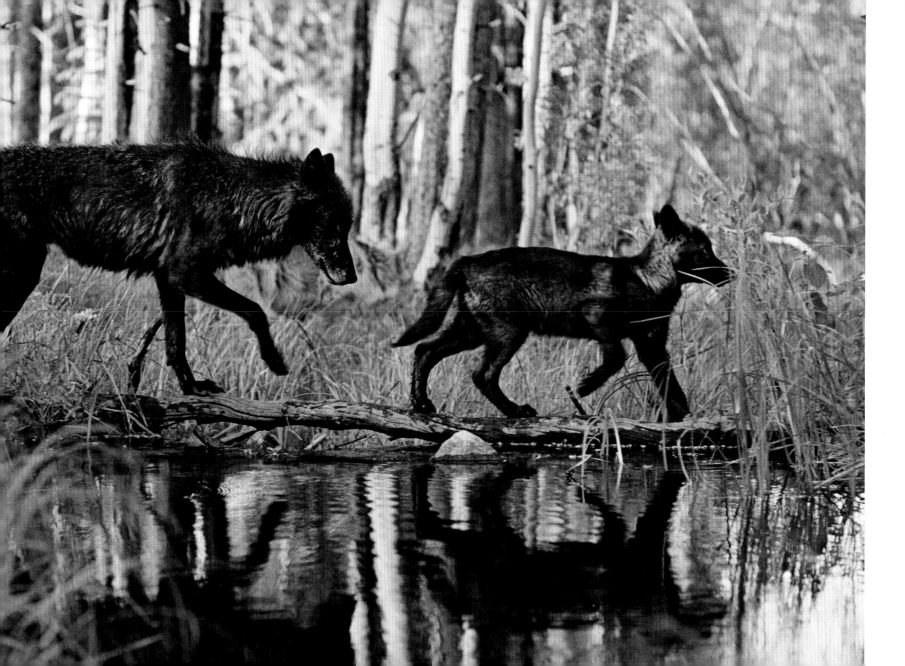

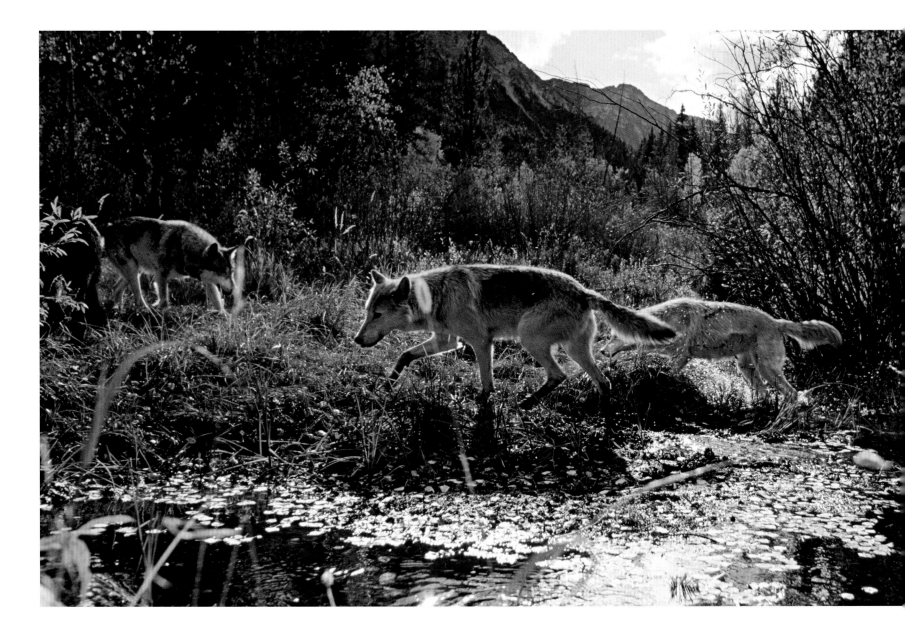

A wolf pack, or family, is a cooperative social unit. Its structure and operation grow out of the need to hunt efficiently and safely, thus giving the wolves the best chance of success. Although wolves will individually hunt mice, voles, and other small game, they generally hunt in groups when taking down larger prey.

They were not nomadic beasts,
as is almost universally believed,
but were settled beasts and the possessors
of a large permanent estate with very
definite boundaries . . . clearly indicated
in wolfish fashion.

FARLEY MOWAT, *NEVER CRY WOLF*

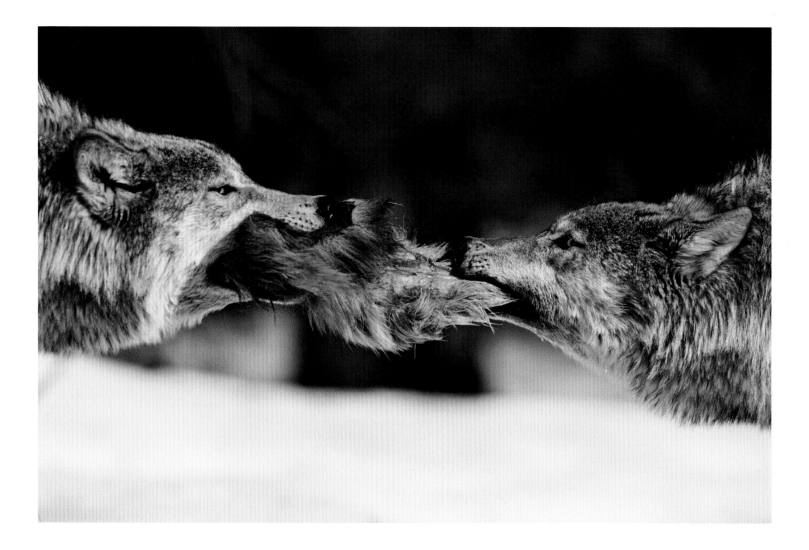

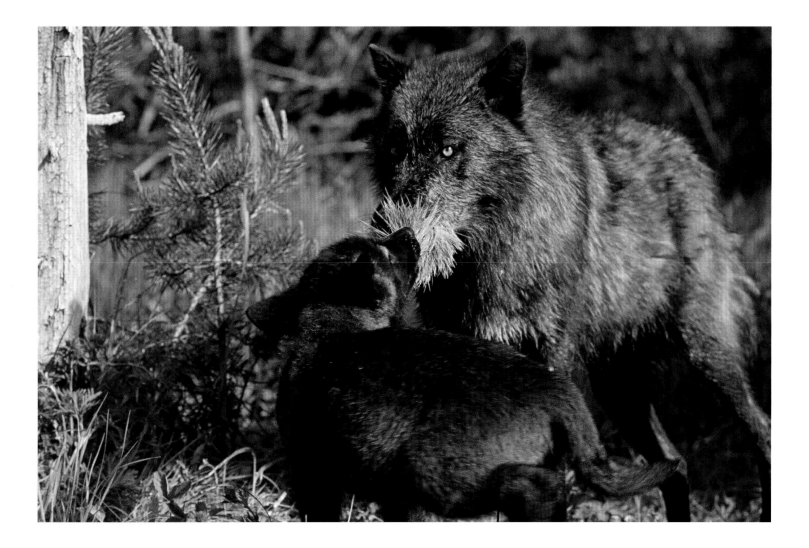

Preceding page (146): As yearlings, Kamots and Lakota had a close, affectionate relationship. Their very different roles as alpha and omega were always clear, but that didn't stop them from playing together.

Preceding page (147): Chemukh and her pup, Piyip, play tug-of-war with fur from the remains of a meal. Pulling like this strengthens teeth, jaws, and muscles.

Opposite: A wolf pack is an extended family, wholly devoted to one another. It is bound together by a common purpose and, it seems at times, a common mind.

Amaguk is like Nunamiut. He doesn't hunt when the weather is bad. He likes to play. He works hard to get food for his family. His hair starts to get white when he is old.

BARRY LOPEZ, *OF WOLVES AND MEN,* QUOTING
AN OLD ALASKAN ESKIMO MAN ON THE PARALLELS
BETWEEN WOLVES AND HIS PEOPLE

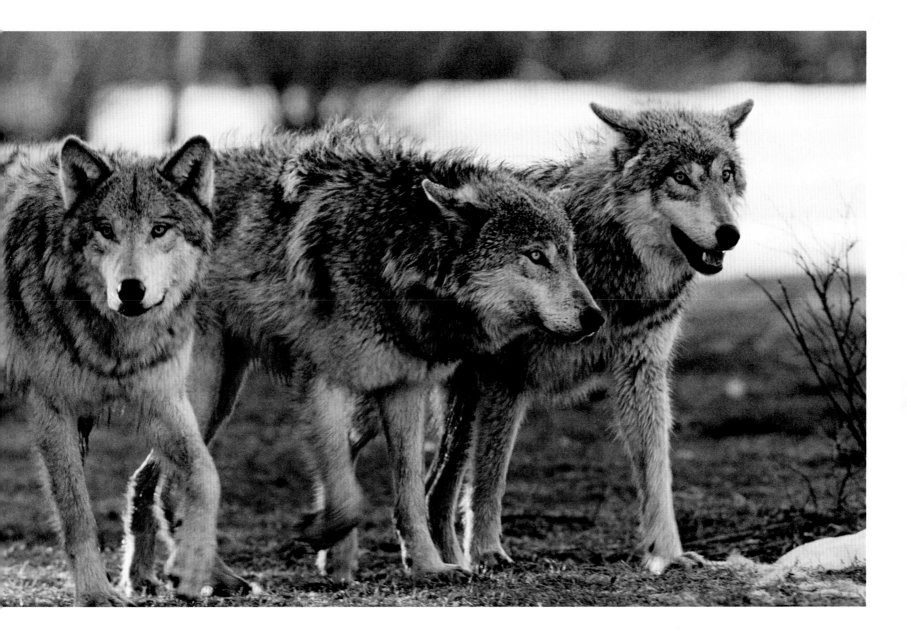

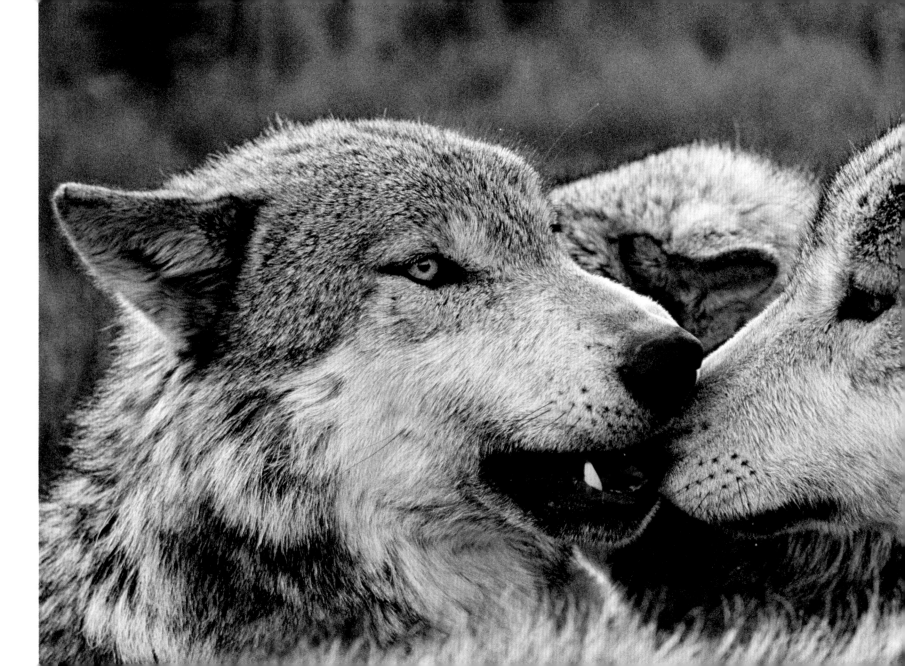

Often the wolves would carry on a spirited conversation that sounded more like Chewbacca from *Star Wars* than anything else we could compare it to.

Great numbers of wolves
were about this place
& verry jentle.
I killed one with my spear.

CAPTAIN WILLIAM CLARK, MAY 29, 1805,
FROM HIS JOURNAL OF THE LEWIS AND CLARK EXPEDITION

TACKLING THE MYTHS

Myth: Wolves are dangerous to people.

Reality: Wild wolves are generally afraid of people and avoid them. Along with other large animals like moose, cougars, and bears, wolves can be dangerous to people. However, incidents involving wolves are exceedingly rare. Over the past 100 years in North America, there have been only two cases in which wild wolves reportedly killed a human being. To put this statistic in context, also in North America, bears have killed at least 35 people since 2000, and, since 1990, cougars have killed nine. In the United States, domestic dogs kill approximately 30 people every year.

Myth: Wolves kill many cattle and sheep.

Reality: According to the U.S. Department of Agriculture, more than six million head of cattle live in Montana, Idaho, and Wyoming, the three states where the vast majority of wolves in the West live. U.S. Fish and Wildlife reports for those states show that in 2011, wolves killed 180 head of cattle, or 1 cow out of every 33,666. In the same three states, 835,000 sheep live. U.S. Fish and Wildlife reports show that in 2011, wolves killed 162 sheep, or 1 in every 5,154. However, because these losses are unevenly distributed, they can take a toll on a single producer.

Myth: The wolves that were brought back to the West are supersize and more aggressive than those who lived there before reintroduction.

Reality: Gray wolves on average weigh between 85 and 115 pounds. The Rocky Mountain gray wolf is now, and always was, the same wolf living along the Canada-U.S. border. Like all wildlife, wolves are totally unaware of invisible political boundaries.

Myth: Wolves are killing all the elk and deer.

Reality: Elk, the primary prey of wolves in Wyoming, Montana, and Idaho, have recently been holding steady in number. In fact, since wolves were reintroduced in 1995, the number of elk has substantially increased. But wolves have made elk more alert to danger and more challenging to hunt, causing resentment among some hunters.

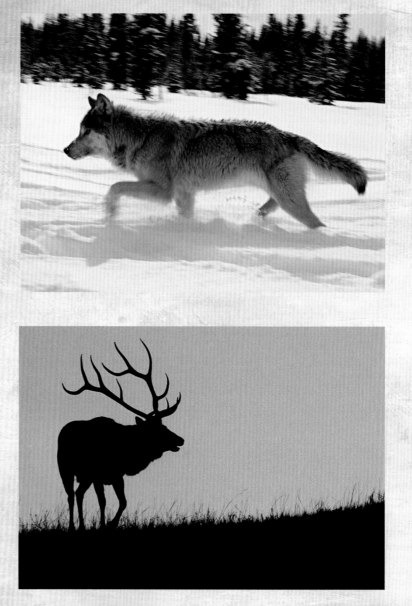

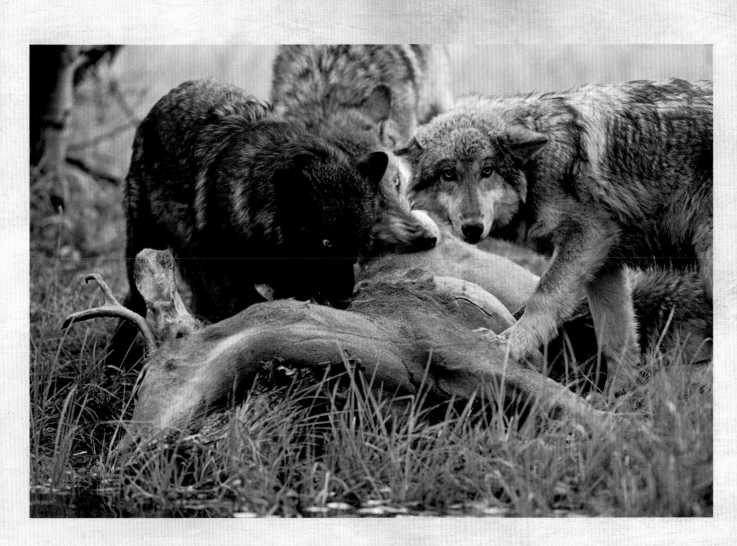

Myth: Wolves kill for sport.

Reality: It is often assumed that wolves kill their prey, eat part of it, and leave the remains behind. This is not true. Wolves almost always eat the entire animal, returning to their food repeatedly, sometimes over weeks and months, especially when food caches are critical for winter survival. Wolves are also wary and alert, easily chased from their kill if other predators or people approach. If wolves are chased off, other animals benefit by feeding on the carcass. In addition, the behavior of their prey affects how wolves respond. Instead of fleeing from danger, as deer and elk do when confronted by a predator, sheep often run in circles, an unnatural reaction in the wild. This elicits a prey response in wolves and other predators and can lead to the killing of multiple animals.

THE HUNTING CONTROVERSY

When people hunt and trap wolves, packs are often broken up into smaller, dysfunctional groups. Based on our experiences with the Sawtooth Pack, the alpha leader is frequently the first to investigate disturbances in his territory. Alphas are also more apt to be killed as the largest "trophy animals." Diminished packs, lacking the knowledge and leadership of experienced members, may turn to livestock for food, forced to find prey that's easier to kill.

When small packs hunt, usually at least one adult stays behind with the pups, putting pressure on fewer hunters that are not as capable of taking down large prey. The remaining pack members are also at a disadvantage when defending their kill from other powerful predators. Grizzly bears and other large predators often succeed in taking over a carcass. This forces the wolves to locate another animal and make another kill, putting more pressure on elk and deer.

Over the years, hunters have contributed extensive funds to the restoration and conservation of habitat and wildlife. The legacy of ranching has helped preserve the open lands of the West, and the proud tradition of ethical hunting has been passed down through generations to this day. But treating any key member of the ecosystem as vermin; indiscriminately poisoning wildlife; and utilizing leghold traps, snares, and ATVs to run down animals are in direct conflict with the proud, ethical tradition of hunting in America.

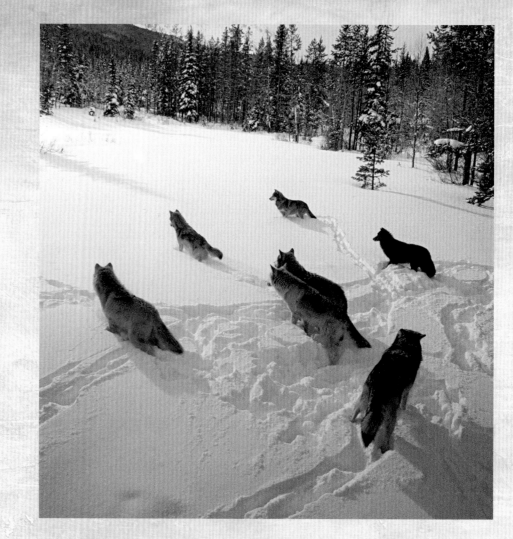

Hunting for food is an effort that involves the entire pack. Different animals take on different roles: selecting prey from the herd, tiring the animal, and bringing it down. The loss of key members with specific skills leaves crucial gaps in knowledge passed down through generations.

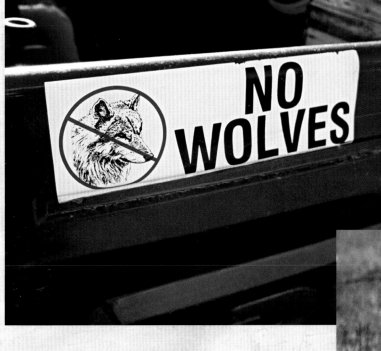

Bumper stickers used to further anti-wolf hysteria are usually based on misinformation or unfounded fear and hatred of wolves.

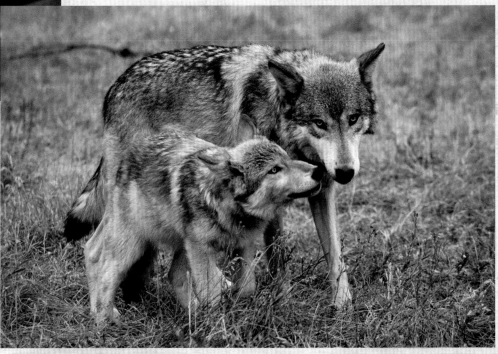

Young wolves begin to learn the art of hunting from older, more experienced pack members, first watching and then participating in the hunt.

RANCHING SOLUTIONS

The vast majority of wolves live on the national forests and other public lands of the West—the same lands commonly used for livestock production. With predators and livestock sharing the same land, conflicts can arise. Although their statistical impact is minimal, wolves can present real challenges to ranchers. By using both traditional and innovative methods of keeping domestic animals separated from wolves, coexistence is possible. The result is fewer dead cattle and sheep—and fewer dead wolves.

The modern range rider keeps vigilant watch over livestock while monitoring wolf packs and other predators. Because wolves often use the same den every spring, well-informed ranchers who know these locations keep livestock away from conflict. The collaring of wolves and the use of radio telemetry also assist range riders and field biologists by revealing the movement of resident wolves.

An unfortunate consequence of ranching on the open range is that livestock frequently die by any number of natural causes, especially weather exposure, disease, and birthing complications. Whenever possible these food sources should be removed. Ranchers also monitor unhealthy livestock that become easy targets for predators. The use of guard dogs and night watchmen provides added protection for the herds and flocks, while birthing corrals with electrified fencing offer protection for newborn animals and nursing mothers.

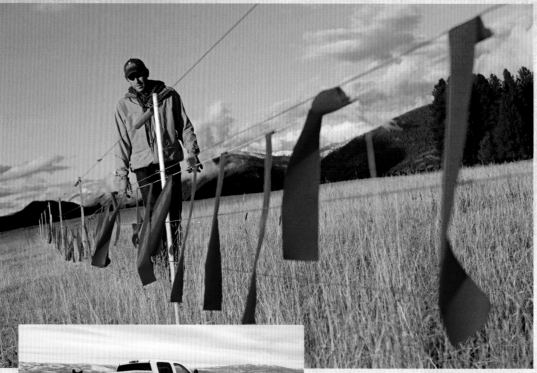

For generations, traditional methods like fluttering flags, or fladry, were used to protect livestock on the range. These portable methods have been updated with electrified fencing.

The presence of animals that died from natural causes draws predators into areas with livestock. When possible, ranchers can help keep wolves and all other scavengers away by removing the carcasses of dead livestock instead of leaving them on rangeland.

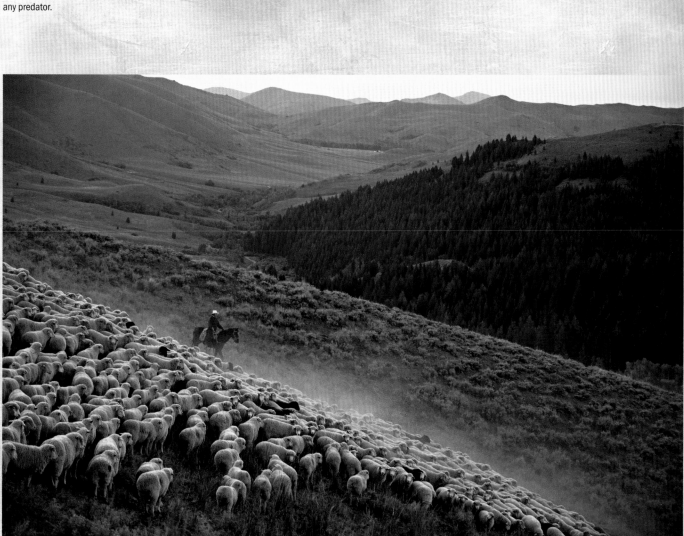

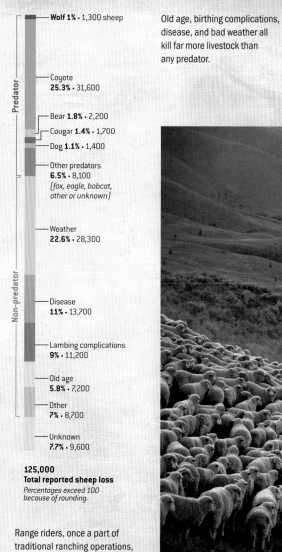

Wolf 1% · 1,300 sheep

Coyote
25.3% · 31,600

Bear **1.8%** · 2,200

Cougar **1.4%** · 1,700

Dog **1.1%** · 1,400

Other predators
6.5% · 8,100
*(fox, eagle, bobcat,
other or unknown)*

Weather
22.6% · 28,300

Disease
11% · 13,700

Lambing complications
9% · 11,200

Old age
5.8% · 7,200

Other
7% · 8,700

Unknown
7.7% · 9,600

Predator

Non-predator

125,000
Total reported sheep loss
*Percentages exceed 100
because of rounding.*

Old age, birthing complications,
disease, and bad weather all
kill far more livestock than
any predator.

Range riders, once a part of
traditional ranching operations,
are again being used to monitor
the movements of predators and
livestock on the open range.

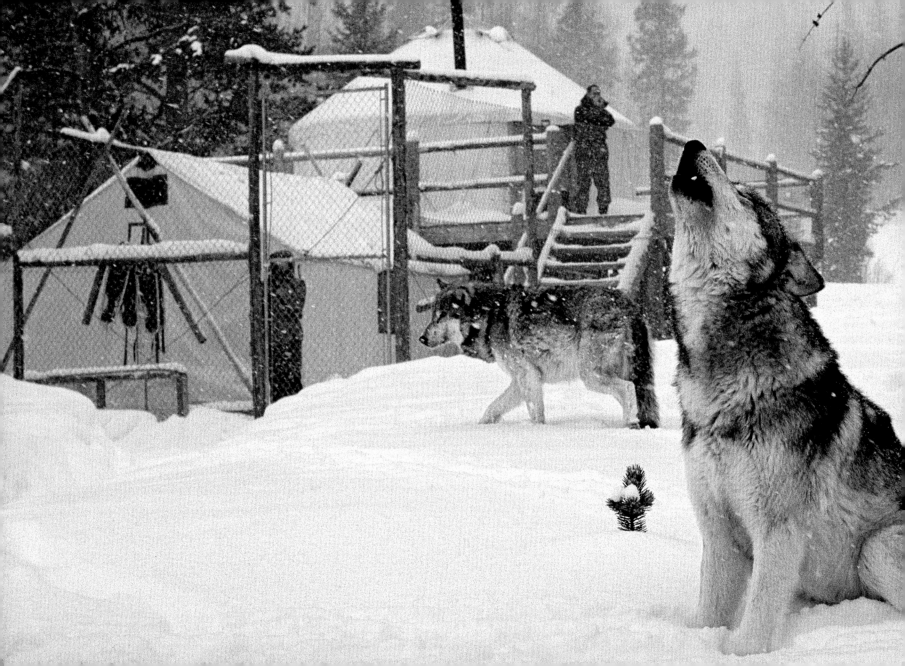

LIVING

WITH

WOLVES

*The wolf is neither man's
competitor nor his enemy.
He is a fellow creature with
whom the earth must be shared.*

—L. DAVID MECH, SENIOR RESEARCH SCIENTIST
FOR THE U.S. DEPARTMENT OF THE INTERIOR'S
U.S. GEOLOGICAL SURVEY

Living so close to the Sawtooth Pack gave us a unique opportunity
to observe the wolves' social behavior.

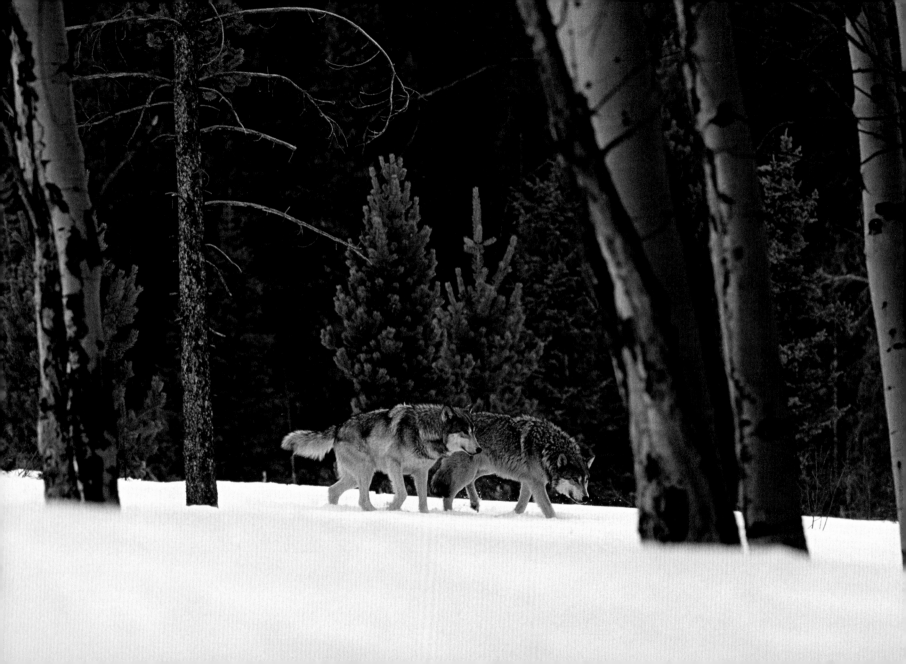

On April 14, 2011, the United States Congress made a radical and unprecedented move. For the first time in the 37-year history of the Endangered Species Act, the legislative body removed an animal from that list. That animal was the gray wolf. Until then, delisting was a laborious process, requiring lengthy scientific review and a consensus of government agencies. The wolf now stands as the lone exception. It's a stretch even to say that Congress voted on the issue; the delisting itself never came up for a vote. Instead, the fatal bit of legislation was intentionally buried deep within the federal budget bill: It was attached as an unrelated rider.

After observing the behavior of the Sawtooth wolves for so long, we have come to believe that the bond a wolf has to its pack is certainly as strong as the bond a human being has to his or her family.

While furious debate and news coverage focused on the debt ceiling, the wolf quietly lost its federal protection in Idaho and Montana. The new law paved the way for further state-by-state delisting. There was no debate, no consensus, no input from scientists. There was only politics.

There had been earlier attempts to get the wolf off the endangered species list, but conservation groups had successfully sued, and courts had been compelled to uphold the Endangered Species Act. The politicians who wrote the rider into the budget bill had learned from these mistakes. The language of the 2011 delisting included a mandate that it "shall not be subject to judicial review"—meaning the issue couldn't be sent back to the courts.

The response in the western states was immediate. Left to manage its own wolf populations, Idaho wasted no time in declaring the wolf "recovered" and launching the most aggressive wolf hunt since the early 20th century. Idaho Fish and Game sold 43,300 wolf-hunting tags to people hoping to kill one—or several—of Idaho's 1,000 wolves. In most of the state, the season lasts an astonishing seven months of the year, and even longer in some areas. Wildlife Services, the federal agency in charge of

dealing with "problem wolves," shot any wolf accused or suspected of killing livestock. By the spring of 2012, one year later, Idaho's wolf population had been cut in half. Politicians in Montana were only slightly more restrained, opening a limited hunting season in 2011. Even so, of a population that began the year at 566, 230 wolves were killed by hunters, ranchers, and Wildlife Services. Many hunting and ranching organizations thought that was nowhere near enough. They successfully pressed for the introduction of trapping. One group paid a $100 bounty for each dead wolf.

Even in states without legal hunting seasons, wolves did not fare well. In Washington, poachers effectively wiped out the famous Lookout Mountain Pack, the only pack confirmed to be living in the Cascade Range. Following the lead of the western states, representatives in Minnesota and Wisconsin established hunting seasons as well. Wyoming is poised to adopt the most aggressive wolf plan of all: It would allow wolves in 83 percent of the state to be shot on sight as vermin at any time of year, with no license required.

The battle has always had everything to do with political control and nothing to do with wildlife. Earlier, in 2010, Idaho's governor, C. L. "Butch" Otter, ordered Idaho Fish and Game officials to stop enforcing federal protection of wolves, essentially declaring wolf poaching an unpunishable offense. Otter and others have proposed reducing the wolf population to near 150 wolves, just above the threshold that would warrant renewed federal protection under the Endangered Species Act. The extremists know where they want this to end: not total eradication, but close enough.

Politicians, government agents, ranchers, and hunters often use the word "management." When hunters are permitted to kill wolves all 12 months of the year, that is called "management." When Wildlife Services gets in a helicopter and opens fire on a pack that may or may not have preyed on livestock, that is also called "management," or lethal control. It follows some simple premises: Fewer wolves mean fewer problems; killing wolves deters them from attacking livestock; and removing wolves unilaterally benefits game animals like elk. Unfortunately, none of these premises has a foundation in what we know about wolf biology and behavior. In practice, they prove tragically flawed, but they are the basis for every official policy concerning wolves. Currently, in western states, hunting and lethal control, whether carried out by Wildlife Services or by private hunters, are by far the primary official "management" methods used to kill wolves.

We hope that this is a temporary backlash. Beyond the political posturing, intentional misinformation, and online nonsense, moderate voices remain. These voices speak of science, a willingness to adapt, and a desire for coexistence. Wolves were reintroduced for sound reasons: to bring back America's top predator and to restore valuable ecosystems to their proper balance. Those who work most closely with them believed that wolves can coexist with the traditions and livelihoods of America's ranching and hunting communities. They—and we—are convinced it can be done.

WOLVES AND LIVESTOCK

We would not have been able to live with the Sawtooth Pack, to amass a wealth of observations and experience, and to produce our films and books were it not for cooperation from local ranchers. They allowed us to cross their land to reach our wolf camp. On many occasions, they visited us during our work because they were drawn by curiosity—and, perhaps, that timeless human-canine bond. When we think of the American West, with its wide-open emptiness, independent spirit, and rugged lifestyle, it is a West that ranching culture has helped shape.

Ranching is a part of our collective heritage. It is unrealistic and impractical to expect the ranching community to adjust immediately to a brand-new set of rules. However, much of the land that ranchers use—tens of millions of acres—is public land, where human interests and uses blend with the needs of wildlife. The vast majority of wolves in the American West live in national forests—public land, much of it open to use by ranchers. If we are to share the landscape with wolves, people will need to adapt and to learn. Ranching methods that were practiced in the absence of wolves cannot be sustained in their presence.

There is no denying that wolves are predators, and predators sometimes eat sheep and young cattle. According to the USDA, more than six million head of cattle live in Montana, Idaho, and Wyoming, the three states where the vast majority of wolves live in the West. U.S. Fish and Wildlife reports for those states show that in 2011, wolves killed 180 head of cattle, or 1 cow out of every 33,666. In the same three states, 835,000 sheep live. U.S. Fish and Wildlife reports show that in 2011, wolves killed 162 sheep, or 1 in every 5,154. According to these figures, wolves account for far less than 1 percent of the damage, yet they receive 90 percent of the attention and anger. Bad weather, disease, and birthing complications kill vastly more livestock than all predators

Wolves are extremely wary of humans, and they have good reason to be so cautious. Approximately one million of their kind were exterminated as American settlers moved west. Renewed hatred has accompanied today's reintroduction of wolves.

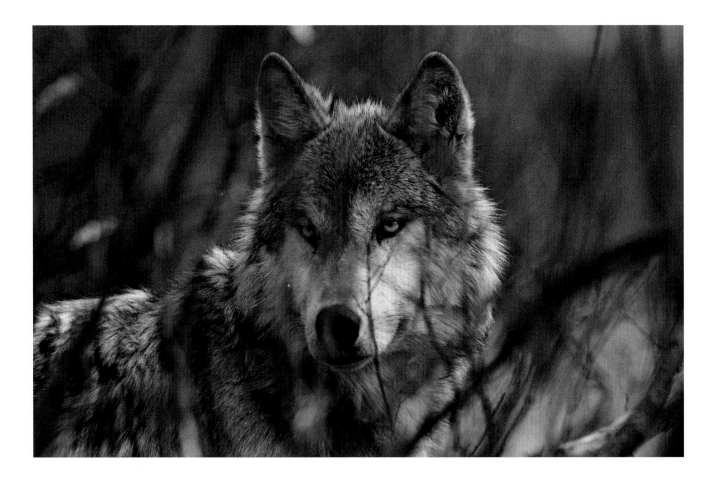

combined, yet no one is suggesting that we try to change the weather to save a few sheep. A problem pack may take several animals from the same herd, however, delivering a significant financial blow to just one producer. Still, such cases are isolated within a region where millions of sheep and cows roam free.

So far, our way of dealing with livestock loss has been primarily reactive: a two-pronged approach of lethal control and compensation (paying ranchers for livestock loss). Both were introduced in an attempt to soften the financial impact caused by wolves and to mollify frustrated ranchers. Quite simply, when a livestock producer loses an animal to a wolf, he gets paid for it, and the wolves suspected of doing the damage are killed. In order to authorize lethal control actions and trigger a payment to a rancher, an official "trapper" from Wildlife Services, a branch of the USDA, must look at the carcass and declare it an official "wolf kill." While this dual approach was intended to increase public acceptance of wolves, it has not. In some situations, it even increases animosity.

Until 1997, Wildlife Services went by the more descriptive name of Animal Damage Control. For 26 years, Carter Niemeyer worked for Wildlife Services, serving as the organization's wolf management specialist for the final ten years of his tenure. Over his career, he inspected many dead cattle and sheep. He also had to kill several wolves. This unique position placed him squarely in the middle of the wolf controversy, taking fire from all sides. In his memoir *Wolfer*, Niemeyer acknowledges the predicament of Wildlife Services trappers:

Trappers were, and still are, stationed near their work, and in the West that means they live in rural areas where there are ranches. The trappers' kids attend the same schools as the ranchers' kids; everyone shops at the same grocery store. Trappers, understandably, don't want to get crossways of their ranching neighbors, so if a rancher thinks a wolf killed his cow, the trapper isn't going to argue with him . . . The Animal Damage Control form barely contained room for a trapper to write a comment regarding a livestock death scene. But who needs room to write when the answer to a dead cow is simple: Wolves killed it.

Few Wildlife Services trappers are biologists; they are valued more for their skill at killing wolves than for their expertise in forensics. Niemeyer, with his biology degree and lifelong experience in taxidermy, often came

to unpopular conclusions about how a cow or sheep died. He became known as the guy who wouldn't rubber-stamp "wolf kill" on every death report. For that, he received the ire of many influential people in the West, but he also earned a reputation as an unbiased expert.

Niemeyer and an increasing number of biologists believe that compensation programs and excessive lethal control are not solutions but self-perpetuating problems. When a livestock death is wrongfully attributed to a wolf, it starts a chain reaction of negative results. First, a rancher gets paid with money that should have gone to a legitimate case—hardly the best use of tax dollars. Next, official statistics are skewed, and wolves get blamed for killing more livestock than they actually do. Finally, wolves die to pay for the crime. From the standpoint of those ranchers who abuse the system and don't want to see wolves back in the first place, this is a win-win situation. From the standpoint of good management practice, it's a disaster. It fails for one simple reason: It is all reaction and no prevention.

Many ranchers are willing and eager to adopt preventive solutions. Unfortunately, there are other ranchers who find excuses not to implement proven techniques that might keep their animals safe. Insisting that these techniques are ineffective or impractical, they block any

progress toward coexistence with wolves. But their neighbors are proving them wrong.

Working with biologists and field technicians, many ranchers are utilizing an array of alarms and other technological solutions to deter wolves from preying on livestock. Strips of red ribbon strung on electrified wire, called turbo fladry, have been shown to deter wolves for up to 60 days—long enough to provide extra protection when young calves and lambs are most vulnerable.

But wolves are clever creatures, and trying to fool them may not be the answer. We will serve ourselves better by incorporating the wolf's intelligence and social nature into our approach. Wolves learn, and they teach the other wolves in their pack what they know. Current management practices often ignore this crucial fact about wolf behavior. Instead, we've fallen into the unfortunate mind-set of thinking in terms of "good" wolves that stay away from our property and "bad" wolves that eat livestock, often as repeat offenders. Of course, there are no good or bad wolves; there are only wolves that do what wolves do. Wolves typically target their natural prey rather than livestock, but they are resourceful and opportunistic carnivores. They may harass an animal they've never encountered before, testing it as potential prey. If that animal responds

by running, they may pursue it and take it down. Hungry wolves may also take a chance by scavenging on an unfamiliar carcass. The key is reducing the temptation for wolves to try something new.

LIFE AND DEATH ON PUBLIC LAND

Consider a scenario based on current ranching practices: In early summer, a rancher drives his cattle out onto national forest land, where he leaves them behind to graze and move at will. When he returns to check on the herd two or three weeks later, he finds two or three dead calves. The rancher knows there are wolves in the area, and, due to centuries of preconditioning, his first impulse is to blame them. Maybe wolves did prey on a calf or two, or maybe they didn't; the carcasses have been picked on by every predator and scavenger in the area, including wolves, so it's impossible for anyone other than a forensic biologist to identify the initial cause of death for sure. Following the path of least resistance, Wildlife Services makes an official report declaring the incident a "wolf kill" and then proceeds to trap or shoot the "bad" wolves.

Suppose those wolves were indeed guilty. Wildlife Services will kill a few, but not the entire pack. Perhaps this selective removal will rid the pack of any future inclination to hunt livestock; perhaps it won't.

The surviving wolves may stay in the area, or they may travel hundreds of miles in search of a new mate or an adoptive pack. Perhaps they have learned that killing livestock is a good way to get food. They may take that knowledge with them wherever they go, possibly teaching new pack mates and offspring how to do it. The offending wolves never saw a human being among the cattle, so they have not necessarily learned to associate cows with people. The partial slaughter of their pack has probably not taught them to avoid livestock; canids are smart, but they're not abstract thinkers. One wouldn't scold a dog two weeks after it got into the trash and expect it to make the connection. Ultimately, this reactive course of action potentially makes the problem worse. There may be temporarily fewer wolves, but those that survive may pair up and have offspring. The learned behavior of calf killing can spread to other areas and other wolves.

Wouldn't it be better for cattle, wolves, and people to have a few stable healthy wolf packs living in the area but avoiding livestock? Wouldn't it be better for dispersing wolves that create new packs in new areas to teach their offspring that cattle and sheep *do not* make good prey? This is entirely possible with one simple change: increased human vigilance, a return to more traditional methods, dating from a time when predators

were an accepted reality. These methods are, in fact, still in practice in much of the world.

The Mountain Livestock Cooperative, a partnership between ranchers and biologists, is working to modify ranching and grazing practices, not only to increase economic benefits to ranchers, but also to reduce public acrimony directed at wolves, bears, and other large carnivores. Spearheading the effort is Timmothy Kaminski, a biologist who has been at the forefront of wolf recovery and reintroduction since the 1970s. He sums up the problem succinctly: "Our current way of dealing with wolf-and-livestock conflicts is reactive, 'an eye for an eye.' That approach is completely disconnected from what we know about the behavior of wolves and their prey."

This new approach merges the rancher's animal husbandry expertise and the biologist's knowledge of large carnivore behavior. The process begins by treating cattle and sheep as if they are a natural prey species like moose and elk. By studying the predator-prey dynamic in the wild, Kaminski and his colleagues have gained a better understanding of what makes livestock vulnerable. In Kaminski's experience, nearly 99 percent of cattle killed by wolves are calves and yearlings, vulnerable due to their behavior more than their size.

Wolves hunt by chasing. When prey flees, it initiates a predatory instinct in wolves. Like wild bison, domestic cows and bulls usually stand their ground, but calves and yearlings often panic and run when harassed. That panicked response triggers an instinctive pursuit, building an association with livestock as vulnerable prey. Kaminski and the Cooperative's ranchers protect multiple herds, ensuring that wolves never reach this stage.

In the summer, when the participating ranchers graze their cattle on public land, range riders, like cowboys of old, move from herd to herd, providing a human presence every one to three days. When consistently applied, this proactive emphasis on vigilance plays directly into wolves' capacity for learned behavior. Disrupting their predatory behavior can achieve the desired result: wolves don't think of livestock as predictable food sources.

When livestock die from any number of causes, the carcass should ideally be removed to keep it from attracting predators. But summer ranges can be vast, making removal problematical. However, where Kaminski and his colleagues ride regularly, carcasses are more readily located, allowing the herd to be moved away from possible conflict with predators.

In the 1990s, wolves were captured in Canada and reintroduced to central Idaho and Yellowstone National Park. They were originally protected by the Endangered Species Act of 1973.

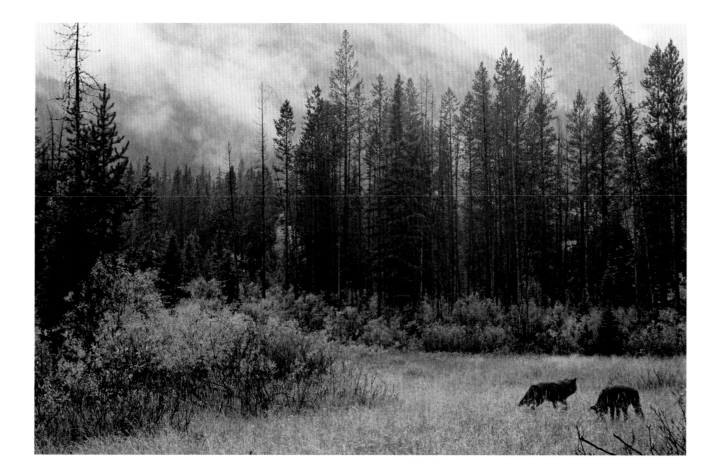

If wolves focus on the herd, vigilant cowhands greet them aggressively with pursuit, harassment, and bear-bangers and screamers—essentially fireworks that frighten off predators—or warning gunshots. This interrupts predatory behavior, giving the wolves a negative learning experience. Summer is also when wolves raise their pups. Ranch managers and riders learn where local wolf packs have their dens and rendezvous sites and avoid putting livestock in such areas of heightened risk.

All of these methods teach wolves to do what we want—stay away from livestock—and make it difficult for them to do what we don't want. Evidence suggests that with continual repetition of these techniques, wolves remember and retain their wariness, associating livestock with people. Kaminski says he periodically watches wolves pass directly through a herd of cattle without initiating any predatory behavior, just moving on to somewhere else. The long-range hope is that wolves will carry what they learn across generations, teaching future pack mates to hunt their natural prey and not livestock. If these efforts succeed, it will be to the benefit of wolves, ranchers, and all Americans who believe in the importance of having wolves on their public land.

There is a catch to this system. It only works if wolves aren't killed every time a dead calf or sheep is found. As Kaminski puts it, "Dead wolves don't learn anything, and removing them from problem areas does little more than create space for new wolves to begin the problem all over again. We need to work with people toward new methods of management that create fewer problems, not more."

THE PROBLEM WITH HUNTING

Prior to 2011, killing wolves was the responsibility of Wildlife Services and other government agencies. With the gray wolf removed from the endangered species list, anyone with $20 to spare could hunt a wolf legally in Montana and Idaho. Other states are already following suit. Hunting, especially when trapping is also permitted, proved to be an effective tool for reducing the wolf population. Should that be the only goal? Timmothy Kaminski's conclusions about dead wolves and disrupted packs are valid whether a bullet or a leghold trap breaks up a wolf pack's society. Five scattered, inexperienced, and desperate wolves may cause more problems than a stable pack of 15.

In observing the Sawtooth Pack, we saw that Kamots, the alpha, was the most vigilant member, the first to investigate strange sounds or other perceived threats. By doing this, an alpha male or female takes on the risk of becoming a target. Moreover, hunters in search of a trophy

will target the biggest animal they see, and that's often the alpha male. The loss of an alpha or other pack elders can have a devastating effect on a wolf pack. They are the keepers of knowledge and the teachers of the younger generations. When too many adults die, the link to the pack's culture is severed. Quite often the pack will disintegrate. Internal battles for dominance and breeding rights may erupt, or pack cohesion may simply dissolve in the absence of a breeding pair.

The consequences of this event can reverberate far beyond the single pack. Young wolves would normally stay with their pack for one or two more years. Cut adrift, they may form splinter groups or disperse and find mates. In either case, they may lack a complete education, having never been taught to locate and take down large prey that has evolved to evade them. Even if they succeed, they may not be able to defend their kill from other predators. While five or six wolves could fend off a 500-pound grizzly, two or three wolves might lose a meal—and then they will need to kill again. Desperation forces these wolves to seek out easy quarry that they might otherwise have learned to avoid: namely, domestic cattle and sheep. More livestock get eaten, more wolves end up dead, and the cycle continues—all because of an ill-informed attempt to control the wolf population.

Nevertheless, wolf hunting will likely remain legal, at least in the near future. Despite its dubious value as a management tool, it gives people a sense of control. If we continue to think of wolves in terms of numbers, however, and not as complex social groups or families, and if we believe that a reduction in wolf population will achieve a parallel reduction in livestock loss, we will be disappointed. We will continue to lose more livestock than we need to, and wolves will receive more hatred than they deserve.

Many hunters in the West swear that the reintroduced wolves have decimated the resident elk. Hunting organizations make dire predictions about the impending crash in the elk population. Official game counts tell a different story. A 2007 survey in Montana revealed that, although certain areas have indeed seen a reduction in elk, the overall population increased from 90,000 to 120,000 in the first 12 years after wolves returned. In 2011, the statewide estimate was 140,613 elk.

Skeptical hunters greet such reports as "more government lies." After all, when they head out to that favorite hunting spot, often they find no elk. The presence of wolves has changed the elk's behavior—the animals have reverted to the way they acted before we killed off so many of their natural predators. They've become more alert and

Today, the presence of wolves has changed the grazing patterns of elk herds. With the return of the wolf, elk have become more alert and elusive. Elk no longer loiter in open meadows.

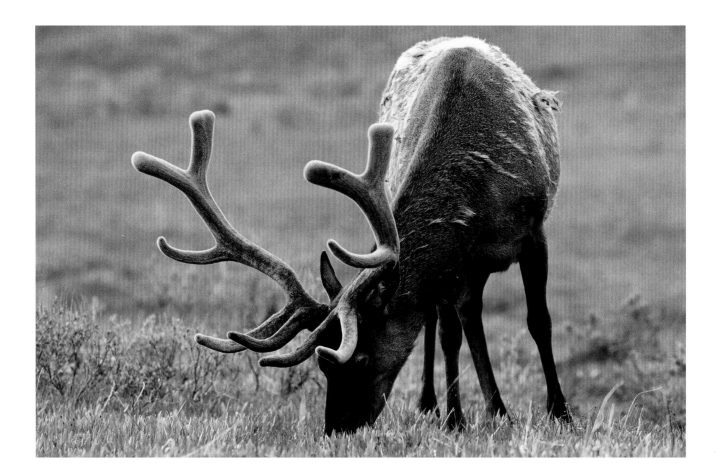

elusive. They're no longer apt to loiter in open meadows for hours without a care. Now they move, hide in the forest, and retreat to the high ground.

In addition to human hunters, wolves are the most significant predator of elk in North America—and the only predator to have this effect on the herds. As coursing predators, wolves chase and move the herds in a way that ambush predators such as bears and cougars do not. It speaks to the eons-long relationship that has fundamentally shaped both species. When wolves are around, elk behave the way they evolved to behave: in sync with their environment.

We're only just beginning to realize the massive repercussions of this simple change. Until recently the debate has focused on the damage—real or imagined—that wolves do, but we've been ignoring the other half of the equation.

The presence of wolves has the power to transform and to restore entire ecosystems.

WOLVES, ASPENS, AND MAYFLIES

Usually we think of the landscape and the animals within it as two separate things. When we view them this way, it's easier to justify the removal of a few species for our perceived benefit. If we just yank out creatures we don't like, the system will chug along better than ever. The more we learn, however, the more we realize that's a delusion. In truth, the landscape and its wildlife are inseparable.

Cristina Eisenberg, a conservation biologist at Oregon State University, studies the relationship between wolves and their ecosystems. In her book *The Wolf's Tooth*, she describes an autumn trip to a riparian meadow in eastern Glacier National Park, Montana—an area used heavily by elk in winter but devoid of wolves. She speaks of the aspen trees attempting to grow there:

These sprouts' zigzagging trunks and scarred stems showed that elk were hitting them hard. Many had become stunted from overbrowsing, growing in thickness but not in height. They faced possible death from unchecked herbivory. The only new stems growing above browse height occurred amid refugia created by the hawthorn thickets armed by vicious three-inch spikes. With the exception of these sheltered stems, those that had lasted beyond a couple of seasons had blackened trunks, heavily scarred by decades of elk gnawing.

Eisenberg describes another region in Glacier National Park, a similar riparian area, but here wolves had crossed over from Canada, claimed the territory, and dug a den:

> The trees around the den grew vigorously, with many saplings reaching beyond browse height—the height an elk can reach to eat, usually six and a half feet. However, these trees also showed evidence of moderate elk herbivory . . . Upon closer inspection the browse pattern here suggested that, rather than standing around eating aspen sprouts to the ground, the elk had exercised restraint, perhaps taking one bite or two, looking up to scan for wolves, moving on, and then stopping to browse some more.

Eisenberg is describing "the ecology of fear." The wolves' influence on elk reaches far beyond just taking a few of their number. The mere possibility of being eaten, the need for vigilance and caution, elicits a profound change in herd behavior. The reason some hunters have a harder time finding a trophy elk to shoot is the same reason those aspen trees near the wolf den had a chance to grow. Instead of eating saplings to the quick, the elk are browsing and moving on, one small sequence in what biologists call a "trophic cascade"—a chain reaction that ripples through the ecosystem.

The study of trophic cascades is relatively new to biology, but the message is already becoming clear: When one element of an ecosystem is altered, the cumulative effects of the change may not be immediately apparent, but they can be far-reaching and profound. Other major forces such as drought or wildfire have a severe impact, but less obvious changes, such as the introduction of a non-native plant, matter, too. Eisenberg has found the presence or absence of wolves to be one of nature's more powerful driving forces.

Nowhere has the phenomenon of trophic cascades been studied more closely than in Yellowstone National Park. In less than two decades, the region went from having no wolves at all to having one of the highest concentrations of wolves in the world. Biologists always expected that the returning predators would impact other fauna, but in certain areas the changes were far more profound than anticipated. In some areas along stream banks that were previously heavily impacted by elk, willows and aspens began to return. When their favorite food and building material reappeared, beavers flourished, engineering

broad wetlands that attracted frogs, swans, and sandhill cranes. Stream banks once picked clear of vegetation and eroded by hooves erupted in wildflowers, which nourished insects, which in turn fed songbirds that nested among the thick willows. The water below now became shaded, cool, and clear—a better habitat for aquatic-born insects.

Scientists are just beginning to map how wolves fit in to ecosystems and how they work with other forces, such as fire, to create trophic cascades. Such massive changes don't occur everywhere wolves reappear, but in these highly studied areas where biologists have tried to connect the dots, the path of connections leads them to wolves. When a native cutthroat trout gulps down a larval mayfly, how distant that event seems from the terrestrial dance of top predator and large prey, yet the two are inextricably entwined. This is not some abstract sense of oneness; it is a measurable fact.

The presence of wolves in the landscape also affects fellow predators. When wolves were absent from Yellowstone and nearby Grand Teton National Park, coyotes multiplied. Although similar, the two species fill different predatory niches. Coyotes prey heavily on rodents and pronghorn antelope fawns. Wolves, on the other hand, seldom prey on pronghorn when there's bigger and slower prey around. With no wolves and too many coyotes, the number of pronghorn dropped sharply. Coyotes were also estimated to have been eating 85 percent of the mice in certain regions of Yellowstone.

When the wolves returned, they immediately began to compete with coyotes for territory, driving the smaller canids away or killing them outright. (Considering that coyotes take a far greater toll on sheep than wolves do, perhaps wool growers should take note of how well wolves keep coyote populations in check.) Coyotes, like elk, appear to have changed their behavior in reaction to wolves. They have become less solitary and more social—more wolflike—sticking together in larger packs, likely for protection. As the two species struck a balance, the coyote population declined and the pronghorn recovered. The rodent population rebounded as well, and soon biologists started counting more raptors, foxes, and weasels—all smaller predators that rely on rodents for food.

For every animal wolves kill, they feed a dozen more. When wolves bring down their prey, the prize eventually belongs to the entire ecosystem—from bears to wolverines to ravens to shrews, to the very soil and the plants that grow there. Not long ago, we held the notion that wolves existed only to consume—to terrorize and to take. How ironic to realize they are one of nature's greatest providers.

Human hunters often imagine that our species can, and should, usurp the environmental role of wolves and other predators. But hunters don't give back to the ecosystem the way wolves do. Human hunters target the healthiest and most robust of game, but odds are wolves will target a more vulnerable animal that can be brought down with less risk—usually the youngest and the oldest, the injured, and, crucially, the sick.

Chronic wasting disease can sweep through and decimate populations of elk, deer, and moose. Wolves not only remove diseased animals, but their presence also keeps the herds moving and less densely packed, reducing the disease's opportunity to spread. Ultimately, wolves do not necessarily increase or decrease a prey population; they stabilize it. They remove the unhealthiest animals and sharpen the senses of those that remain. Over time, this guides the prey's genetic selection. The herd becomes stronger and freer of disease. It is less likely to overgraze and overbrowse its own resources, and it is less apt to suffer wild fluctuations in population—less likely to end up, as Aldo Leopold said, "dead of their own too much."

The incredible changes brought about by the return of this single predator, the wolf, show that all creatures, no matter how insignificant, have a similar power. Trophic cascades can occur from the top down or the bottom up, radiating in all directions from all things. Wolves work in the same manner as other ecological forces, such as fire and drought, sending energy rippling through ecosystems, creating healthier communities. At the same time wolves were being removed from the American West, fire suppression became a common management practice. Fire creates a surge of nutrients and growth in aspen. Thus, aspen rely on both fire and wolf predation on elk to stay vigorous and resilient. Just as the restoration of wolves reverberates in the life of a mayfly, the destruction or restoration of a single plant or insect works its way into the life of a wolf. As Cristina Eisenberg puts it, "No species is truly redundant because all contribute to an ecosystem's ability to function efficiently . . . Although we don't know why we need each species of chickadee or spider, we are likely to find out later, when it's too late, why it's wise to save all the pieces, including those."

All species, all things, truly are linked, and wolves and other large predators exert a great influence on their environment. When wolves return to a region, they alter the population, distribution, and behavior of the other creatures living there—plant and animal—and in doing so they change the landscape itself. Like sunshine, rainfall, and wildfires, wolves are forces of nature that enrich the land. That is a gift we all share.

The return of wolves to the places where they once lived has had a revitalizing effect throughout ecosystems, increasing populations of countless other species, from birds of prey to pronghorn antelope, aspen trees, and even trout. Because of their important role, wolves are recognized as a keystone species.

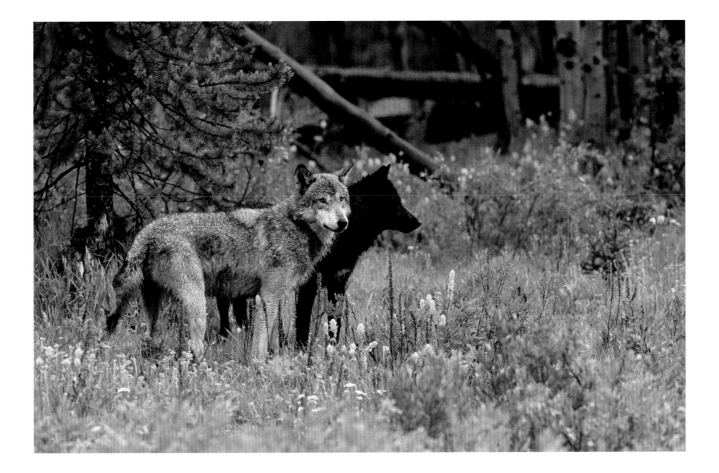

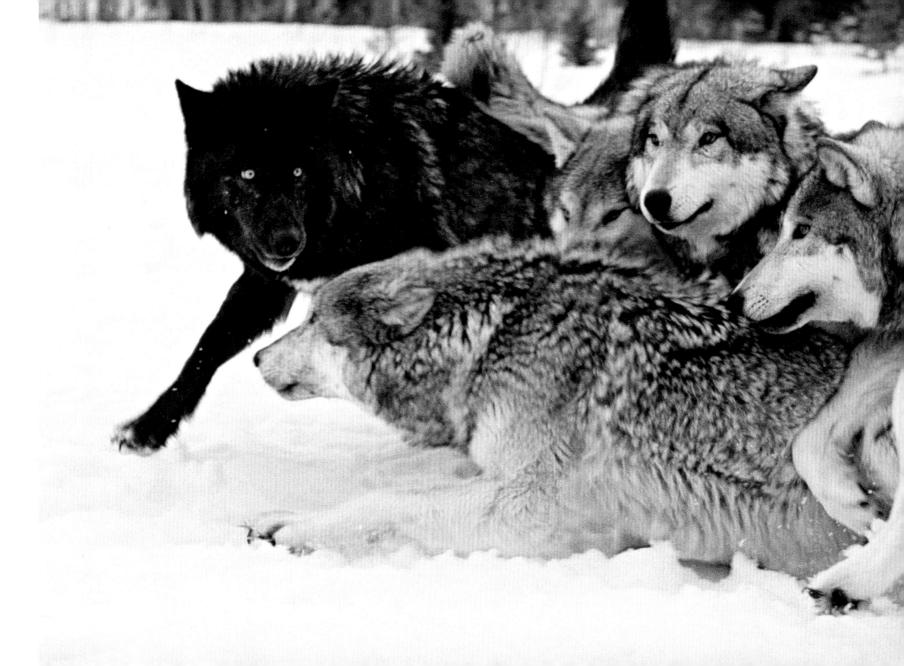

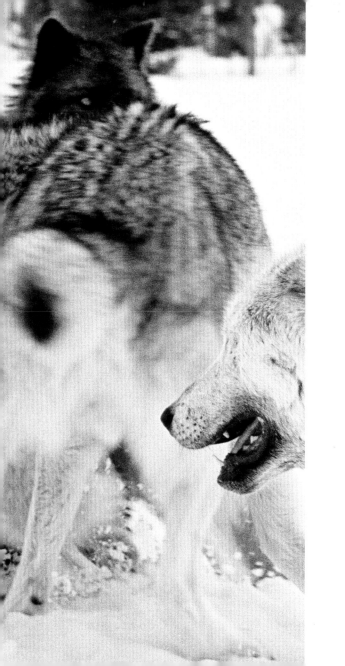

Often, the pack would form a mob around the hapless omega. These attacks on Lakota, here at the bottom of the pile, would distress the beta wolf, Matsi, who had formed a friendship with the omega. Matsi is watching the situation from the right. Sometimes Matsi would bodycheck the aggressors and stop the fighting. In this case, however, Lakota sank to the ground and worm-crawled his way out of the ring.

For the strength of the Pack
is the Wolf,
and the strength of the Wolf
is the Pack.

RUDYARD KIPLING, *THE JUNGLE BOOK*

We need another and a wiser and perhaps a more mystical concept of animals . . . We patronize them for their incompleteness, for their tragic fate of having taken form so far below ourselves. And therein we err, and greatly err. For the animal shall not be measured by man. In a world older and more complete than ours . . . gifted with extensions of the senses we have lost or never attained, living by voices we shall never hear. They are not brethren, they are not underlings; they are other nations, caught with ourselves in the net of life and time.

HENRY BESTON, *THE OUTERMOST HOUSE*

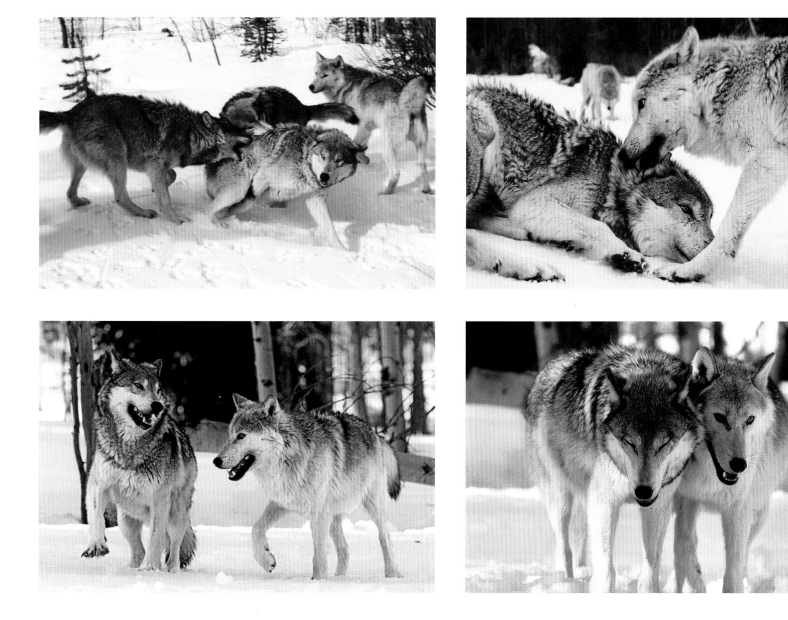

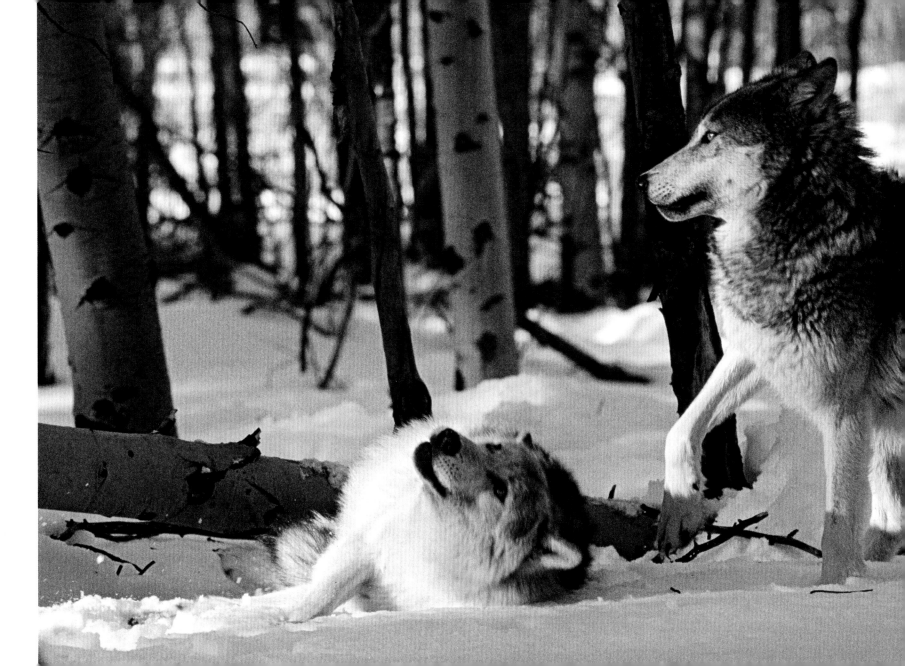

With Matsi, Lakota was free to do things he wouldn't dare do around the others. He never would have jumped on Amani's or Motomo's back to instigate play. No wolf, not even benevolent Kamots, would have stood for that sort of audacity from an omega. Matsi, on the other hand, let it pass. One of the happiest sights we experienced in all our time with the pack was the sight of these two frolicking together—and the look of joy on the face of Lakota, freed for a moment from his burdens.

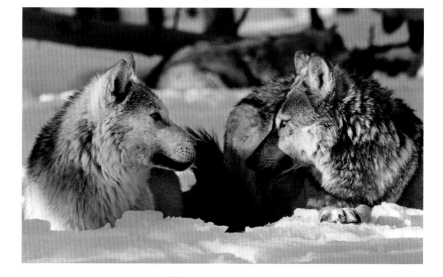

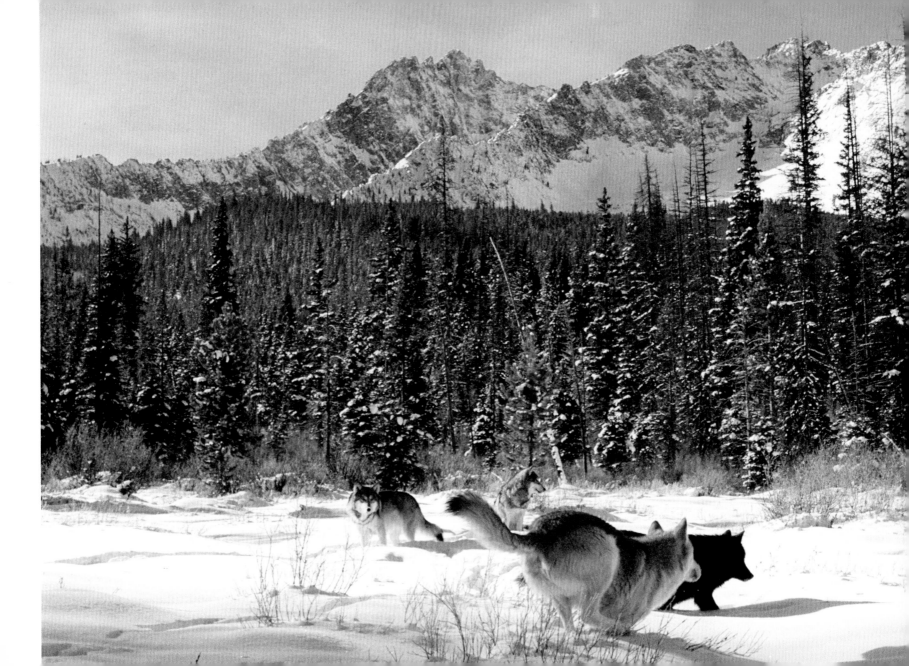

The focus of our project was to examine the individual relationships that wolves have with one another, which revealed the more subtle signs of pack unity. More than anything else, this is the social behavior we hoped to share, the side of wolves that people understand the least.

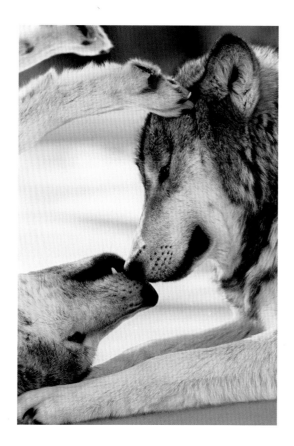

Opposite: A wolf pack is a complex social unit—an extended family of parents, siblings, aunts, and uncles. There are old wolves that need to be cared for, pups that need to be educated, and young adults that are beginning to assert themselves, all constantly altering the dynamics of the pack.

The strongest impression remaining with me after watching the wolves on numerous occasions was their friendliness. The adults were friendly toward each other and amiable toward the pups.

ADOLPH MURIE, *THE WOLVES OF MOUNT MCKINLEY*

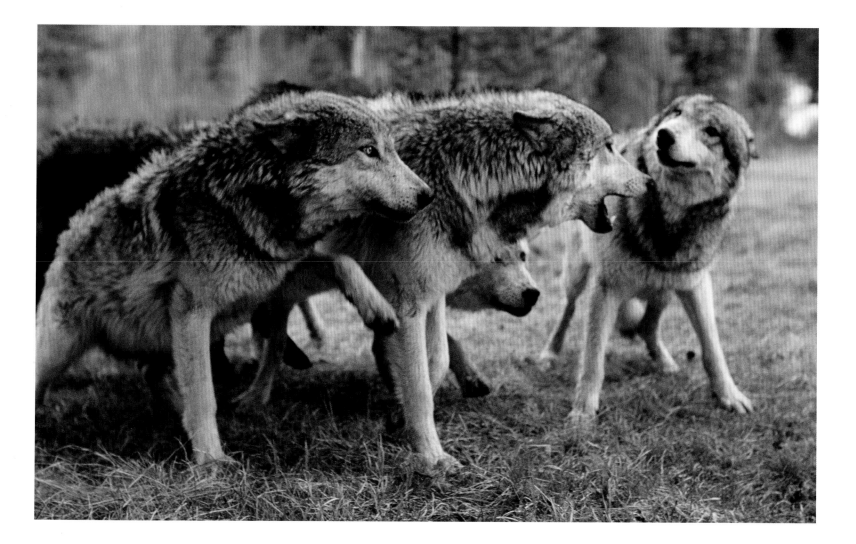

When one of the first Sawtooth Pack members was killed by a mountain lion, we observed a drastic change in the pack's behavior. Previously they had coursed through the meadow in a daily game of tag, but for six weeks after their pack mate's death, we observed no play. The spirit had simply left the pack. Where expressions of solidarity were usually common, the wolves spent this time alone.

Opposite: After the cougar incident, the pack drifted about their territory, engaging in minimal interaction but frequenting the spot where the attack had occurred and sniffing the ground in silence. Their normally exuberant howls became eerie and mournful and, for these six weeks, they tended to howl alone. To us, it appeared that they were remembering—and mourning—their pack mate.

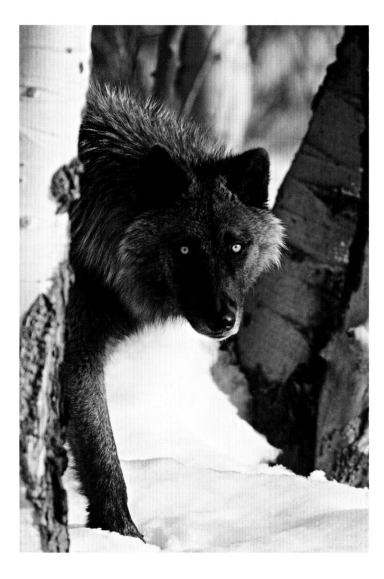

Opposite: Over the six years that we lived with the wolves, we watched as the pack built their own society, chose their own leaders, and sorted out their own disputes. We witnessed their physical and vocal interactions, camaraderie, the digging of a den, the birth and raising of pups, and reactions to the death of a pack member who was killed by a wild cougar. We even observed empathy, sadness, joy, and guilt.

Following pages (194-195): Our approach to this project was not to film wild wolves nor to habituate this endangered species to a human presence. We knew that our constant intrusion into their world would erode their fear of people. Our concern was that the next time someone pointed something at them, it might not be a camera.

Joseph Campbell . . . wrote . . . that men do not discover their gods, they create them. So do they also, I thought . . . create their animals.

BARRY LOPEZ, *OF WOLVES AND MEN*

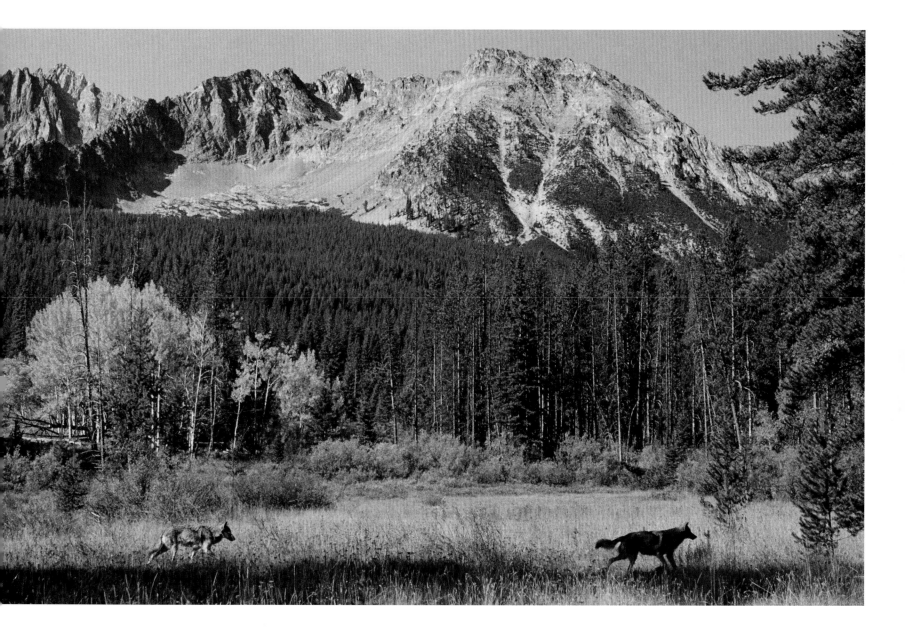

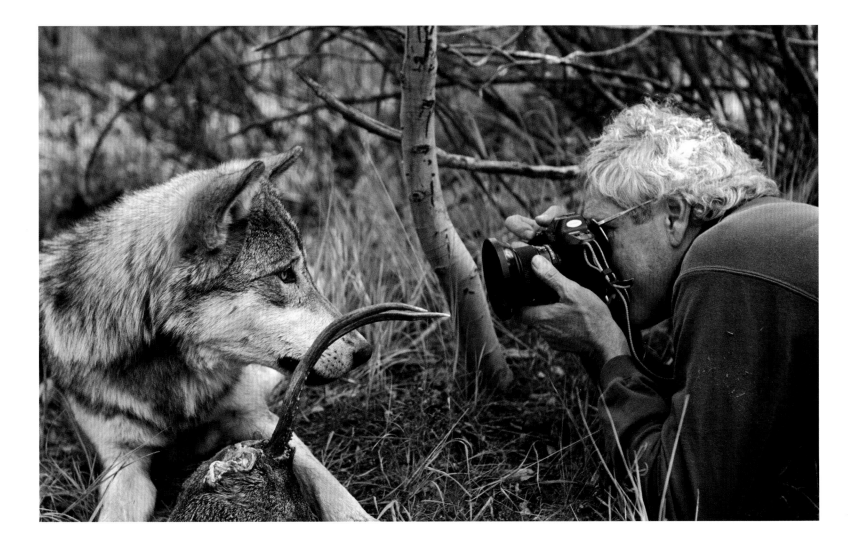

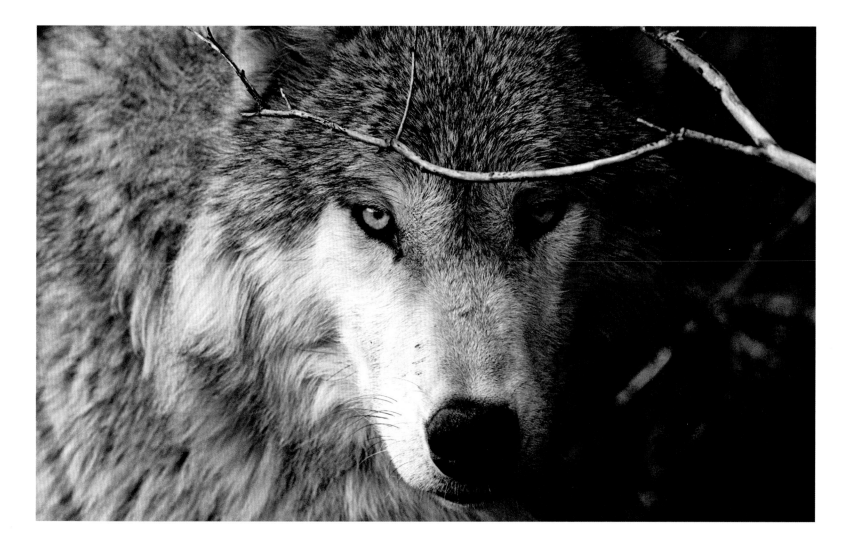

Lakota was the mildest and gentlest wolf we have ever known. As he aged, he was finally relieved of his omega status, leaving the position to Wahots.

We reached the old wolf in time to watch a fierce green fire dying in her eyes. I realized then and have known ever since that there was something new to me in those eyes—something known only to her and to the mountain. I was young then, and full of trigger-itch; I thought that because fewer wolves meant more deer, that no wolves would mean a hunters' paradise. But after seeing the green fire die, I sensed that neither the wolf nor the mountain agreed with such a view.

ALDO LEOPOLD, *A SAND COUNTY ALMANAC*

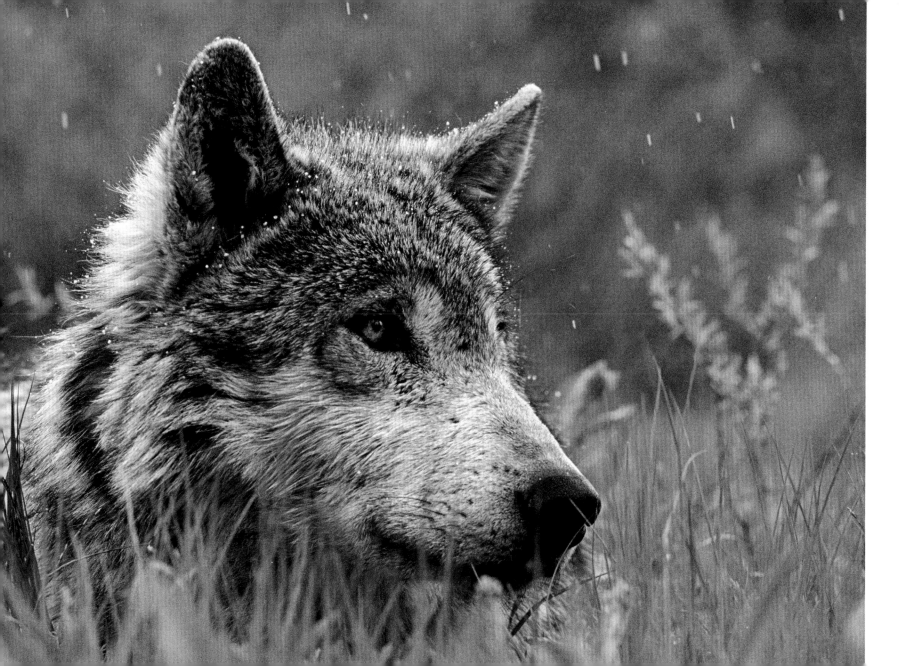

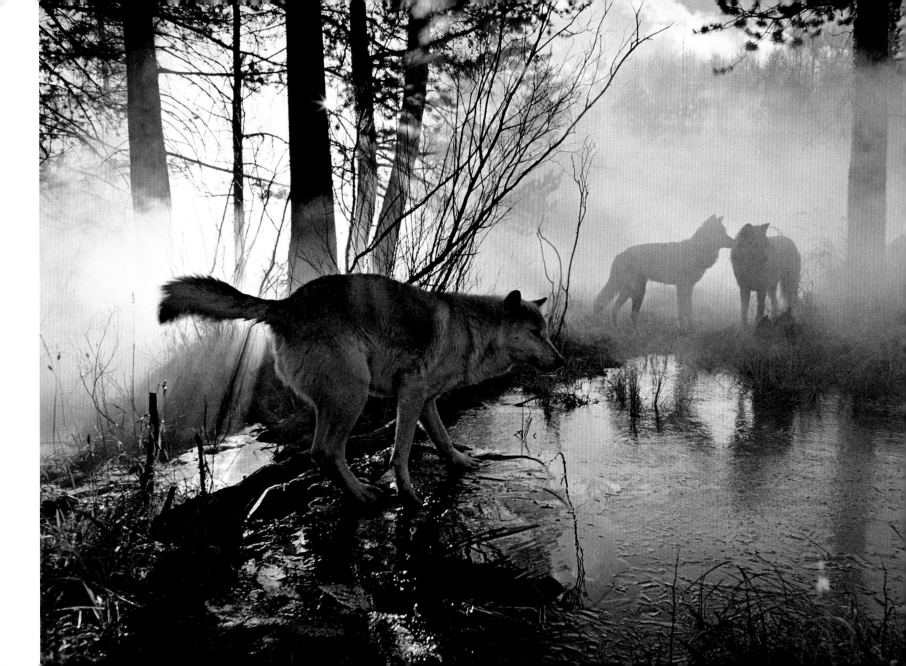

Opposite: The life of a wolf is short, averaging about five to seven years. Born between 1991 and 1996, the Sawtooth Pack exists mostly as memories now. Kamots, Lakota, Matsi, and the rest revealed their beauty, their depth, and even their contradictions for all to see. As ambassadors for their wild cousins, we hope they made a difference.

The Sawtooth Mountains of Idaho emerge from low-lying clouds.

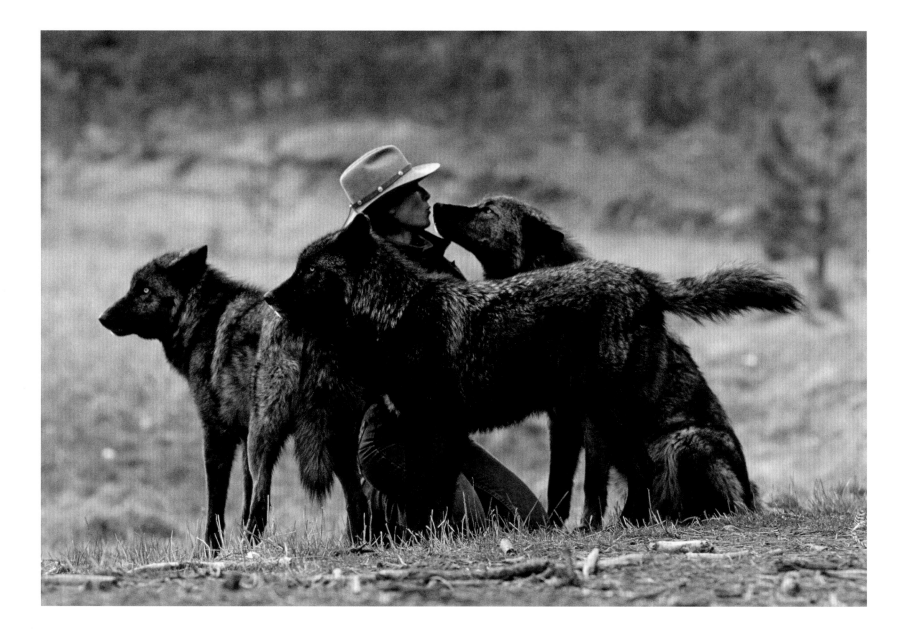

Jamie reunites with Kamots and Chemukh's male offspring, Piyip, at the Nez Perce Reservation.

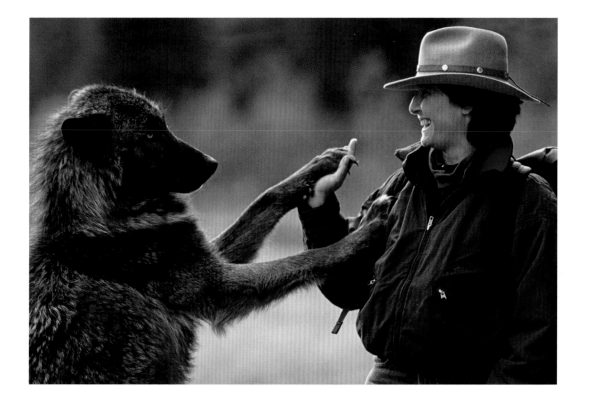

Aspens

Coyote

Elk

WITHOUT WOLVES
1926–1995

The wolves of Yellowstone National Park were eliminated by 1926, influencing a cascade of changes that altered the park's entire ecosystem.

ELK, no longer pressured by predatory wolves, were killed and relocated in large numbers by park rangers to control their burgeoning population. Having lost the fear of being hunted, elk gathered near streams, overbrowsing willows, cottonwoods, and shrubs that grow on banks and prevent erosion. Birds lost nesting space. Habitat for fish, amphibians, and reptiles declined as waters became broader, shallower, and, without shade from streamside vegetation, warmer.

ASPEN trees seldom reached full height in Yellowstone's northern valleys, where elk winter. Browsed by elk, the new sprouts were eaten, and existing trees were stunted.

COYOTES, no longer having to share the land with wolves, became abundant. Though they often kill elk calves, coyotes prey mainly on ground squirrels, voles, and other small mammals. They also specialize in killing the fawns of pronghorn antelope. The lack of carcasses left behind by wolves reduced the food available for foxes, badgers, raptors, and scavengers.

WITH WOLVES
1995—NOW

ELK numbers have decreased. Their behavior changed as wolves returned. No longer lingering along streams, elk retreated to higher ground with better vistas for spotting predators, allowing riparian areas to recover. Additionally, drought, severe winters, and other large predators, including grizzly bears, have all contributed to the recent decline in elk within the park.

ASPEN, willows, cottonwood, and other vegetation have resumed their natural growth with reduced pressure from elk, stabilizing trampled stream banks and restoring the natural water flow. Overhanging branches shade the streams, providing cooler water and benefiting trout and other aquatic life. Songbirds nest in willows. Streamside trees provide food for beavers and materials for building dams that hold back ponds and create a thriving aquatic habitat.

COYOTE numbers dropped as they once again shared the land with wolves. Many coyotes were killed or driven away by wolves, helping to bring about a resurgence in pronghorn.

WOLVES, now returned to their original habitat, play a vital role in keeping the world of predator and prey in balance. Once they've eaten their fill, the leftovers from their kills provide food for scavengers, including bald and golden eagles, coyotes, ravens, and bears.

Raven

Elk

Young aspen

Pronghorn

Beaver

Green-winged teal

Boreal chorus frog

Wolf

OUR NEW UNDERSTANDING

Scientists are continually debating about the emotional lives of animals.
Only recently has real consideration been given to the possibility that a creature
like a wolf could be capable of an emotion as complex as compassion.

For us, the insight of compassion was the gift that the Sawtooth Pack gave to us.
Compassion has been an underlying theme in our films, and it is the single most important
message about wolves that we can share. Wolves possess something beyond their
more obvious attributes of beauty, strength, and intelligence.
These animals, who have been maligned for centuries and despised
as the embodiment of all that is cowardly, savage, and cruel,
clearly care about one another. They show signs of what we believe
are nothing less than empathy and compassion.

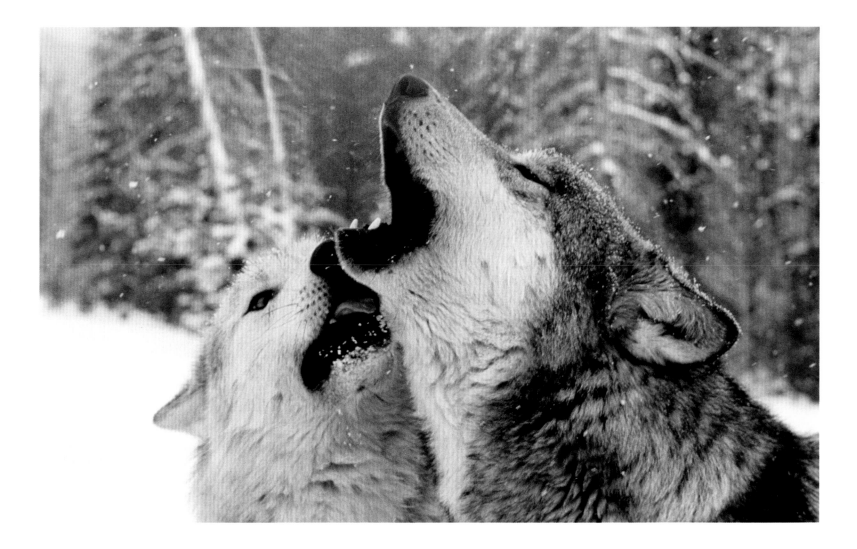

EPILOGUE

Many years have passed since the first pups of the Sawtooth Pack opened their eyes and began to reveal their lives to us. We greeted them with excitement, eager to learn and document their ways. We were ready to nurse them into adulthood, to keep them healthy, safe, and happy, and we planned for the eventuality of a home where they could grow old after our project ended.

But six years later, when the day came to move the wolves to their new home, we were not ready to say goodbye. They had grown into cherished friends and ambassadors for their wild cousins. In every gesture of cooperation and every display of abiding care for one another, the Sawtooth Pack spoke on behalf of wolves everywhere. They cut through mythology and misinformation simply by being themselves. They had not asked for this role, but they fulfilled it with more grace than we ever had imagined.

When our Forest Service permits expired, we dismantled our camp but could not turn away from the Sawtooth Pack. Nor could we ignore their greater family, trying to gain a foothold in the wild—still misunderstood and still persecuted. Wolves need a voice, and the Sawtooth Pack still has so much to teach us all.

One of the most poignant moments they revealed to us occurred as we introduced them to their new home. With our project completed, we carefully sedated each wolf, painstakingly loaded them into transport crates, and drove to the Nez Perce Reservation in northern Idaho. Despite our care, the trip was undeniably taxing on wolves and humans alike. At the end of the journey, the pack faced a transition into unfamiliar territory.

The pups seemed unfazed by the trip, so we released them first. Bounding from their crates, they frolicked in the grass. Then we released Kamots, who immediately went to check on his pups. Finding them well reassured him, and he soon regained his familiar confidence. One by one, the others stepped forward, inspected the pups, and then went to Kamots to offer a supportive lick. The pack was ready to explore their

new territory—all except one. Lakota, the timid omega, refused to emerge. He could see his companions were not in danger. Still, he cowered in the safety of his crate.

Then Kamots broke away from the others and returned to his brother, peering in at Lakota, while they whined back and forth. At last, the wide-eyed omega poked his nose through the door and sniffed the air. Then he tentatively extended one paw onto the grass. Kamots stepped forward and pressed his shoulder tightly, reassuringly, against his brother's, and the two walked side by side into the meadow. It was one of the most touching displays of compassion we had ever witnessed. Kamots would not lead his family into their new territory until his pack was complete. He understood his brother needed encouragement, and he was there to reassure him and coax him forward.

A parallel event occurred one year earlier, when another group of wolves made a similar journey in transport crates in the back of a truck, traveling south from Canada. These first wild wolves to be reintro-duced into Idaho quickly became the focus of controversy and political posturing, arriving under a veil of secrecy. Idaho's governor threatened to use the National Guard to stop their release, while concerns sur-faced about disruptions from anti-wolf activists. As handlers unloaded the crates, one could hear shifting and stumbling inside, the scrape of nails on metal floors, the body language of fear. As each crate opened, its occupant shot out, bolting in panic toward the welcoming cover of the forest—all except one.

The last wolf cowered in her crate and refused to move. A veterinarian hired by Idaho Fish and Game stepped forward with a snare pole—a long, metal rod with a sliding noose at one end, designed for handling rabid and dangerous animals. He reached the pole into the crate, cinched the loop around the reluctant wolf's throat, and dragged her out. This moment was captured on film and published around the world. The wolf—eyes wild, teeth bared, snapping at the metal pole—was the perfect embodiment of our ancient preconceptions, the image of an irredeemably savage beast.

What is the difference between these two frightened wolves—one thrashing and snarling, the other timid but gentle? Human beings are the difference. This panicked wolf may have been an omega, like Lakota,

but in her most desperate moment, she lacked the one thing she needed: the reassurance of a supportive pack mate. Perhaps if the people surrounding her had moved back and waited, she would have emerged at her own pace. But that's not how we deal with wolves. We *manage* them. We invent rules for them to live by, and kill them for their transgressions. We count them like marbles while politicians decide how many is too many. But patience and restraint might bring about a more desirable outcome. The more we learn about wolves, the more we see that taking into account their intelligence and their ability to learn and adapt could lead us to a path of coexistence.

Conflict between our species occurs where wolves' predatory inclinations clash with the ways we use the land—namely for ranching and hunting. First, an honest, thorough analysis of the impact of wolves, negative and positive, on livestock, game, tourism, and the ecosystem is needed. The next step is to understand the wolf's true nature and to work with it, not against it. More than wolves themselves, it is our relationship with wolves that needs to be managed. As Timmothy Kaminski of the Mountain Livestock Cooperative says, "This is not a wolf issue; it's a people issue. The space once available to be filled with truth and facts is instead a vacuum filled with ideology, myths, acrimony and mistrust. That is a disservice to wolves and to people."

The wolves of the Sawtooth Pack have done their part to fill this vacuum. They lend their faces to the wild wolves we seldom see—the ones we manage, hunt, and kill when they step out of line. In forests of North America, Europe, and Asia, there are confident alphas looking after their packs, dutiful parents digging dens and raising pups, indulgent uncles, mischievous siblings, and gentle omegas inciting games of tag. We know these wolves, for we have seen their reflections in the Sawtooth Pack.

Thanks to them, and the efforts of so many biologists, ranchers, government officials, and visionaries, we have an opportunity to replace mythology and mistrust with patience and understanding. If we are truly willing to allow wolves to live, hunt, and build stable societies, then the nature—and culture—of wolves must inform and guide our actions. As we seek a path toward lasting coexistence, wolves and people need to take the next step together.

As the pack entered their new territory, Kamots immediately sensed that his brother, the omega, needed encouragement. Shoulder to shoulder, he was there to coax Lakota and to provide reassurance.

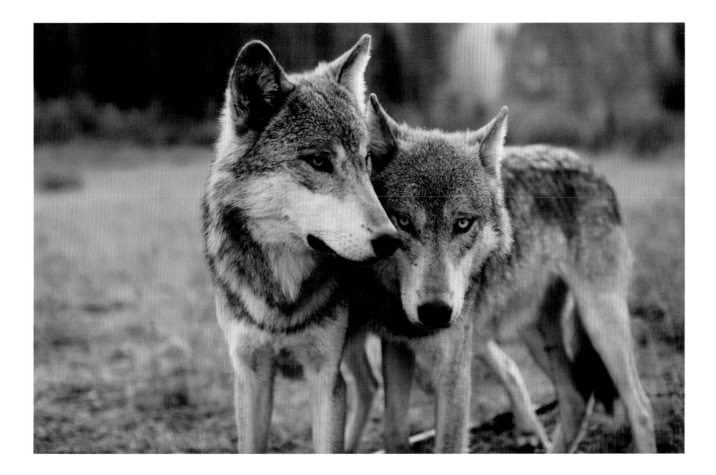

Range of the Gray
Wolf in North America

■ Current range
■ Former additional range

THE GRAY WOLF
IN NORTH AMERICA
A TIMELINE

■ **1870–77**
Wolf extermination peaks. In addition to ongoing state-by-
state bounty programs, the federal government employs
bounty hunters to eradicate wolves. During this period, as
many as 100,000 wolves are killed each year.

■ **1914**
The U.S. government approves destroying all species
"injurious to agriculture" in the West. Yellowstone National
Park begins a wolf eradication campaign.

■ **1926**
Park rangers shoot two wolf pups, the last two wolves in
Yellowstone.

■ **1935–1968**
Yellowstone rangers shoot, trap, and export elk and other prey
species that are now overpopulating and overgrazing the park.

■ **1944**
Aldo Leopold, pioneer of American conservation, recommends
bringing wolves back to Yellowstone.

■ **1974**
The gray wolf is protected by Congress under the Endangered
Species Act, and the Rocky Mountain wolf recovery team is
established.

■ **1987**
The U.S. Fish and Wildlife Service approves the Northern
Rocky Mountain Wolf Recovery Plan.

■ **1995–96**
After extensive public input, including testimony from more than
160,000 people, and based on the wolf recovery plan, 66 wolves
from Canada are released into Yellowstone and central Idaho.

THE GRAY WOLF IN THE LOWER 48 STATES

A CHANGING LANDSCAPE:
NATIVE, DIMINISHED, AND REESTABLISHED RANGES

HISTORIC GRAY WOLF RANGE

1974 GRAY WOLF RANGE

PRESENT-DAY GRAY WOLF RANGE

■ 2005
A federal mandate allows livestock owners in Montana and Idaho, with no permit required, to kill wolves threatening their livestock. State and tribal agencies can also kill wolves to protect their elk and deer herds.

■ 2007
The U.S. Fish and Wildlife Service proposes removing the northern Rocky Mountain wolf population from the endangered species list. Three months later, it receives a letter from 247 independent scientists opposing the proposal and stating that the wolf population is too small to maintain long-term genetic viability.

■ 2008–10
The U.S. Fish and Wildlife Service removes wolves from the endangered species list twice, only to be overturned twice by a federal court upholding the Endangered Species Act. Wolves are hunted by the public in Idaho and Montana while court cases are pending.

■ 2011
In a rider attached to the federal budget, Congress removes wolves from endangered species protection. To block lawsuits, the law bans any future judicial review of the issue. Wolf hunting resumes. A lone wolf crosses from Oregon into California, the first in more than 80 years.

■ 2012
In one year, nearly 50 percent of Idaho's wolves have been killed. Wyoming announces a shoot-on-sight policy in more than 80 percent of the state, any time of year, no license required. Montana triples its hunting quota and introduces a wolf-trapping season.

In 1974, after a century of aggressive extermination efforts had nearly extinguished gray wolves in the lower 48 states, the Endangered Species Act took effect, and the dwindling species was whisked onto the list. The U.S. Fish and Wildlife Service (FWS) subsequently initiated recovery programs for the gray wolf in three regions, setting population goals for the West, East, and Southwest.

FURTHER RESOURCES

Bekoff, Marc. *The Emotional Lives of Animals*. New World Library, 2007.

Bekoff, Marc and Jane Goodall. *Minding Animals: Awareness, Emotions, and Heart*. Oxford University Press, 2002.

Busch, Robert. *The Wolf Almanac*. The Lyons Press, 1995.

Coleman, John T. *Vicious: Wolves and Men in America*. Yale University Press, 2004.

Crisler, Lois. *Arctic Wild*. Curtis Publishing Company, 1956.

Derr, Mark. *How the Dog Became the Dog*. Overlook Press, 2011.

Eisenberg, Cristina. *The Wolf's Tooth*. Island Press, 2010.

Goodall, Jane and Marc Bekoff. *The Ten Trusts: What We Must Do to Care for the Animals We Love*. HarperCollins, 2002.

Holleman, Marybeth, ed. *Among Wolves: The Work and Times of Dr. Gordon Haber*. University of Alaska Press, in press.

Knight, Elizabeth, ed. *Wolves of the High Arctic*. Voyageur Press, 1992.

Landau, Diana, ed. *Wolf, Spirit of the Wild*. Walking Stick Press, 1993.

Leopold, Aldo. *A Sand County Almanac*. Oxford University Press, 1949.

Lopez, Barry Holstun. *Of Wolves and Men*. Charles Scribner's Sons, 1978.

McIntyre, Rick, ed. *War Against the Wolf*. Voyageur Press, 1995.

Mech, L. David, and Luigi Boitani, eds. *Wolves: Behavior, Ecology, and Conservation*. University of Chicago Press, 2003.

Murie, Adolph. *The Wolves of Mount McKinley*. University of Washington Press, 1985.

Musiani, Marco, Luigi Boitani, and Paul Paquet, eds. *A New Era for Wolves and People: Wolf Recovery, Human Attitudes, and Policy*. University of Calgary Press, 2009.

Niemeyer, Carter. *Wolfer*. Bottle Fly Press, 2010.

Robisch, S. K. *Wolves and the Wolf Myth in American Literature*. University of Nevada Press, 2009.

BOOKS BY JIM AND JAMIE DUTCHER

Dutcher, Jim with Richard Ballantine, *The Sawtooth Wolves*. Rufus Publications, Inc., 1996.

Dutcher, Jim and Jamie, *Wolves at Our Door: The Extraordinary Story of the Couple Who Lived with Wolves*. Simon and Schuster, 2002.

Dutcher, Jim and Jamie, *Living with Wolves*. Washington: Mountaineers Press, 2005.

DOCUMENTARY FILMS BY DUTCHER FILM PRODUCTIONS

Water, Birth, the Planet Earth. PBS/National Geographic, 1985.

A Rocky Mountain Beaver Pond. National Geographic Special, 1987.

Cougar: Ghost of the Rockies. ABC World of Discovery, 1990.

Wolf: Return of a Legend. ABC World of Discovery, 1993.

Wolves at Our Door, Discovery Channel, 1997.

Living with Wolves, Discovery Channel, 2005.

ILLUSTRATIONS CREDITS

THE HIDDEN LIFE OF WOLVES

Jim and Jamie Dutcher with James Manfull

Published by the National Geographic Society
John M. Fahey, *Chairman of the Board and Chief Executive Officer*
Timothy T. Kelly, *President*
Declan Moore, *Executive Vice President; President, Publishing and Digital Media*
Melina Gerosa Bellows, *Executive Vice President; Chief Creative Officer, Books, Kids, and Family*

Prepared by the Book Division
Hector Sierra, *Senior Vice President and General Manager*
Jonathan Halling, *Design Director, Books and Children's Publishing*
Marianne R. Koszorus, *Design Director, Books*
Susan Tyler Hitchcock, *Senior Editor*
R. Gary Colbert, *Production Director*
Jennifer A. Thornton, *Director of Managing Editorial*
Susan S. Blair, *Director of Photography*
Meredith C. Wilcox, *Director, Administration and Rights Clearance*

Staff for This Book
Sanaa Akkach, *Art Director*
Susan Blair, *Illustrations Editor*
Carl Mehler, *Director of Maps*
Gregory Ugiansky and XNR Productions, *Map Research and Production*
Judith Klein, *Production Editor*
Mike Horenstein, *Production Manager*
Galen Young, *Illustrations Clearance Specialist*
Katie Olsen, *Design Assistant*
Patricia Kilmartin and Sheryl Schowengerdt, *Assistants to the Dutchers*

Manufacturing and Quality Management
Phillip L. Schlosser, *Senior Vice President*
Chris Brown, *Vice President, NG Book Manufacturing*
George Bounelis, *Vice President, Production Services*
Nicole Elliott, *Manager*
Rachel Faulise, *Manager*
Robert L. Barr, *Manager*

CELEBRATING ‹125› YEARS

The National Geographic Society is one of the world's largest non-profit scientific and educational organizations. Founded in 1888 to "increase and diffuse geographic knowledge," the Society works to inspire people to care about the planet. National Geographic reflects the world through its magazines, television programs, films, music and radio, books, DVDs, maps, exhibitions, live events, school publishing programs, interactive media and merchandise. *National Geographic* magazine, the Society's official journal, published in English and 33 local-language editions, is read by more than 60 million people each month. The National Geographic Channel reaches 435 million households in 37 languages in 173 countries. National Geographic Digital Media receives more than 19 million visitors a month. National Geographic has funded more than 10,000 scientific research, conservation and exploration projects and supports an education program promoting geography literacy. For more information, visit www .nationalgeographic.com.

For more information, please call 1-800-NGS LINE (647-5463) or write to the following address:

National Geographic Society
1145 17th Street N.W.
Washington, D.C. 20036-4688 U.S.A.

For information about special discounts for bulk purchases, please contact National Geographic Books Special Sales: ngspecsales@ngs.org

For rights or permissions inquiries, please contact National Geographic Books Subsidiary Rights: ngbookrights@ngs.org

ISBN: 978-1-4262-1012-9

Printed in China

12/CCOS/1

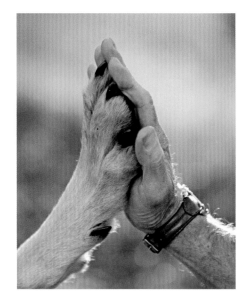